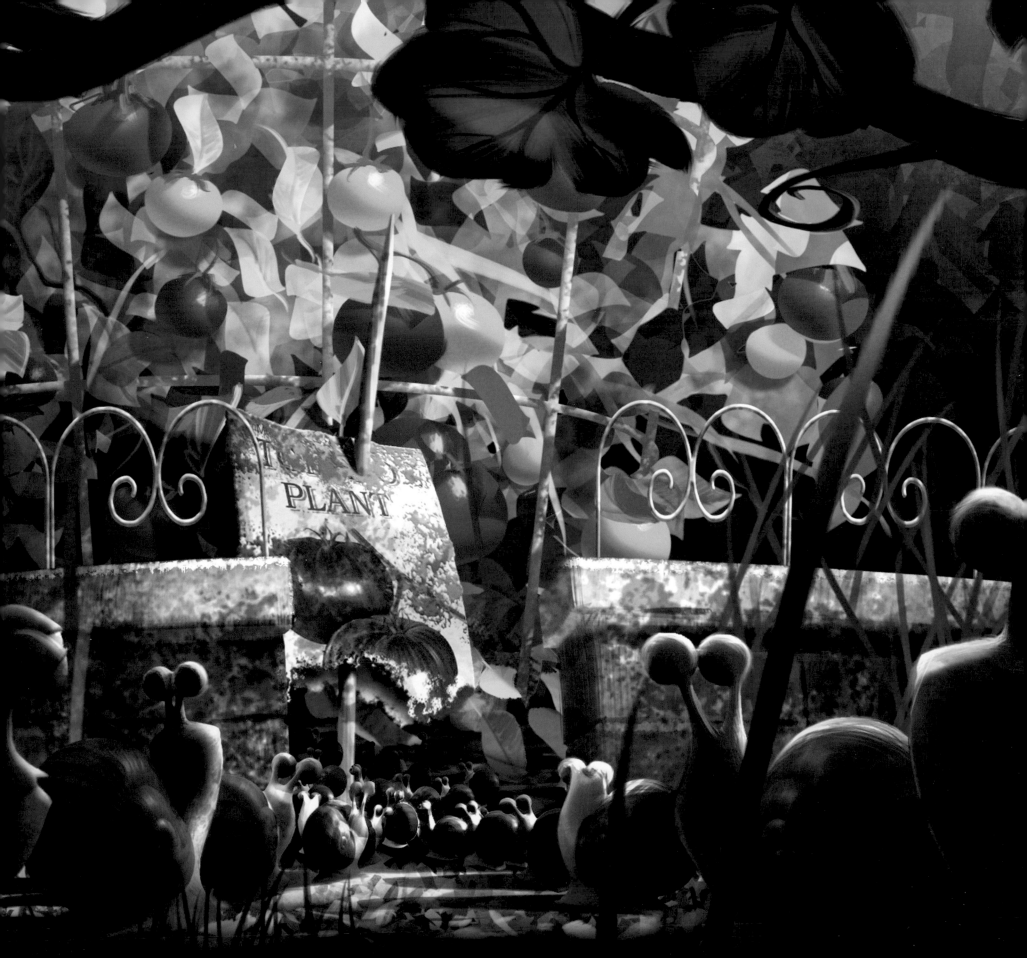

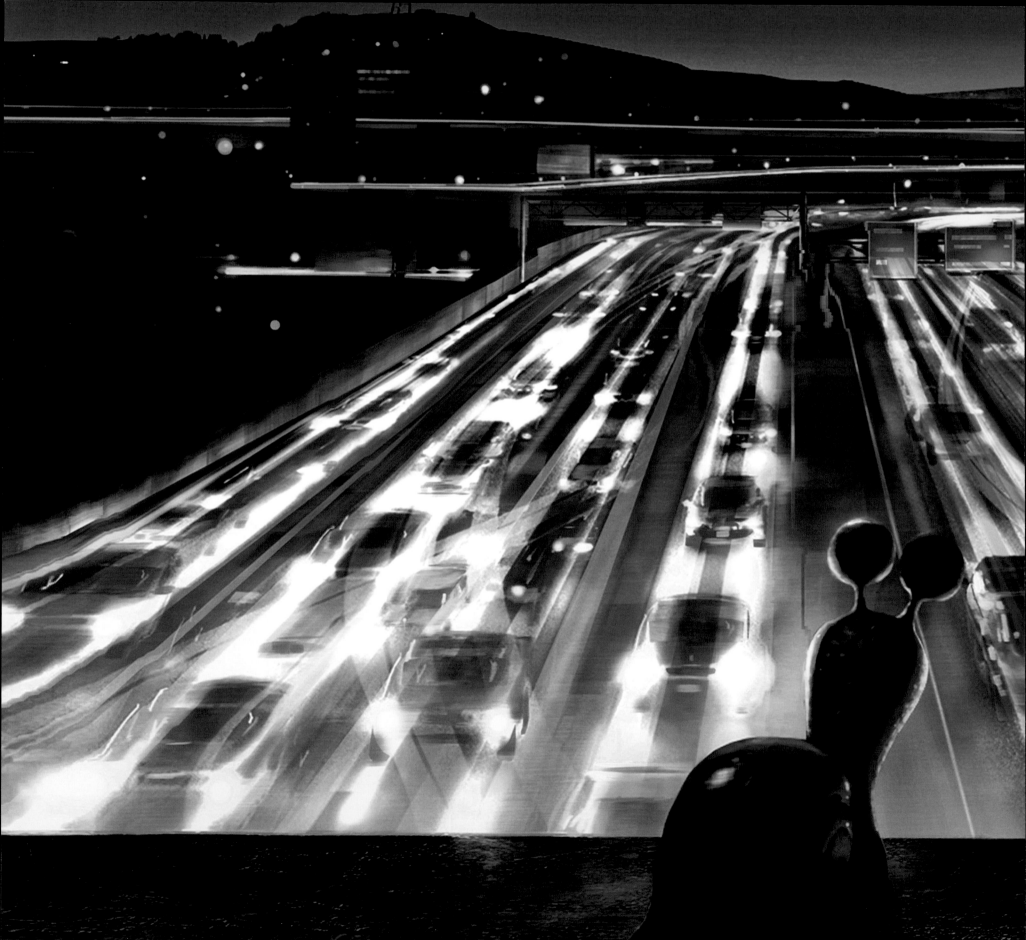

DreamWorks

THE ART OF TURBO

FOREWORD BY **RYAN REYNOLDS**

PREFACE BY **DAVID SOREN**

WRITTEN BY **ROBERT ABELE**

INSIGHT EDITIONS

contents

FOREWORD BY *Ryan Reynolds* 6

PREFACE BY *David Soren* 9

INTRODUCTION: A SNAIL'S TALE 11

CHARACTERS 19

HUMAN/NATURE 21

TURBO 25

 THE TRANSFORMATION 35

CHET 37

TITO 41

ANGELO 44

GUY GAGNÉ 47

BOBBY 51

KIM LY 52

PAZ 55

RACING SNAILS 56

WHIPLASH 61

BURN 63

SKIDMARK 64

SMOOVE MOVE 67

WHITE SHADOW 68

OTHER SNAILS 70

HUMAN CHARACTERS 73

CROWDS 74

LOCATIONS 77

KEEPING IT REAL 79

SAN FERNANDO VALLEY 82

HOUSE GARAGE 86

TOMATO PLANT 88

STRIP MALL 93

DOS BROS TACOS 97

PAZ AUTOBODY 100

INDIANAPOLIS MOTOR SPEEDWAY 104

GAGNÉ'S GARAGE 106

PAGODA 109

RACETRACK 111

VEHICLES 119

MUSCLE CARS 121

TACO TRUCK 125

INDY CARS 126

BUILDING A SEQUENCE 133

SEQUENCE 950: SNAIL RACE 134

THE FINISH LINE 145

THE CREW 148

ACKNOWLEDGMENTS 149

COLOPHON 150

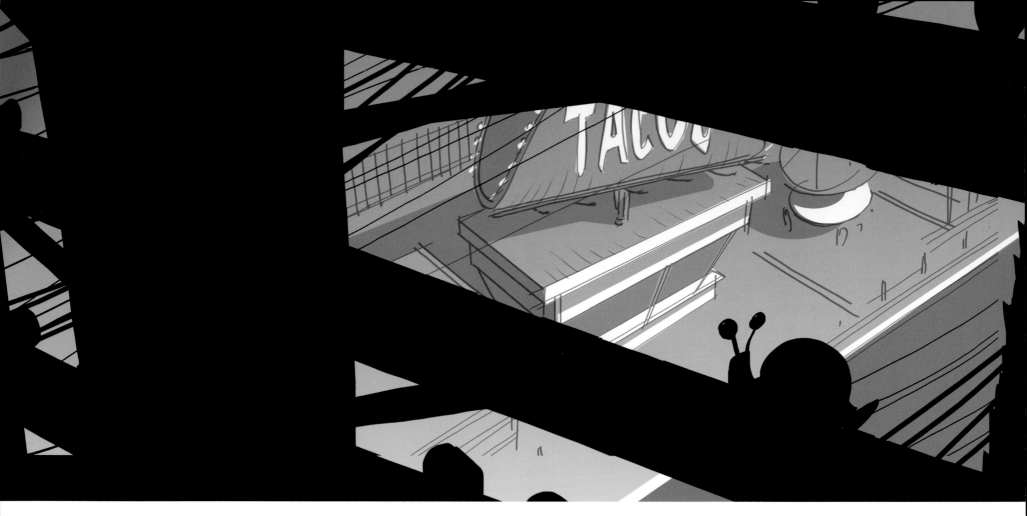

Marcos Mateu-Mestre

FOREWORD

BY RYAN REYNOLDS

Not long ago, I was invited to dinner with Jeffrey Katzenberg and his lovely wife, Marilyn. We enjoyed a wonderful meal and, as usual, delightful and effervescent conversation covering a broad range of subjects. Toward the end of dinner, Jeffrey said he'd like to know if I'd be interested in working on one of his films—a film called *Turbo*. Not surprisingly, I perked up and asked what the subject matter of the film would be. Jeffrey mentioned it would be set in the exciting world of INDYCAR racing.

Let me pause for a moment to tell you that I'm a longtime fan of INDYCAR racing, and I've always held a soft spot in my heart for the sport. It's among the highest class of single-seat auto racing and one of the most exhilarating and dangerous sports in the world. With cars reaching speeds of up to 250 miles per hour, it's no surprise the sport attracts a worldwide audience of tens of millions of fans each year. Like James Garner or Steve McQueen before me, I looked forward to suiting up and sitting atop a 600 horsepower speed machine and learning the craft of auto racing from some of the world's best.

I wondered whom I'd be portraying. Perhaps it would be racing legend Mario Andretti or Rex Mays. I was banking on the latter. Mays was widely considered to be the greatest driver never to have won the Indianapolis 500. He possessed the uncommon resolve of a panther, his racing skills balanced in perfect symphony with a rebellious nature. Indeed, a fertile prelude to the as yet untold story about—

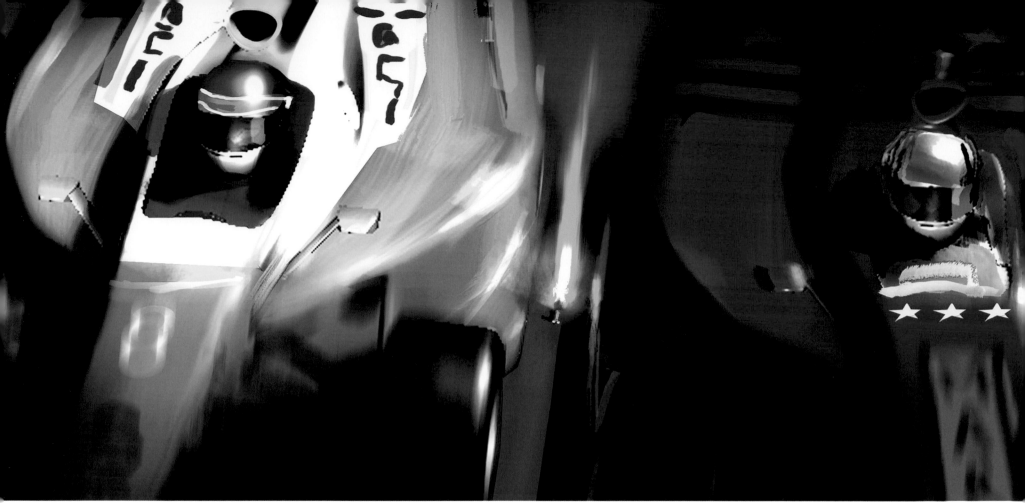

"A snail," said Jeffrey.

"I'm sorry?" I whispered back to him, sneaking a French roll off his plate.

"A snail. The movie is about the fastest snail in the world." He said all this very plainly, like he was perfectly comfortable with the technical, physical, and logistical implausibility of his last sentence.

"The story is about a snail, with an impossible dream. A dream so big it can barely fit on the screen. The snail's dream . . . is to win the Indianapolis 500."

I wanted to congratulate Jeffrey on his recent upgrade to massive clinical insanity. I've heard a number of nutty ideas in my day, but this took the cake.

With no thought for my own safety, I said, "Jeffrey. You're an adventurous filmmaker, a true pioneer, and probably my favorite mogul. But why would you choose to put your energy into this costly and fruitless endeavor? This idea is absurd. If you're not gonna eat the rest of that chicken potpie, I will."

I held his gaze. As intimidating as Katzenberg is, I wasn't about to back down. Perhaps he'd lost his edge. Maybe it was the complete box office failure of the Shrek franchise that had brought him to the very precipice of his own self-propelled delusion. I can't say for sure. No one can. But it was evident the man had lost his marbles.

"A feature-length action film about a snail is perhaps the most ridiculous thing I've ever heard. Countless production days would be lost to uncooperative mollusks meandering aimlessly around set. Think about it. Race cars would be zooming around the track at breakneck speeds while a cinematographer attempts to expertly light and capture the facial expressions of a 2-inch snail? In a word? Super dumb. Two words. Whatever. Look, I understand the finely tuned balance between magical realism and special effects, but this just won't work. I'm sorry to break it to ya, big guy . . . A snail—even a stunt snail—could only reach a top speed of what—2 or 3 feet PER HOUR? The hardest job wouldn't belong to the snail, or the director, or even the snail wrangler, assuming there even IS such a thing. No sir, the hardest job would belong to the AUDIENCE. You can't expect them to suspend their collective disbelief for ninety-plus minutes in order to indulge some fantasy you might have about this little, slimy—"

"It's animated," he said.

"It's what?" I said, drinking the remainder of his sparkling apple cider.

"It's animated. It's an animated film. Do you understand?"

"Well . . ." I said. "That certainly changes things, Jerry."

"Jeffrey."

"That's what I said."

And then he just carried on eating his meal in silence. Pretending I wasn't there for the rest of the evening and/or relationship.

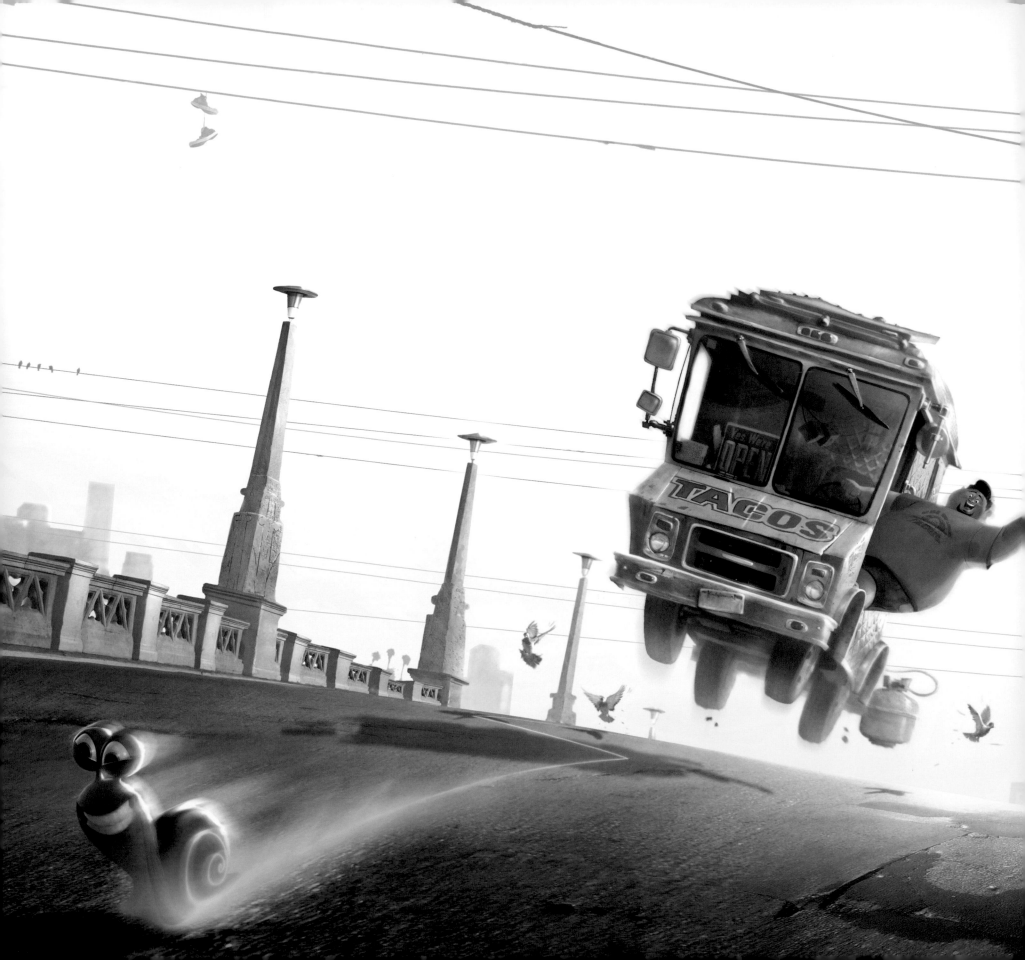

PREFACE *BY DAVID SOREN*

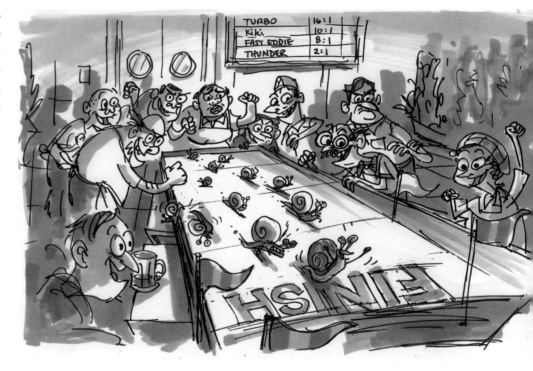

I've always loved "Art of" books. When I was an animation student, they were part of my education. Now that I'm a professional, they've been a way to study the decisions that led to the movies I've admired. I pull them off the shelf when I need inspiration. But it wasn't until I became a director that I realized just how valuable the art that fills the pages of these books could be. Yes—art makes stories come alive. But more than that, art has the power to persuade, to influence, and to unite. As a first-time feature director trying to make a movie about a snail, I found that art would prove to be my strongest ally.

Snails are gross. That's right, I said it. We all know it's true. The French eat them. Kids smush them. Gardeners despise them. They are the unwilling subjects of slow jokes around the world. So . . . how do you make a movie about a snail that's exciting? That gives audiences a hero they can really get behind?

The answer: Tell the ultimate underdog story; create a character whose life is so stacked with impossible obstacles and limitations that nobody expects him to succeed. Win or lose, we love to root for the little guy!

The more I fleshed out Turbo as a character, the more I started to relate to him. We both had wildly unrealistic dreams: Turbo's absurd fantasy of racing glory and my own foolish hope of seeing an original idea through to the big screen. Like Turbo, I too had many obstacles in my path but I found the support of a crew—a wildly talented crew that got behind my idea and ran. And it was through their outstanding work— much of which you'll see on the following pages—that my underdog story made good.

Early on, people asked basic questions that in my mind were already solved: Should Turbo have arms? (*No, that's creepy.*) Should his eyes be below his stalks or on top of them? (*On top, of course!*) How does he go fast, does he drive a tiny race car? (*Are you kidding me???*) But with the right character design or story sketch or painting by my side, I had evidence to prove my case.

Then there was the world . . . a tomato plant, a strip mall in Van Nuys, the Indy 500. This story takes place in the real world. Yet in animation, everything is fantasy. The concept alone is so far-fetched that if I had any hope of getting people to root for Turbo I knew I had to ground the movie in a believable reality. Sounds nice but what does that look like?

It wasn't until I had the help of a few talented artists that things really began to gain momentum. The characters started to come to life. The idea became clearer to people. Its appeal started to shine through. As we continued to hone the story, more artists came on, bringing their ideas to the table, and everything started to snowball. Suddenly, Turbo was a go! And like the film's namesake, we had to go fast.

Sitting in lighting reviews, I was often breathless, watching the coming together of character and production design, camera, acting, FX, and lighting into one beautifully cohesive and original look. This wasn't luck. It was hard work produced by a stunningly talented and unified group of people who embraced my silly idea about a snail and made it so much better than I could have ever imagined.

It is without question that the art you'll see on these pages was instrumental in helping both Turbo and I achieve our dreams. And look! We've got our very own "Art of" book! Now I'm thrilled to be able to share it with you.

(opposite) Richard Daskas & Michael Isaak, (above right) David Soren

INTRODUCTION
A SNAIL'S TALE

What happens when a snail doesn't want to live at a snail's pace? How special would such a creature have to be to compete in the Indianapolis 500? That's the concept driving *Turbo*, an uplifting—and gear-shifting—story about the ultimate underdog, a snail who dreams in miles per hour, not inch by agonizing inch.

In response to a studio-wide pitch program at DreamWorks Animation in which aspiring filmmakers can pitch their own original movie concepts, writer/director David Soren drew on two elements from his own home life—a son obsessed with zooming cars and trucks, and a front yard riddled with nature's icons of slowness: snails. "I put the story together inspired largely by those two opposite things," says Soren, who turned in his pitch about a snail who dreams of racing glory, and got a green light.

Years of story development, design challenges, and artistic breakthroughs later, *Turbo* hits movie screens as a heartwarming, funny, and fanciful twist on the time-honored concept of the impossible dream tantalizingly realized. *Turbo* takes audiences on a journey during which, to borrow a classic superhero-movie tagline, you'll believe a snail can speed.

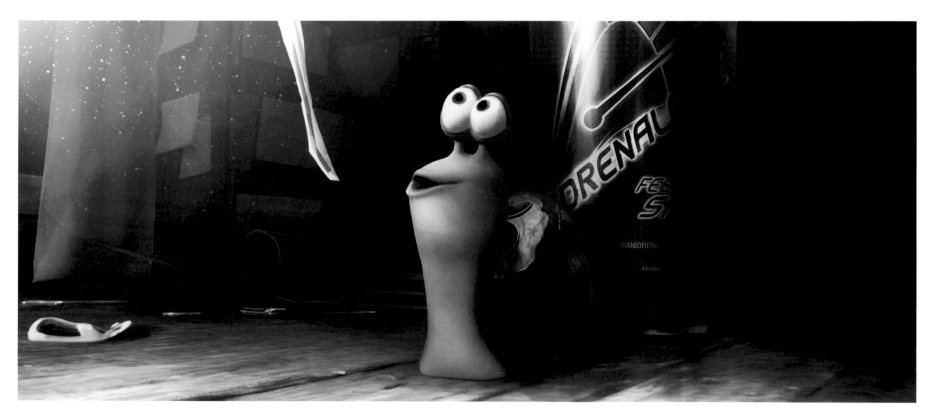

(opposite) Marcos Mateu-Mestre, (above) Richard Daskas

(above) Mike Hernandez, (opposite, top) Dominique R. Louis

But in the backyard tomato plant where Turbo (voiced by Ryan Reynolds) works with a team of everyday gastropods, his love of racing is a fantasy easy to mock. His safety-minded, practical brother, Chet (voiced by Paul Giamatti), considers Turbo a deluded creature that will never be happy until he accepts his limitations. The fantasy even turns dangerous when Turbo's belief in his own propulsiveness nearly gets him killed by a gardener's lawnmower.

Then a mournful night away from home turns into a transformative experience when a chance encounter with a drag-racing muscle car gives Turbo a molecular makeover, and the greatest possible gift: superspeed. Suddenly, a new path is blazed for Turbo, sparked in part by meeting a handful of new, like-minded friends who have uphill battles of their own. They include a tightknit group of racing snails, named Whiplash, Smoove Move, Skidmark, Burn, and White Shadow, and a band of strip mall shopkeepers—taco-stand owners Tito and Angelo, ace mechanic Paz, beautician Kim Ly, and hobbyist Bobby—trying to make a living for themselves. Turbo's newfound abilities suggest the ultimate opportunity: to race in the world's most attended sporting event, the Indianapolis 500, alongside his hero, dashing race champion Guy Gagné. When our revved-up snail gets his shot in the famed competition, *Turbo* becomes more than just a movie about one snail's ambition. It explores the very nature of drumming to your own beat, and how you never know whom your dreams will inspire.

"For me, the movie is ultimately about dreamers and realists," says Soren, "and all those things that get in the way when you have a dream in this world. Turbo is surrounded by obstacles, both environmental and physical."

Storytelling's long-standing attraction to the circumstance-challenged little guy, says producer Lisa Stewart, is what enhances *Turbo*'s appeal: "Everybody is an underdog in this movie. The idea that you've got this group that is starting at a disadvantage, but wants to push boundaries—it's universal."

Bringing this aim-big tale to the big screen meant assembling a creative team that could tackle the careful balance of atmospheric realism and fan-

12

(right) Marcos Mateu-Mestre

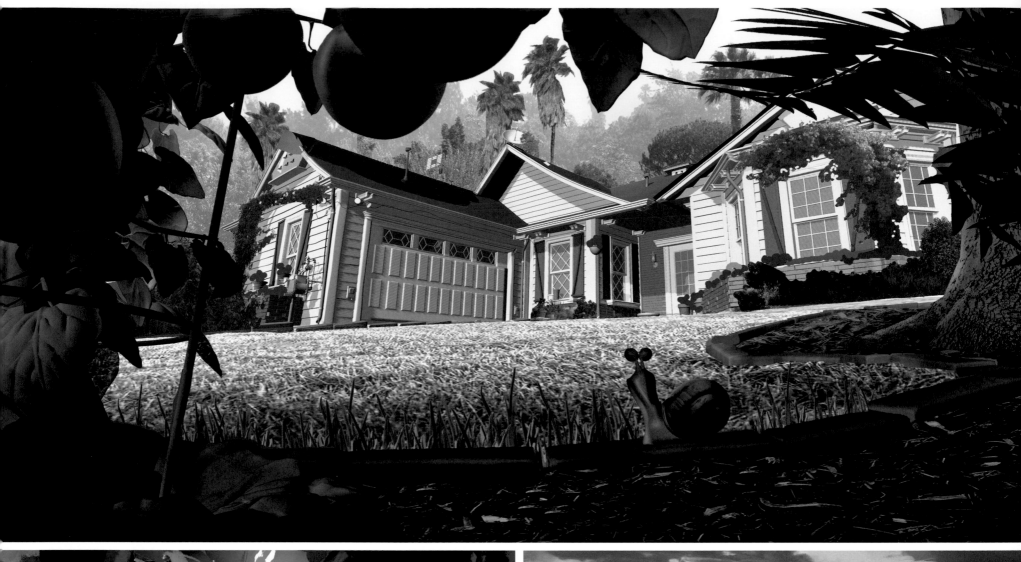

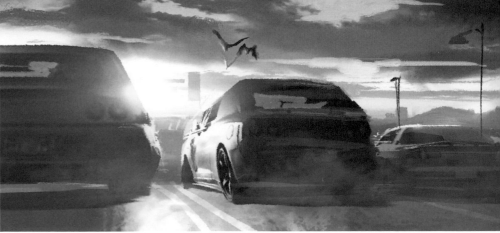

(top) Michael Isaak, (above) Dominique R. Louis

Dominique R. Louis

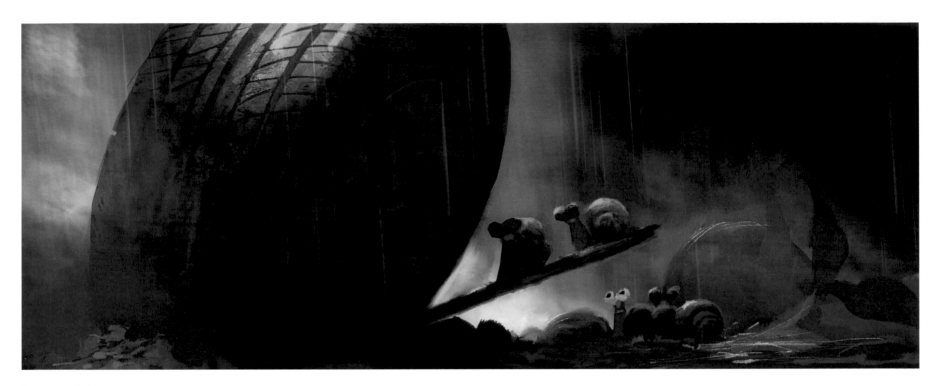

Dominique R. Louis

tasy that would give the story dramatic stakes as well as a consistently high level of visual richness. Production designer Michael Isaak brought a studied architectural eye to the real-world environments—a leafy suburban garden, a Los Angeles strip mall, the Indianapolis Motor Speedway—that surround Turbo's story, while the painting background of art director Richard Daskas strengthened the coloring/lighting texture necessary to visualize a world that shifts frequently between snail scale and human scale. In an inspired move, cinematographer Wally Pfister (*The Dark Knight*) was brought in to consult on how to achieve a look for *Turbo* that couched this fantastical story in the type of live-action visual sophistication rarely attempted so rigorously in 3D animation.

"When we met, Wally Pfister really connected with the high concept of the movie married with a more grounded execution," says Soren. "He was helpful in showing us how he would shoot specific scenes and what camera to use. In animation, you can do more, augment more, push more. But in many cases where we could have done that, we preferred the effect of a live-action approach for a shot."

At the character level, the miniature creatures at the heart of *Turbo* have never had the most welcoming cultural image: slowness, sliminess, take your pick. This ensured that the character design work of Shannon Tindle and Sylvain Deboissy, and the animation department's job in

Michael Isaak

giving the snails life and movement, had to be right. Early feedback from DreamWorks Animation CEO Jeffrey Katzenberg helped: the snails of *Turbo* had the right look and sensibility but they shouldn't leave slime trails. But that didn't mean the challenges ended there. These snails had to be expressive, endearing, and relatable characters, and, in the case of Turbo after his transformation, believably fast when zooming alongside Indy cars at more than 200 miles per hour.

"When you get to the Indy 500," says Soren, "the idea of a snail that's an inch off the ground racing against these 1,600-pound race cars is what makes it original. It's a challenge, but we wanted to show a race that didn't feel like every other car race you've ever seen."

Realizing the vision of *Turbo*—from storyboarding to visual development, through modeling, layout, and animation, bolstered by effects work and lighting—stretched many of these veteran animators to new heights of creativity. The movie they saw through to the finish line is a testament to their talents, a no-dream-is-too-small saga bursting with misfit comedy, heartfelt community, and the thrill of the race.

What follows are the hundreds of drawings, conceptual art, and colorful renderings that celebrate that journey from first flag to final lap.

(above) Philippe Tilikete, (below) Dominique R. Louis

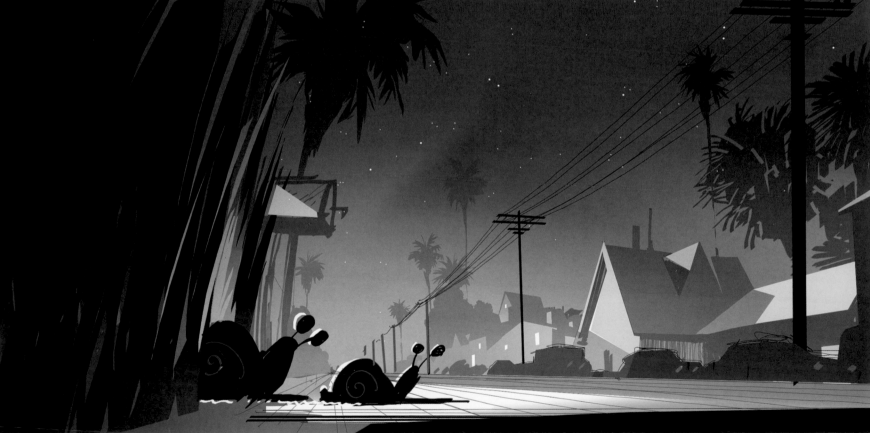

(top) Dominique R. Louis, (above) Marcos Mateu-Mestre

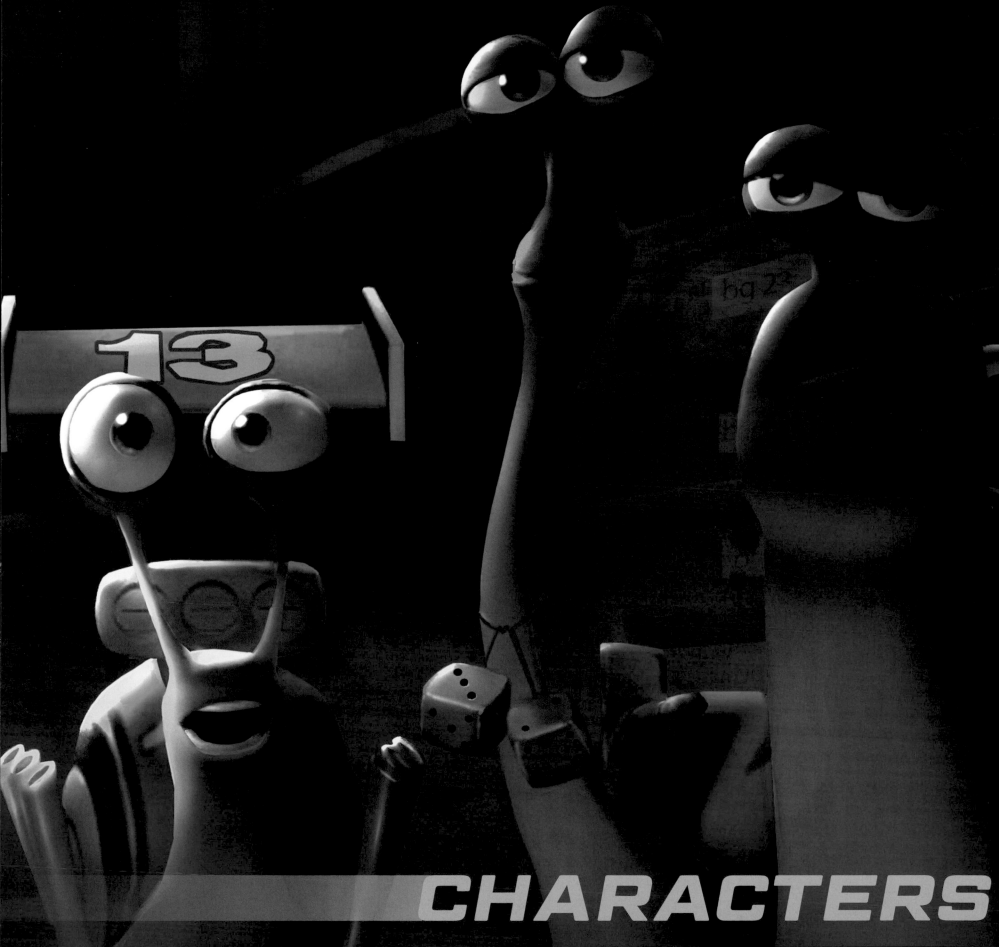

CHARACTERS

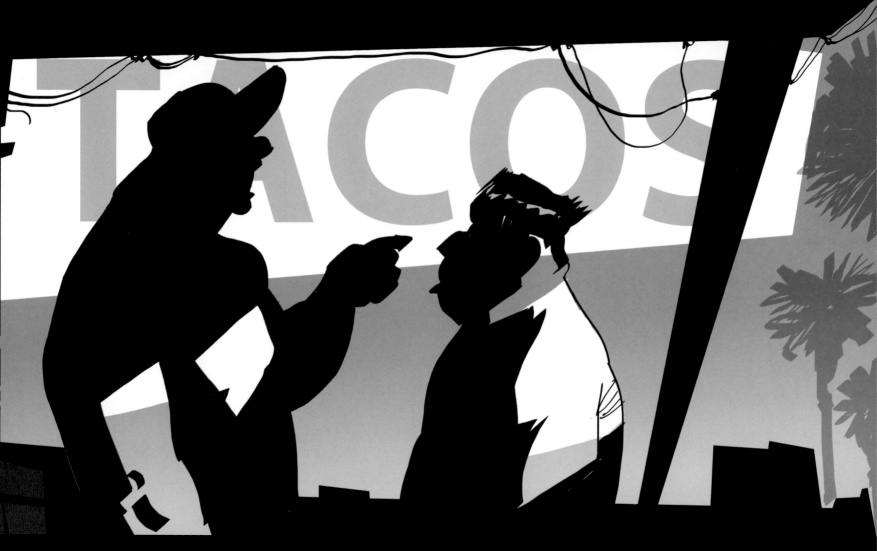

HUMAN/NATURE

*T*urbo was a story that was always going to be divided into two distinct character camps: snails and humans.

The snails would run the gamut from our core group of ambitious speed enthusiasts led by Indy 500 aspirant Turbo to the garden-variety snails whose s(low)pokesperson would be Turbo's cautious brother, Chet. But as the story developed, the friction between Turbo's wish-fulfillment personality and Chet's spirit-dampening pragmatism would take center stage as a theme, leading to a corresponding human story featuring Los Angeles taco stand-owning brothers Tito and Angelo. Boyishly enthusiastic Tito lives to promote Angelo's delicious Mexican fare, but this leads to some distracting schemes, including the secret snail racing that inadvertently brings Turbo and Chet into the humans' world. Like Chet, Angelo wishes his brother would get his head out of the clouds and back to the real-world task at hand.

"It's how these two parallel relationships form that for me, really, is the crux of the movie," says director David Soren. "If it was a story of just snails in a garden with other snails, the world would be small to me. Since Turbo has a desire to be in a human race from the get-go, it seemed more compelling and dramatic to have humans and a similar sibling relationship in the world."

By the time *Turbo* got to the character-development stage, the emotional foundation of its story about brothers was rock solid enough that character designer Shannon Tindle, who joined the project in its earliest stages, felt well equipped. "If you're not aware of who the characters are, you're just kind of going in generic circles," says Tindle. "Thankfully, because it was David's original idea, he knew quite a bit about Turbo and the other characters. I had a lot to start with."

One of the first real issues, then, was nailing down a design that gave the snails an enduring appeal, rather than the ick factor often associated with them. Slime

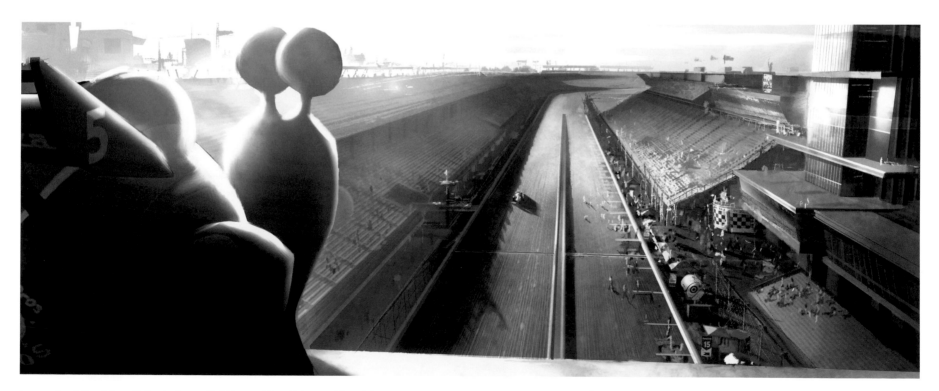

(pages 18–19) Dominique R. Louis, (opposite) Marcos Mateu-Mestre, (above) Dominique R. Louis

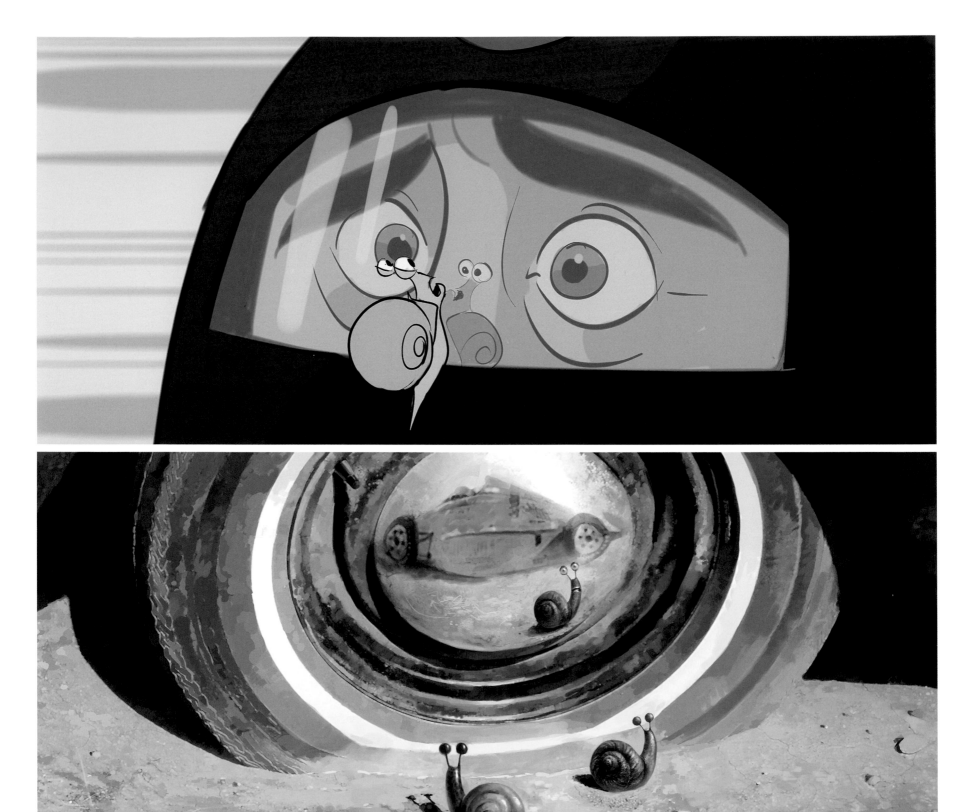

22

(top) Shannon Tindle, (above) Richard Daskas

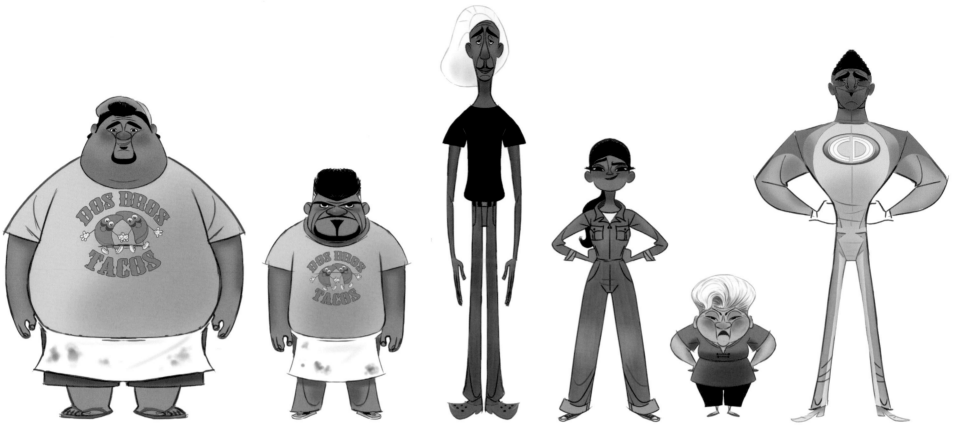

Shannon Tindle

trails were out of the question, but so were the animator's standard tools for anthropomorphizing creatures: arms, hands, and eyebrows. "There's the body, the stalks, and the shell—that's all you have to work with," says Tindle. "So you have to get everything across with the face and the body movement. It was one of the most difficult design challenges I've ever had. These characters need to be able to act, and animators need to take them through a lot of subtle emotions."

With the look of the face a key to the snail design, the question became, how far apart are the eyes from the mouth when your character has no nose? "We realized that the mouth had to stay as high up as we could get it," explains head of animation David Burgess, "and the eyeballs and the mouth had to form a nice triangle shape, which helps you skip past the fact that there's no nose. But as soon as the mouth got low, it was tough to connect it up as a face. When there's a big spatial break between eyes and mouth, you struggle to put it all together."

As the snails came into their own, performance and movement issues fell into place: eyelids could act as eyebrows; stalks might double as hands in measured ways—as when Turbo hammers futilely at his TV when it won't work—and the cartoon flexibility of the snail body could make for a nice juxtaposition with the authentically rigid, shiny shell renderings. "The computer is really good at making hard, shiny objects,"

says Burgess, "but with our snails, we've actually got a really nice textural contrast. You can feel that difference between the fleshy and the hard and shiny. The shell never completely deflates or droops or turns into a ribbon, because I think that would completely break the illusion of what these guys are made of."

The human characters, meanwhile, merged the classic graphic simplicity of 2D animation with the type of artistic stimulation that can only come from venturing out onto the streets of Los Angeles with sketchbook and pencil. "All I had to do was walk out my front door and look at people," says Tindle. "Because I actually lived in the city that the film was set in, it was very easy to draw inspiration from not only how people look, but the kinds of clothes they wear." In other words, if you ever happened to cross Tindle's field of vision during his time on *Turbo*, let this be fair warning: you might have inspired a Dos Bros taco-stand customer.

Though broad touches could be found in the human character designs, by the time animation and lighting were done with them, they had found their unique place in the *Turbo* world of realistic backdrops and cinematography. "The human sare especially reminiscent of Al Hirschfeld characters," says art director Richard Daskas. "But when you take that character and throw it into a moody, silhouette-heavy movie, it's got a weird, cool look to it. It's pretty unique."

Sylvain Deboissy

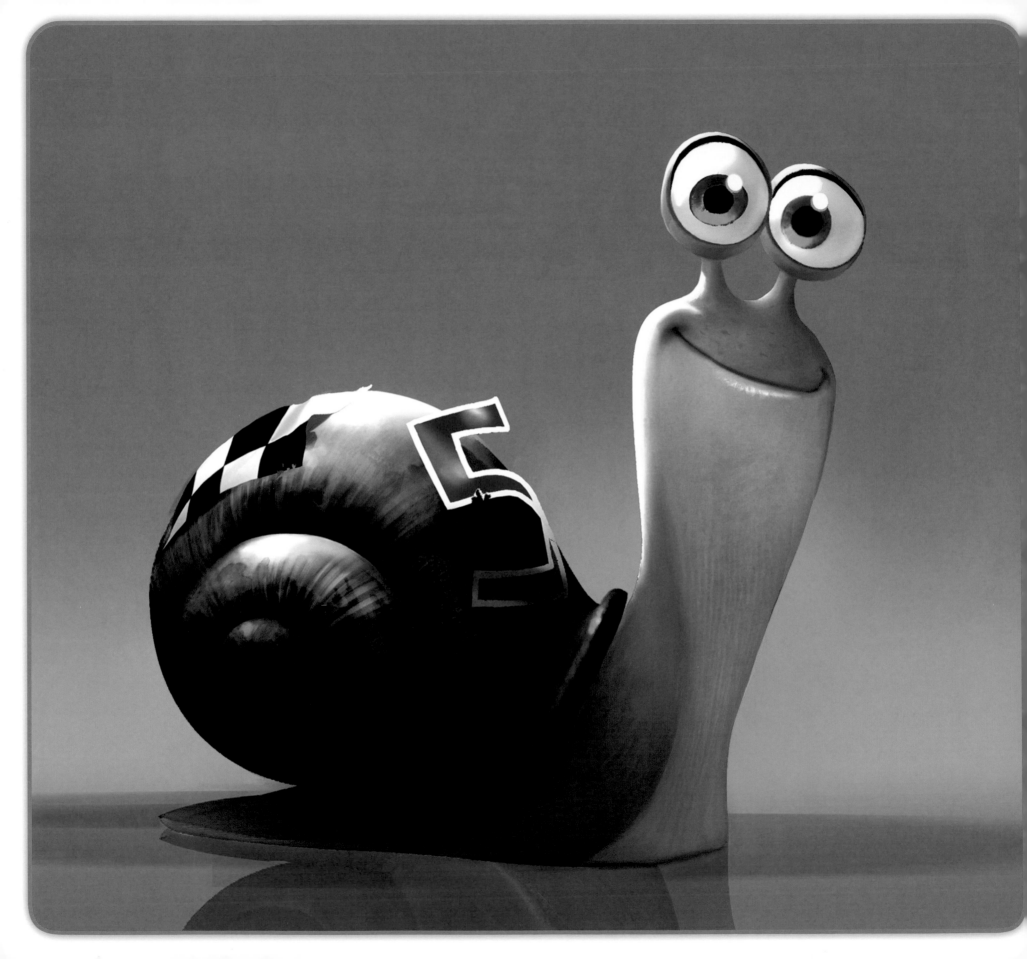

TURBO

Turbo is the perennial outsider, defined by his dream and not by his limitations. Turbo isn't even his real name: it's a self-chosen handle his brother, Chet, won't use. (He calls him by his given name, Theo.) If a snail obsessed with speed could pick the most impossible-seeming goal, racing in the Indy 500 would have to be at the top. Though his brother doesn't understand his abiding passion, Turbo is the story's hero precisely because he doesn't give up.

Heroes need to be distinctive, so designing Turbo was a study in broad appeal, since it was ever apparent to the artists that snails don't have the cuddliest identity in the real world. Simple matters like mouth size and toothiness could make all the difference in securing a likable protagonist, someone the audience *wants* to touch and can be touched by. Turbo may be a snail, but he has to be the cutest, friendliest snail. Head of story Ennio Torresan, who had to think about these matters in storyboarding *Turbo*,

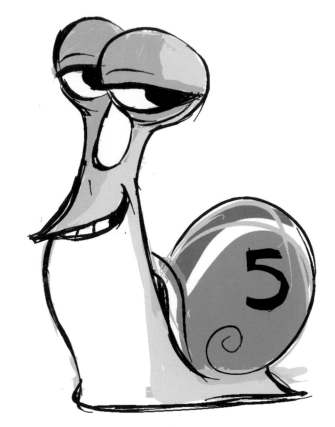

David Soren

> *"Turbo represents all characters who have preposterous dreams. There's no reason in the world why Turbo should ever be able to become a great racer."*
>
> **DAVID SOREN,** DIRECTOR

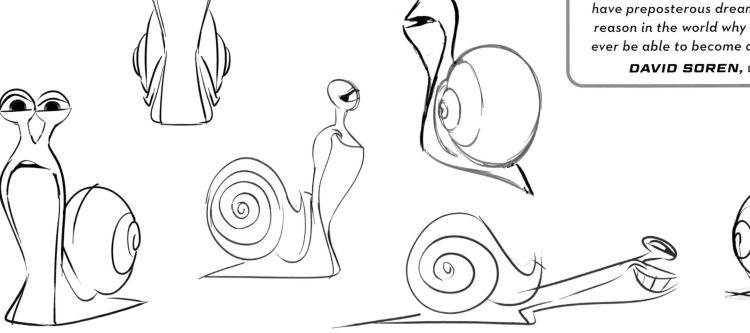

(opposite) Dominique R. Louis, (above) Shannon Tindle

Sylvain Deboissy

David Soren

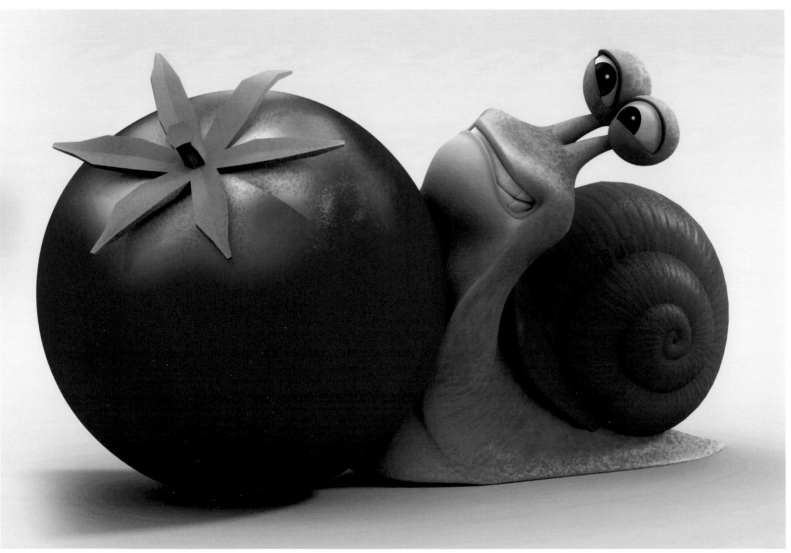

Takao Noguchi

Shannon Tindle

Michael Isaak

Joe Moshier

puts it this way: "You can draw a crazy, weird snail as a side character, but for the main character, it would be too weird. You wouldn't like that character that much."

The filmmakers on *Turbo*, once production began, didn't have the luxury—oddly enough—of working at a snail's pace. But thankfully, between the extraordinary talents of character designers Shannon Tindle, Sylvain Deboissy, and Takao Noguchi, it didn't take long before a vivacious leading snail of simple curves, expressive eyes, and outgoing personality was brought to life and colored an engaging orange that's just this side of speed-associated red. The process was helped, too, whenever a suggestion of Turbo's uphill aspirations made its way into a design pass, by putting a makeshift, partly adhered "5" sticker on Turbo's shell as a way of mimicking the racing world he loves so much. "With the sticker on, all of a sudden he looked cute and charming," says art director Richard Daskas. "That was huge."

Turbo was unusual in that the design process for characters like Turbo himself involved the modeling department working in sync with the designers, rather than waiting for 2D passes to be finalized before modeling could begin. "I was actually sitting in the room with modelers, going over characters and drawings," says character designer Shannon Tindle. "They were amazing, too. Any designer on a CG film will tell you that if you don't have modelers who get your drawings, then it's not going to be representative

of what you did. But these guys got it consistently the first time, again and again. They're just incredible visual sculptors."

Getting down Theo (before he becomes Turbo) was one task. But there was a post-transformation Turbo as well, after an accidental date with a flood of nitrous oxide in a drag racer's engine turns our hero into a lean, mean racing machine. At first, Turbo doesn't understand what's happened to him. Upon returning home, he quickly discovers his eyes can double as spotlight beams, his shell can beep like a car alarm, and his antennae pick up radio stations. It's only when survival instinct tells him to get out of the way of a kid's bicycle wheel that it dawns on him exactly what he can do: floor it.

"We wanted it to feel like the shell was a little engine," says head of animation David Burgess about visualizing Turbo's speed. "It sort of vibrates, and then as he's getting ready to go, he contracts in anticipation, and then he just explodes forward. As the movie progresses, and he gets more control of his abilities, we wanted him to be able to really hunker down and adjust his spoiler, so he can get lower and go even faster."

By the end, Turbo is racing not for a finish line, but for a sense of identity. "He's fought really hard for something he believes in," says his creator, director David Soren. "He has pride in what he's been able to do, and I think he ultimately has come to embrace the qualities of who he was before he got these powers. He's a more well-rounded snail!"

28

Shannon Tindle

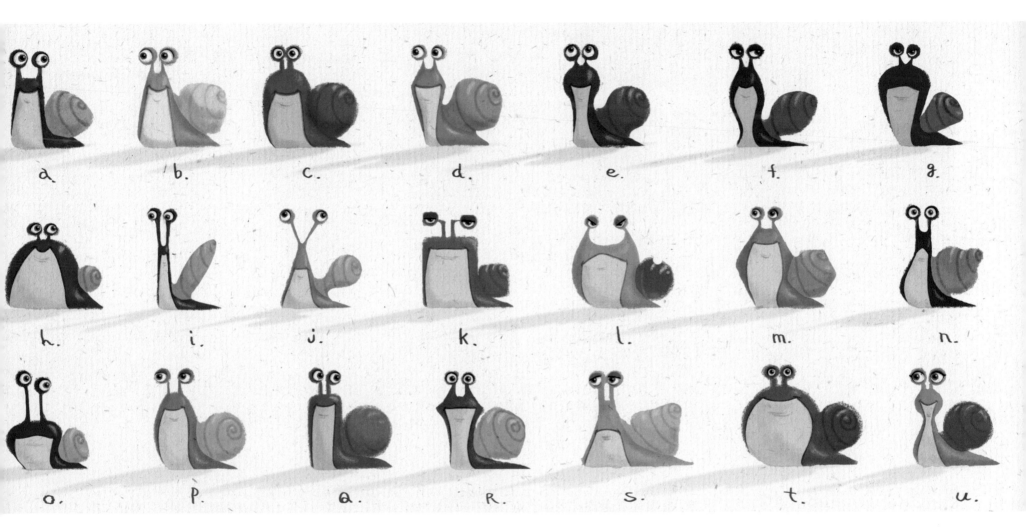

a. b. c. d. e. f. g.

h. i. j. k. l. m. n.

o. p. q. R. s. t. u.

Takao Noguchi

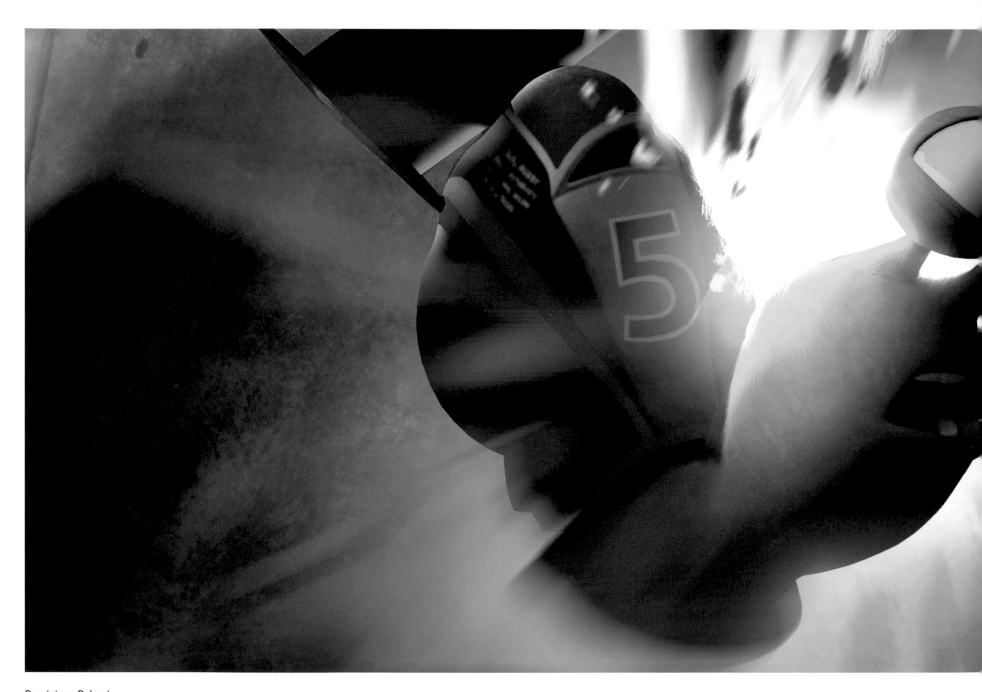

30

Dominique R. Louis

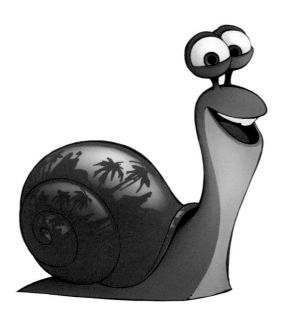

Sylvain Deboissy

Sharon Bridgeman Lukic

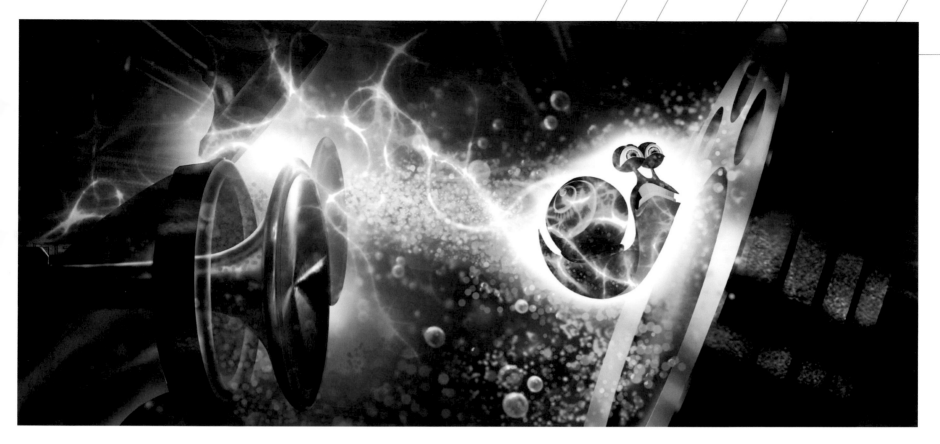

(gatefold and above) Mike Hernandez

THE TRANSFORMATION

It took a long time in the development of *Turbo* to come up with a viable way for the protagonist to become fast, until director David Soren hit upon the idea of him being sucked into a drag-racing muscle car's engine as it's blasted with nitrous oxide by the driver. "It's sort of our version of the spider bite in Spider-Man, really," says Soren. "His DNA changes because of this, and he has no idea how long it's going to last or what the ramifications are. But he's going to milk it!"

Devising the sequence—which pulls us along with Turbo into the Camaro's engine for a subjective roller-coaster ride that includes a trip inside Turbo himself—involved a combination of artistry, effects cleverness, and narrative smarts. Storyboarding hatched the basics of the molecular transformation, including an image of red blood cells lining up and spinning like little tires. The bright electric blue associated with nitrous oxide is what we see Turbo swimming around in, and it becomes the color of his trailblazing streak after he's transformed. Messing around with snail biology is one thing when dealing with a fanciful premise, but the sequence also meant fiddling with under-the-hood realities, too. "It became clear really quickly that we had to do our theatrical version of what an engine should look like," says visual effects supervisor Sean Phillips. "My goal was to have something that looked amazing and believable."

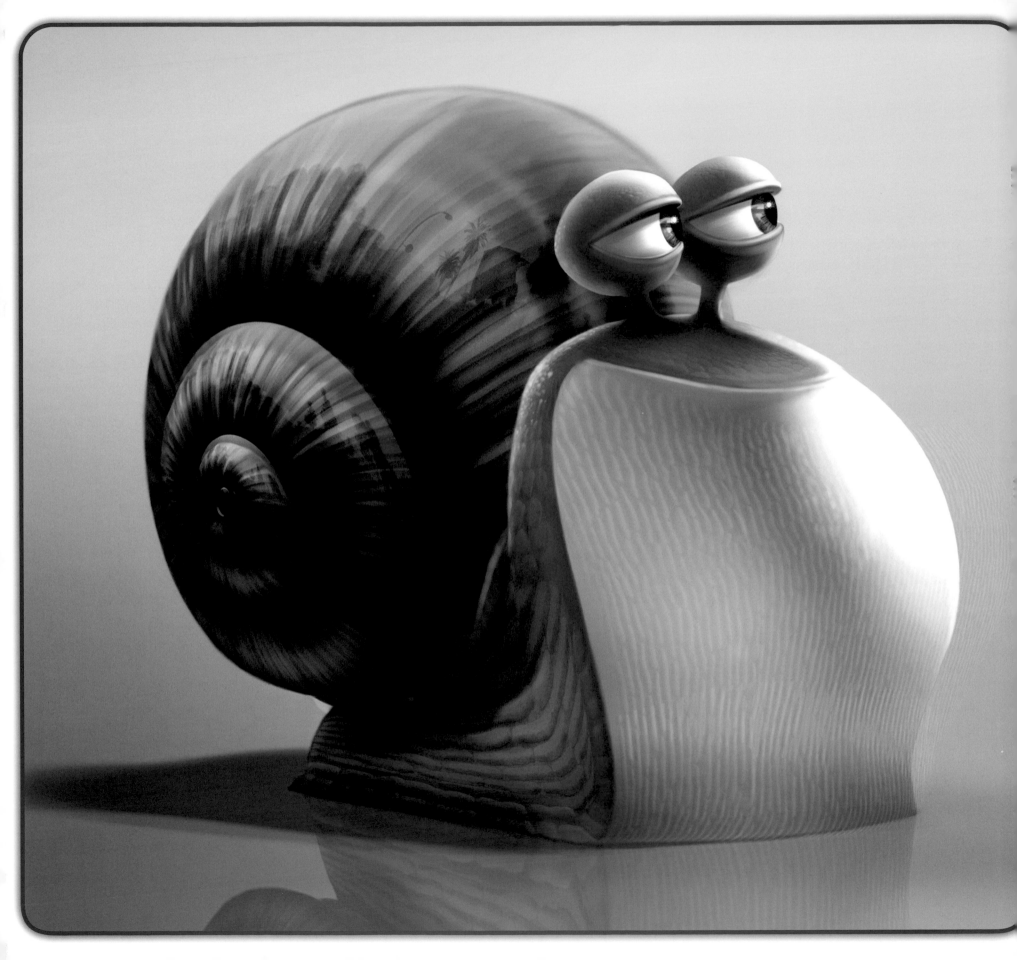

CHET

Shannon Tindle

Chet is skeptical about Turbo's racing fever and fantasies of speed, and his exhortations that Turbo give up his dream and just be a snail, place him squarely at odds with our movie's hero. He's the realist to Turbo's dreamer. "We all have our limitations, Theo," Chet tells his brother early in the movie. "And the sooner you accept the dull, miserable reality of your existence, the happier you'll be."

A paragon of safety over risk, a blue-slate station wagon to Turbo's orange-red sports car, Chet is exemplified by the "tuck and roll" mantra—retracting into one's shell and wheeling away—that he insists all the plant snails use at the first hint of danger. It's the only accelerated movement he endorses, in fact. "Chet is set in his ways and kind of a scared character," says character designer Shannon Tindle, who credits colleague Sylvain Deboissy with nailing down shapes for Chet early on, from the big,

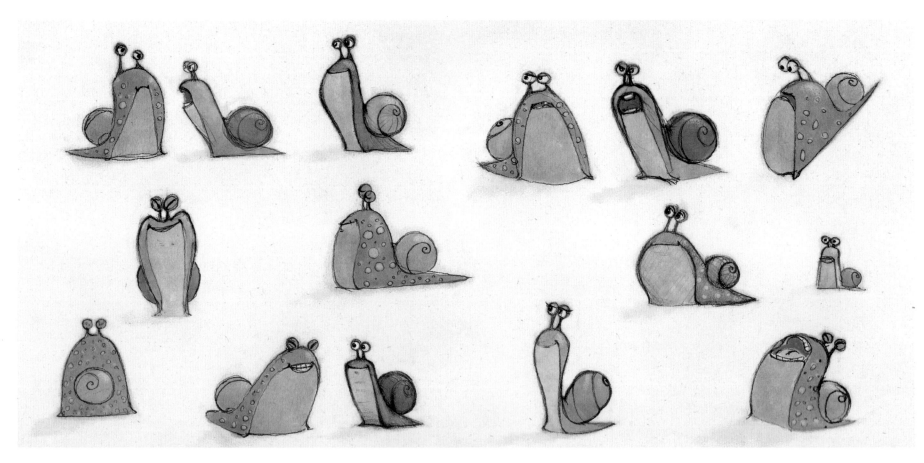

(opposite) Sylvain Deboissy – design & Emil Mitev – painting, (above) Takao Noguchi

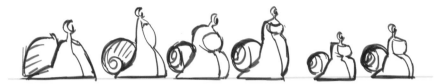

Shannon Tindle

Shannon Tindle

38

Sylvain Deboissy

warily lidded eyes to the pronounced girth. "Chet is stubborn, less willing to move, so we made him bulkier. He doesn't look fast or streamlined."

Head of animation David Burgess says Chet was a breakthrough in terms of determining how fleshy they could make some of the snails. The idea was that when Chet speaks, there's a lot going on. Says Burgess, "You feel the flesh rippling up and down the neck; you feel those cheeks really moving. The air comes out, and the shapes change. Everything goes. I just think he's an outstanding character and really fun to watch."

Chet isn't merely an obstacle for Turbo, however. As the pair go on an adventure that sees them transported by crows, co-opted by snail-racing strip mall owners, and driven to the Indy 500 so a biologically blazing Turbo can fulfill his lifelong dream, Chet goes from killjoy to reluctant supporter, and then finally, in his brother's most dire time of need, his biggest motivator. "That's when Chet decides to take the leap," says head of story Ennio Torresan, "and do everything he was always scared of. It's like an extra story, his arc."

Chet was one instance when voice casting made fulfilling the character's possibilities particularly inspiring. "I'm so glad we cast Paul Giamatti," says producer Lisa Stewart. "He makes a character that could be a kind of one-note nudge into somebody you sympathize with. It's hard to play the naysayer and still be really lovable, and he's done an amazing job of that. He really owns it."

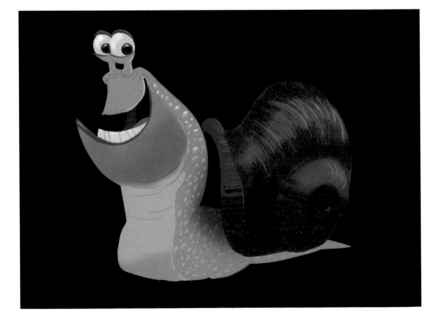

Shannon Tindle

Shannon Tindle

Toby Shelton

Sylvain Deboissy

Shannon Tindle

"At the beginning of the movie, Chet's the guy running things, and Turbo's the outcast. Come the time they get to Indy, the roles have reversed."

DAVID SOREN, DIRECTOR

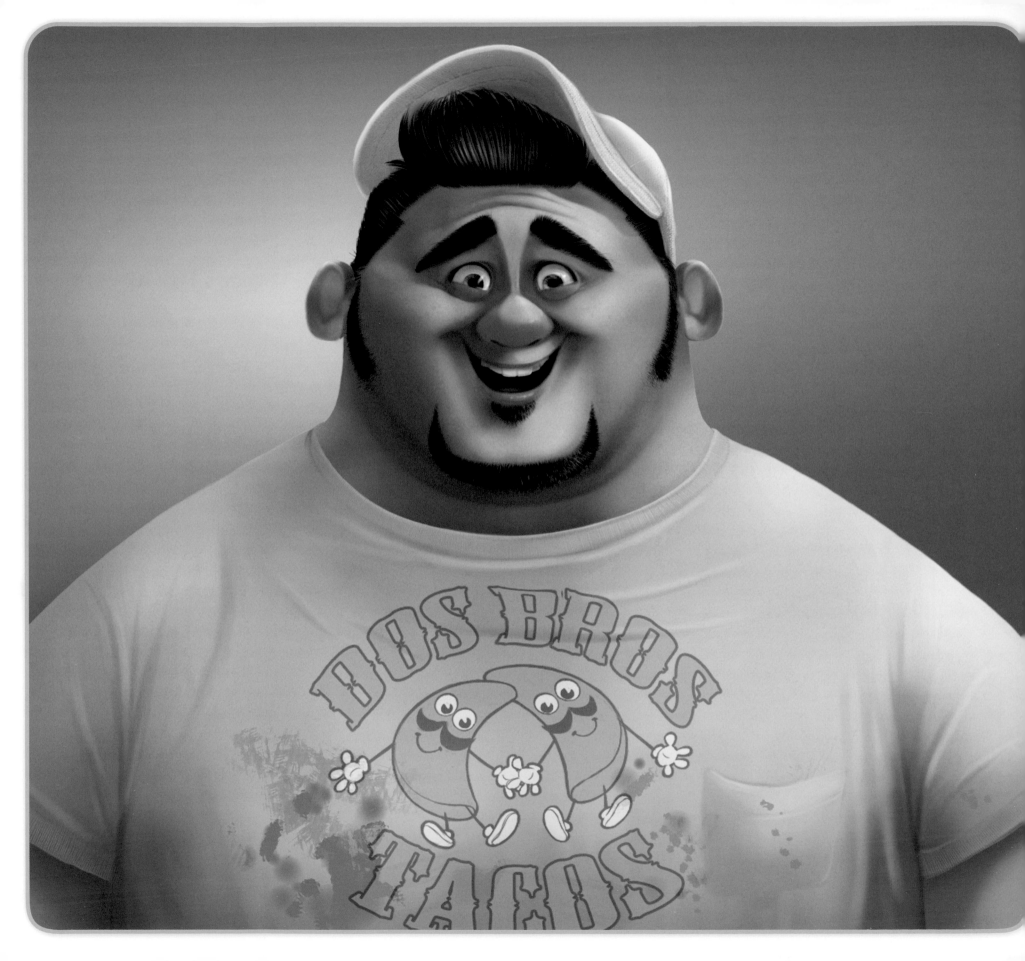

TITO

We should all be so lucky to have a diehard enthusiast like Dos Bros Tacos co-owner Tito championing our talents the way he does his brother Angelo's, even if some of Tito's promotional ideas—a monkey-petting zoo? sushi?—aren't entirely thought out. Producer Lisa Stewart says, "All Tito wants to do is let the world know that his brother makes fabulous tacos, and that everybody should have the opportunity to experience the magic of his brother's cooking. His schemes are really good-natured."

Coming upon Turbo, a snail that can outpace his taco truck—any car, practically—Tito realizes he just may have that opportunity, if he enters Turbo in the Indy 500. "This could put us on the map, bro!" he excitedly tells Angelo.

"What I love about the character of Tito is his boundless enthusiasm," says Stewart. "Like Turbo, he won't take no for an answer. He's completely endearing and has an enormous heart."

Keeping in mind the need for Tito to be appealing—something actor Michael Peña handled perfectly with his voice—the decision was made that visually he would have a roly-poly quality and a happy, childlike face. Some early passes suggested a frame beyond merely overweight, but this idea was ultimately scrapped because nobody wanted the distracting sense that Tito was a walking health risk. Instead, Tito was kept manageably round, which also helped with the film's shape language, connecting Tito to Turbo as brothers in their outlook on the future's possibilities, says character designer Shannon Tindle.

"Tito's not fast and streamlined like Turbo, but he's more of a circle," says Tindle. "And a circle can roll. It's something that can move."

(opposite) Shannon Tindle – design & Emil Mitev – painting, (above) Devin Crane

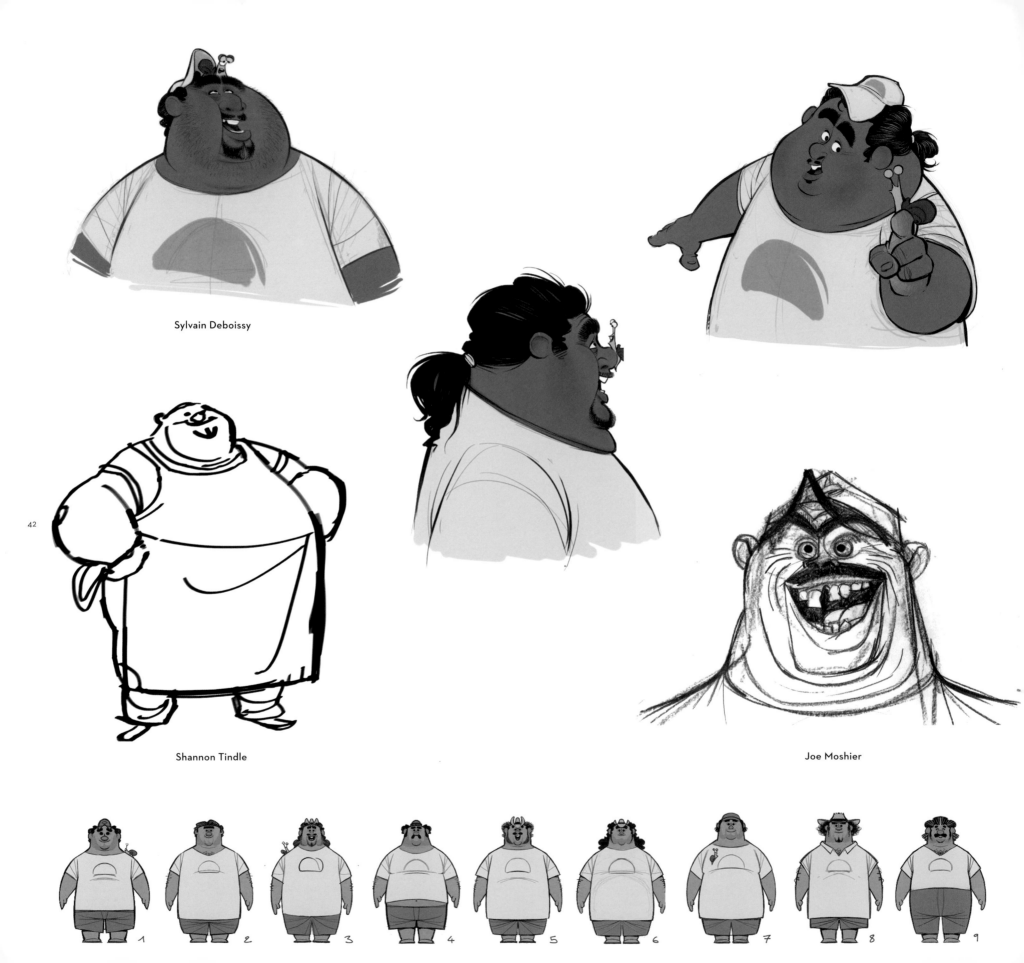

Sylvain Deboissy

Shannon Tindle

Joe Moshier

1 2 3 4 5 6 7 8 9

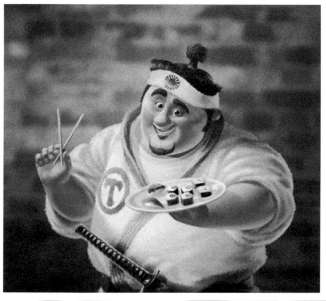

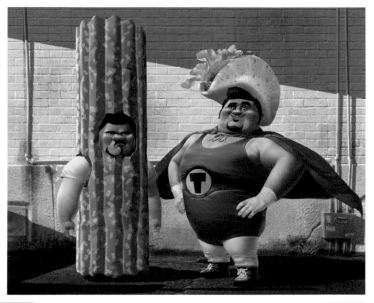

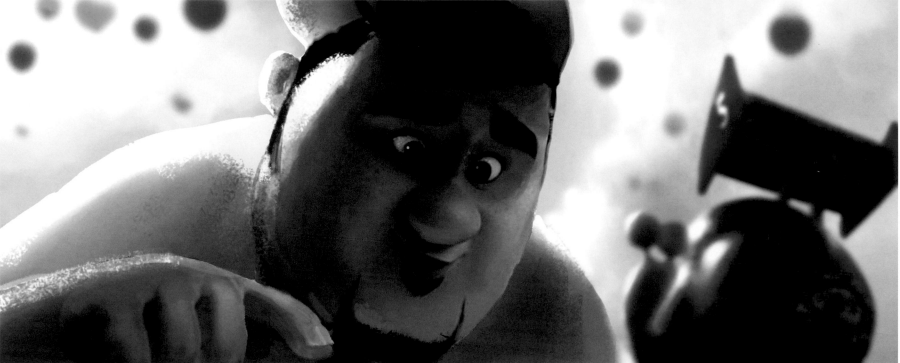

(below) Sylvain Deboissy, (top left) Roy Santua, (top middle) Sharon Bridgeman Lukic & Ron Kurniawan, (top right) Roy Santua, (above) Richard Daskas

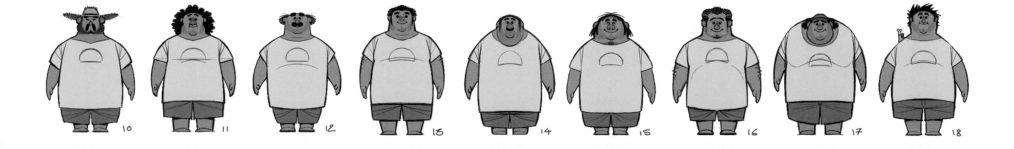

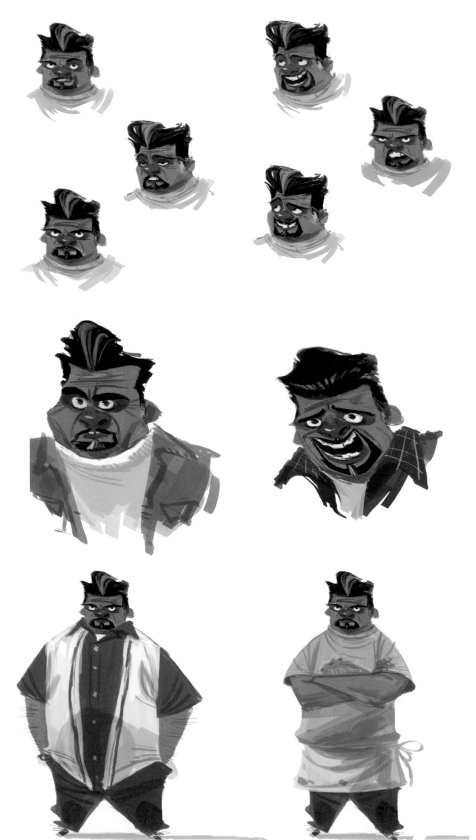

44

Devin Crane

Shannon Tindle

ANGELO

If Tito is a circle, able to move at a moment's notice, it stands to reason that his brother, Angelo—long-suffering, resistant to Tito's outlandish schemes—is, literally and figuratively, a square.

"One of the first assignments you get in any kind of character design class is circle, square, triangle," says character designer Shannon Tindle. "And if you boil it down to simple shapes, it's circle versus square. Something that moves against something that can't, or that is more difficult to move. It's where you get the mirror image of Chet, a brother who's set in his ways."

Tindle couldn't be more excited that acclaimed character actor Luis Guzmán wound up doing Angelo's voice, since Guzmán was an early inspiration for the lived-in, bulldog quality of Angelo. "I had my own little campaign for Luis with my drawings," says Tindle. "I thought he'd be perfect. Then it turns out David was thinking about him, too!"

How to outfit Tito and Angelo was a matter of simply checking out Los Angeles taco trucks. Tindle noticed a de facto uniform of everyday wear across the spectrum of food trucks: sneakers, chinos, and a T-shirt that might have the stand's logo emblazoned on it. "It's an LA style," notes Tindle.

(opposite) Shannon Tindle – design & Emil Mitev – painting

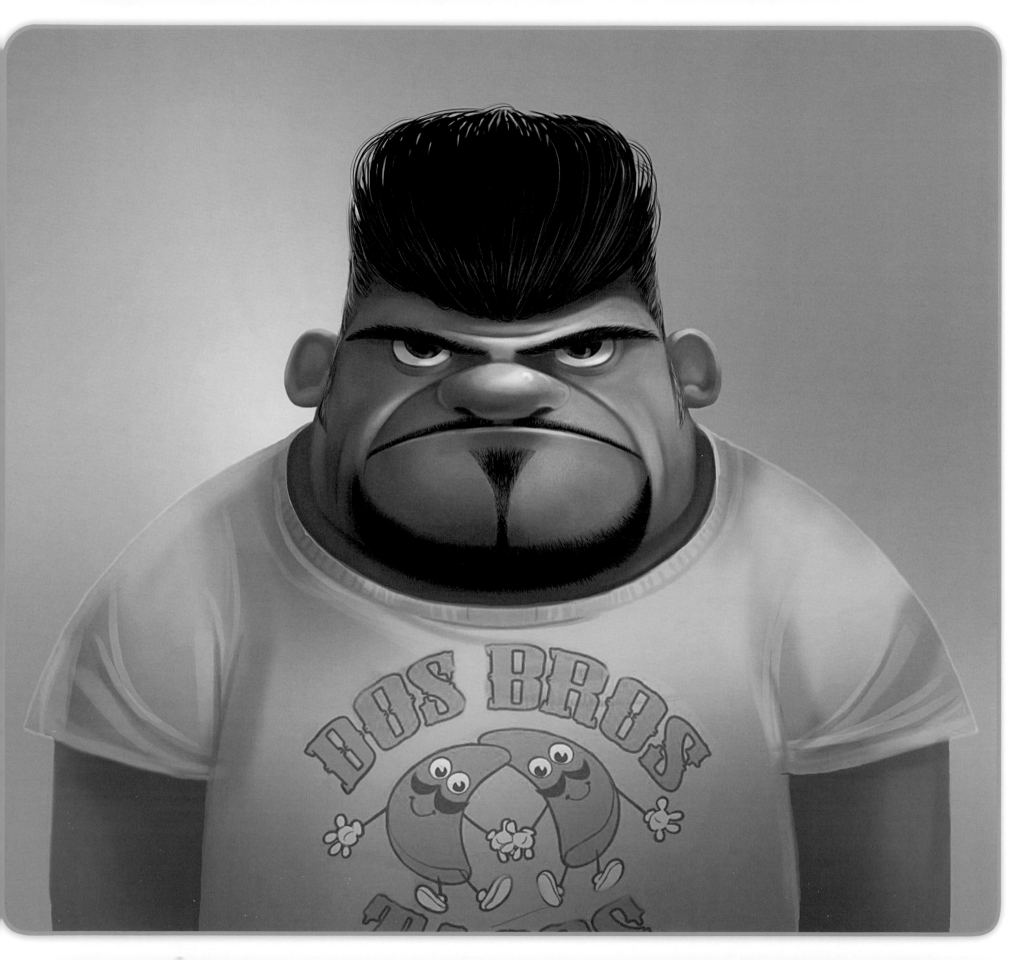

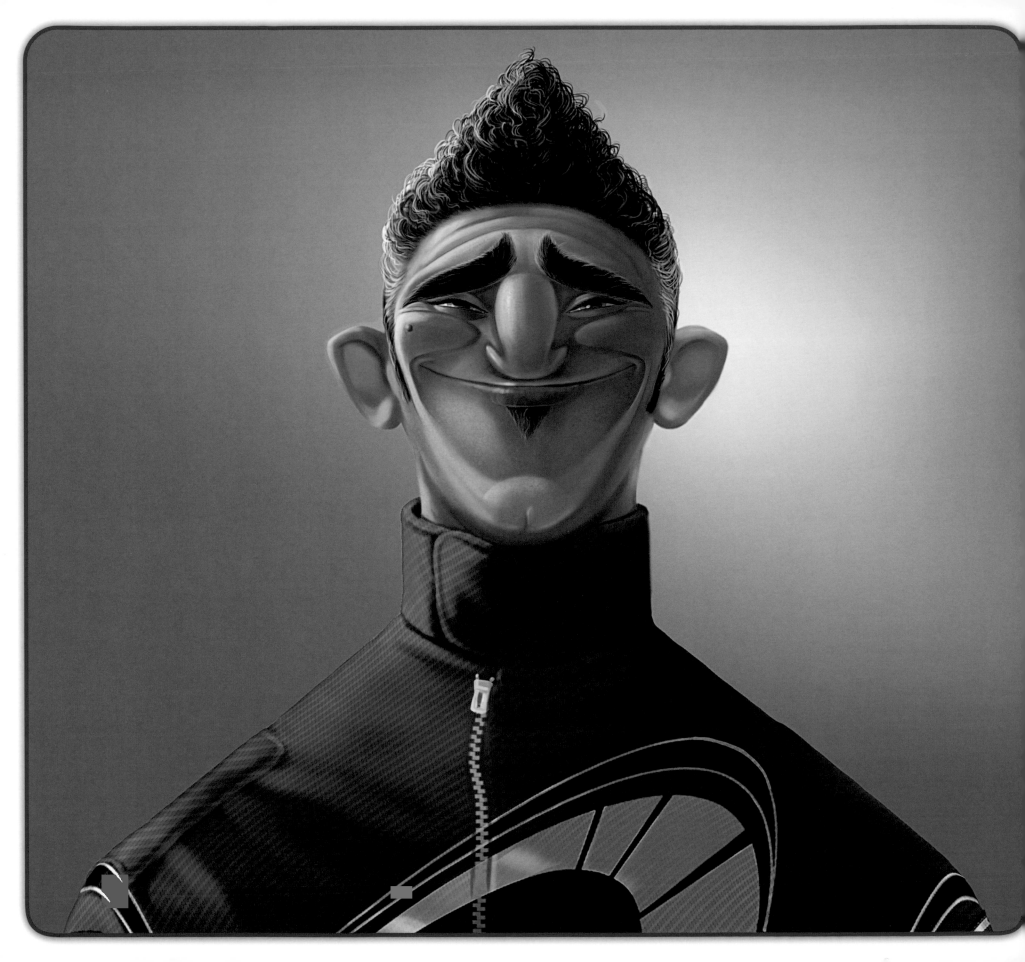

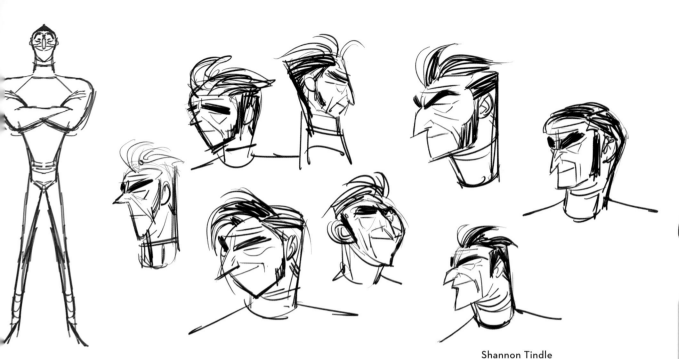

Shannon Tindle

Shannon Tindle

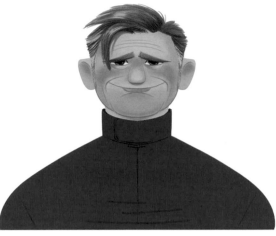

Shannon Tindle

> "You want the broad chest, because he is Turbo's superhero, the guy he looks up to most. He had to be a little flamboyant and kind of vain."
>
> **SHANNON TINDLE,**
> **CHARACTER DESIGNER**

GUY GAGNÉ

Ennio Torresan

Indy 500 champion, high-wattage celebrity, energy drink spokesman, and Turbo's hero, French Canadian driver Guy Gagné is the movie's *first* superhero of speed. "Turbo has been watching him obsessively on an old TV in a dusty garage, and it's his escape mechanism," says director David Soren. "Gagné represents everything Turbo longs to be."

Meeting one's hero, however, isn't always what it's cracked up to be. Once Turbo becomes an Indy 500 competitor with a fighting chance, the facade of sportsmanship Guy displays for an adoring public falls away. Says Soren, "Turbo sneaks into Guy's garage at night, and that's where he faces the cold reality that his hero is not actually such a warm, welcoming guy, but his nemesis. Gagné is one thing when he's mugging for the cameras, but when he actually faces the threat of losing to a snail, his true colors come out."

Head of story Ennio Torresan says working out Guy's attitude from scene to scene was a journey from straight-on villainy—which would have immediately tipped off audiences to a later twist—to something more shaded. "He used to be a very mean guy," Torresan says of early storyboards. "Then he became too funny, too goofy, and finally he became half goofy, half mean. Now he's found his own personality."

Visually, Guy fits a classic triangular superhero mold: broad shoulders, narrow hips and waist, and long, tapered legs. But in sculpting the head's angular features and tightly curled hair, character designer Shannon Tindle had one person in mind, head of story Ennio Torresan. "Guy was initially thought of as Italian, and after some internet research on faces I thought, 'Hey, there's an Italian right here.' In meetings I would do doodles and sketches of Ennio, and he'd never know it."

Dominique R. Louis & Marcos Mateu-Mestre

(opposite) Shannon Tindle – design & Emil Mitev – painting

Sharon Bridgeman Lukic

Shannon Tindle

Shannon Tindle

Shannon Tindle

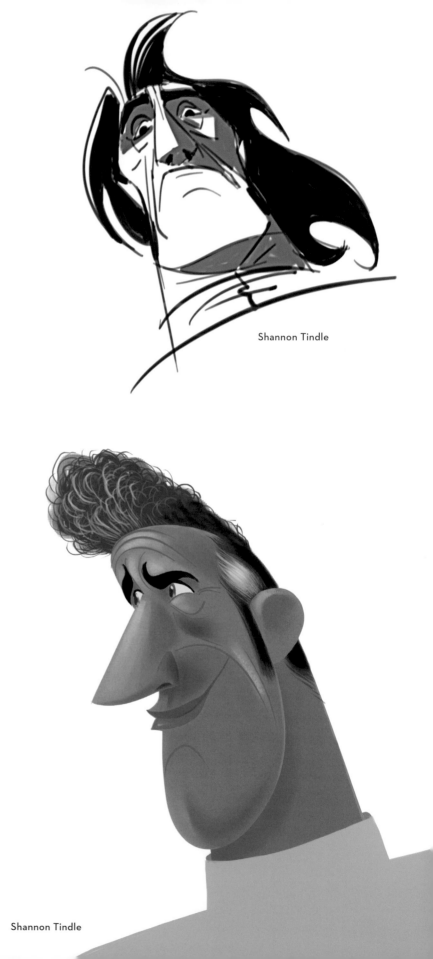

Shannon Tindle

Shannon Tindle

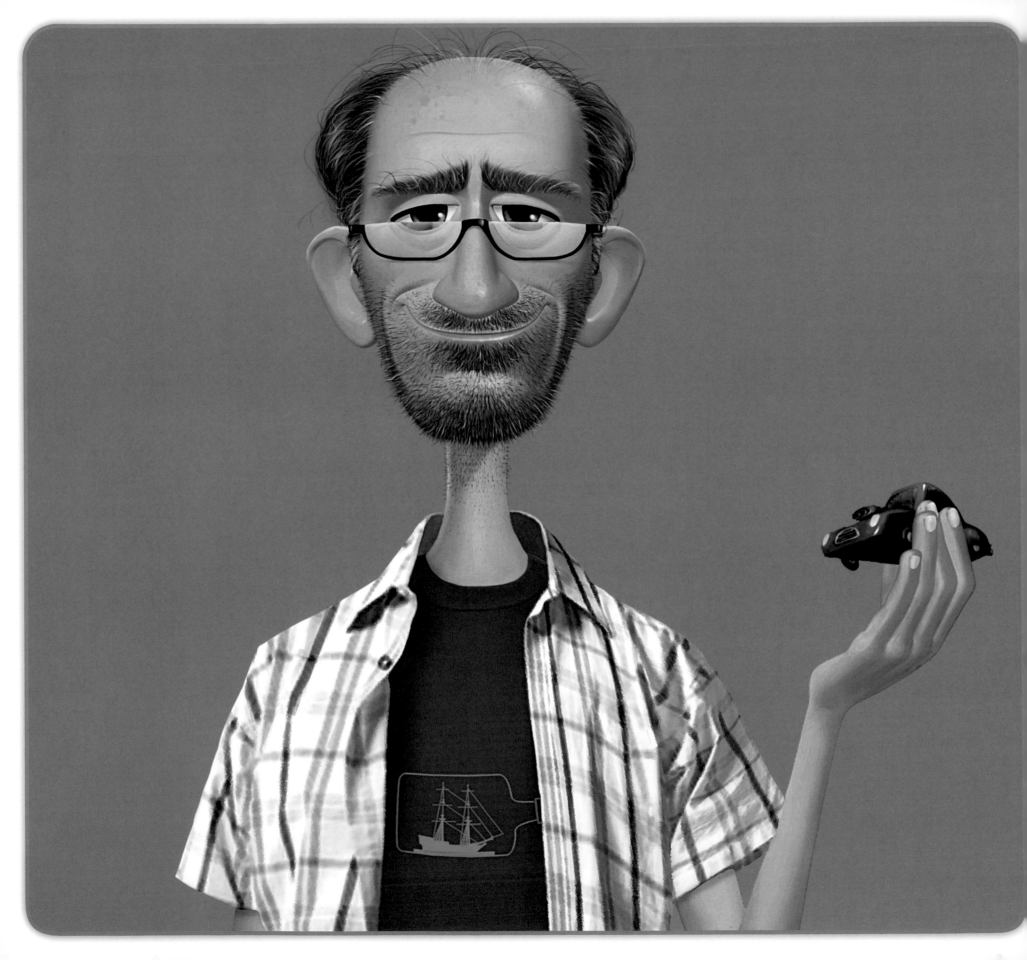

BOBBY

Of the strip mall shopkeepers, genial Bobby went through the most design passes before it was determined what he looked like, and what type of store he ran. He's been a tailor, a chef, a train shop owner, and finally what he is now, a hobbyist who creates the auto-inspired shells for the racing snails. Bobby also went from having short-cropped hair to being bald, and he even changed race once character actor Richard Jenkins was hired to voice him.

Character designer Shannon Tindle ultimately worked Jenkins's lanky frame into the body of Bobby, but animating a character like Bobby isn't as easy as a rounder physique like Tito's. "Because his arms and legs are long and really skinny, making him look good is a challenge," says head of animation David Burgess. "It's fairly easy to get nice shapes on Tito, whereas with Bobby, because he's more angular, it's a bit more of a struggle."

Bobby's was also one of the last personalities to suss out, but as head of story Ennio Torresan explains, it was worth the wait. "What's entertaining about him is he's an oddball guy. For the sequence in which we go into each person's store when there are no customers, we realize that in his world he plays with toys all day and acts them out. He knows it's weird, but he still does it."

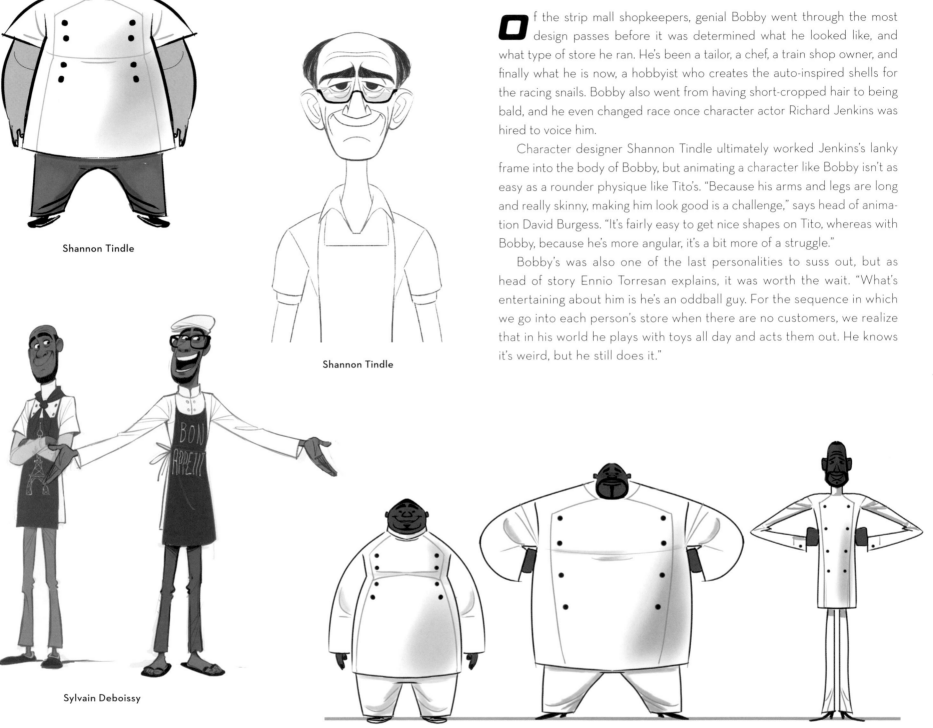

Shannon Tindle

Shannon Tindle

Sylvain Deboissy

Shannon Tindle

(opposite) Shannon Tindle – design & Richard Daskas – painting

Shannon Tindle

KIM LY

"**K**im Ly popped as one of the funniest characters," says head of story Ennio Torresan. "She's angry, she's sarcastic, and she's great to look at. "Vietnamese nail-salon owner Kim Ly is as quick with a cutting remark as she is skilled at a manicure. Part of a rich California immigrant tradition that has seen many Vietnamese women turn a once elite beauty ritual into an affordable procedure for many, Kim Ly is compact and ornery, with her own shell of sorts: a hairspray-fortified up-dollop of hair. "It's a perfect helmet," says character designer Shannon Tindle, "this matrix of slightly blue-dyed thin hair that makes her a bit taller than she should be."

"She comes up to your ribcage," says head of animation David Burgess, describing Kim Ly. "She's full of rage and tension, even when she's being nice. She's kind of birdlike in some of her motions, really tight and fast."

What helps mitigate Kim Ly's toughness, though, are the colors that go with her profession. "She does work in the beauty business, so she wears pastels, pinks, and a satiny kind of smock," says Tindle. "Which is a contrast. That's where you get the softer side."

52

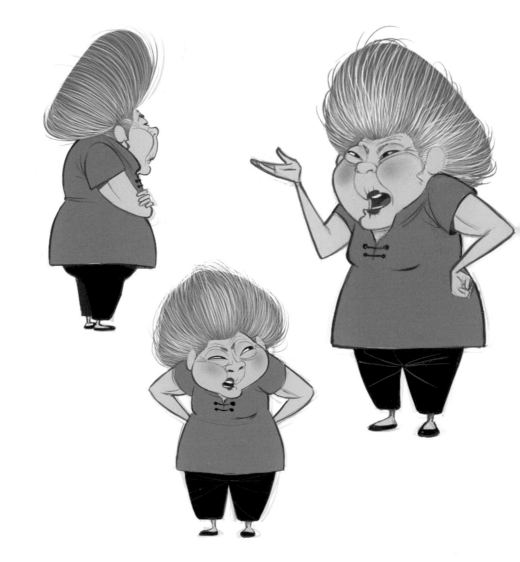

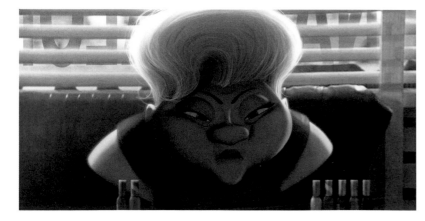

Richard Daskas

(above) Sylvain Deboissy, (opposite) Shannon Tindle – design & Emil Mitev – painting

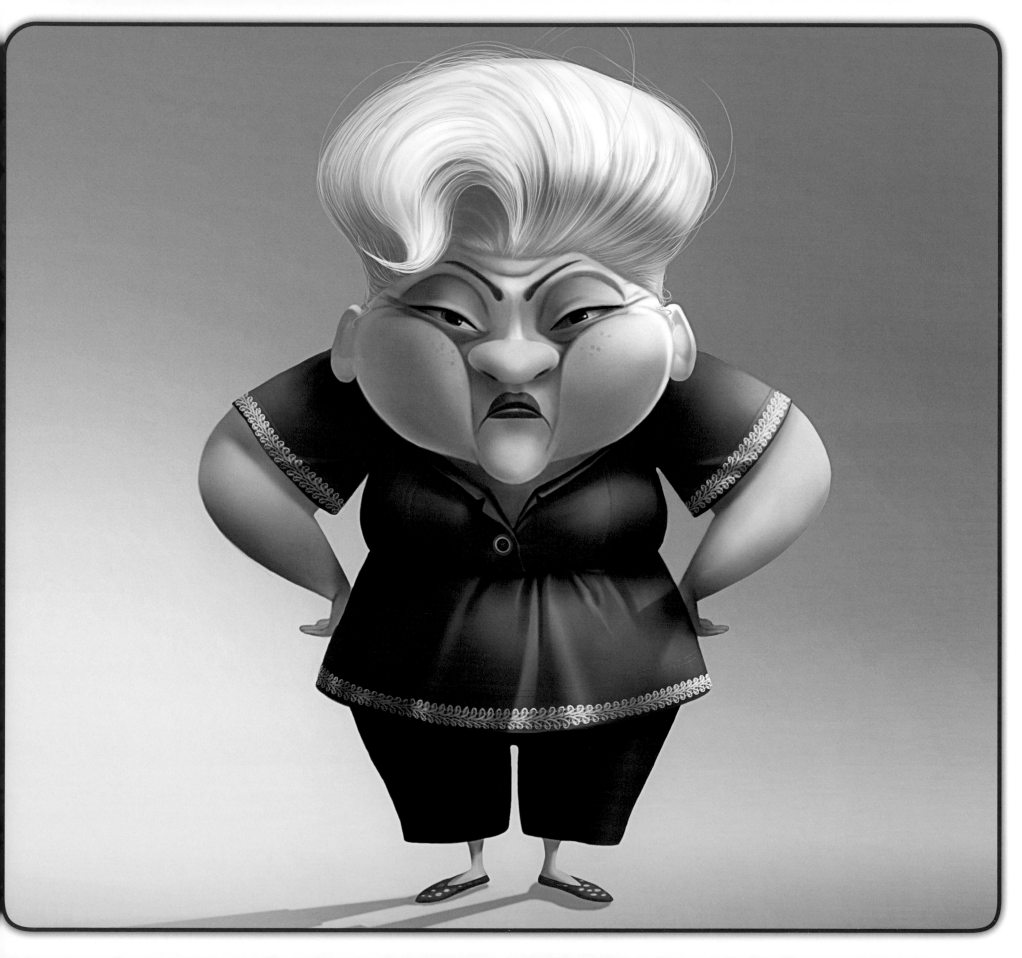

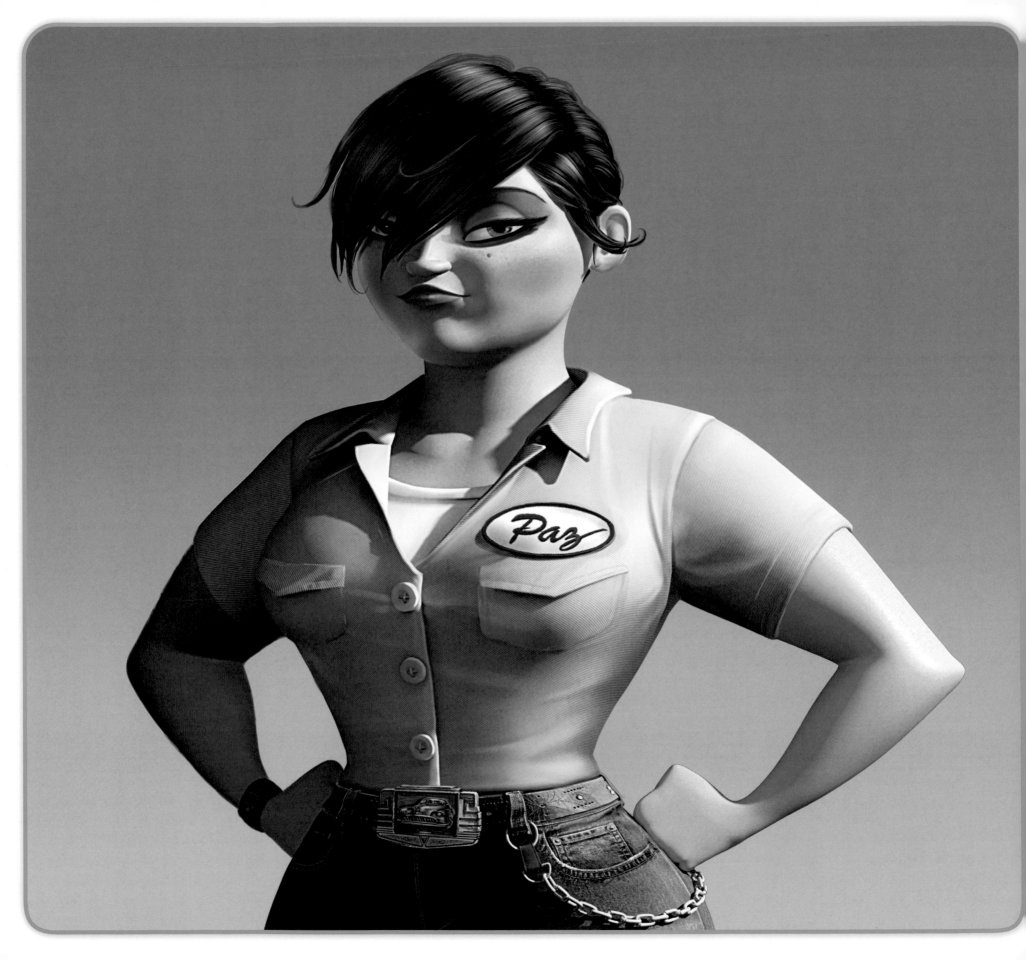

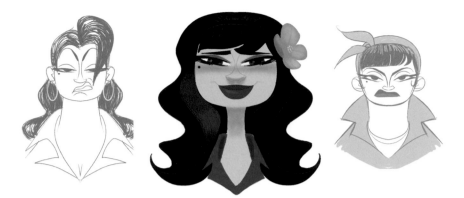

Shannon Tindle

PAZ

Women in animated features usually fall into two types: heroine petite or, if they're sidelined to gag status, cartoonishly overweight. With Paz, however, the *Turbo* team liked the idea of giving life to a curvy, no-nonsense Latina with her own sense of style. "David gave me a book on hot rod rockabilly chicks, the kind who have cuffed sleeves and pegged jeans," says character designer Shannon Tindle. "You want her to be tough, but you want her to be feminine, too."

The other part of the rockabilly world the artists adopted was an emphasis on shapely figures. "The girls in that culture embrace more classic fifties proportions," says Tindle. "I wouldn't say cinched waist, but more that kind of hourglass figure."

Head of animation David Burgess is particularly excited by the cosmetic touch of having Paz's hair completely hang over one eye. "Usually you want to feature the eyes," says Burgess. "But in this case, we felt we could probably hide one, and it would make her more interesting."

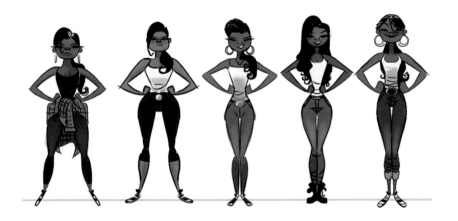

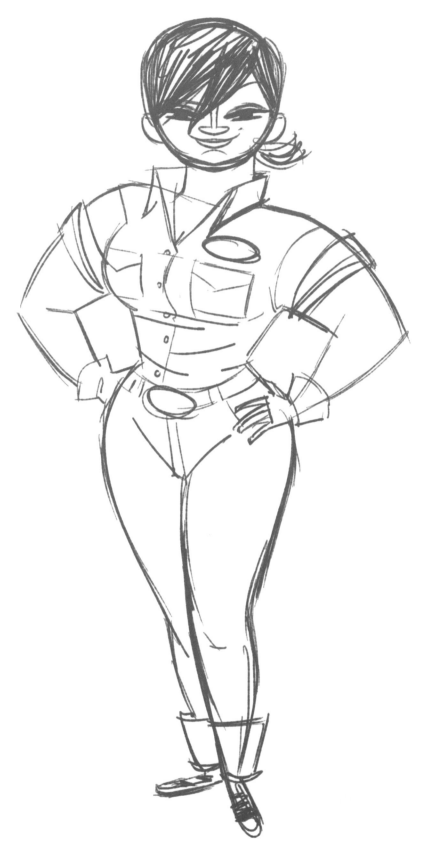

Shannon Tindle

(opposite) Shannon Tindle – design, & Emil Mitev – painting & Bear Williams – modeling, (above) Shannon Tindle

Marcos Mateu-Mestre – drawing & Paul Lasaine – painting

RACING SNAILS

When Turbo and Chet are delivered to the strip mall to be unwittingly entered into a back-alley snail race, they meet a gang of mollusks with their own thrill-seeking personalities. These are the racing snails, and instead of the usual spiral-curve shell, they sport handsomely designed husks that resemble classic race-car bodies.

Initially, though, the shells of the racing snails were designed so as not to appear that polished, a reflection of the make-do nature of the shop owners who created their shells. Explains director David Soren, "We used things like paper clips, screws, and cut-up bits of credit card for their wings, given that they were supposedly made by people with different skills. But once we started to do some painting exploration, it felt a little rinky-dink, and slicker looked better. Then the racing snails would seem more fun and impressive to Turbo, too. Besides, since

we have a hobbyist, and a nail-salon expert who can paint small detail like nobody's business, it seemed we had the skill set to justify pretty high-quality production-level shells."

Central to the connection between a passion for speed and the development of character was giving these snails their own individual links to a unique brand of racing vehicle. Says character designer Shannon Tindle, "It meant thinking about different types of cars, the character of a particular type of car, and then working that into the overall lineup and making sure you had a varied cast."

As a whole, the idea was to give the racing snails a comedic nature. "To play them completely as straight street racers felt like a lost opportunity," says Soren. "From Chet's point of view, being exposed to these guys needed to be an alarming experience, so it was about trying to find personalities that could rattle him a little. They're all slightly weird."

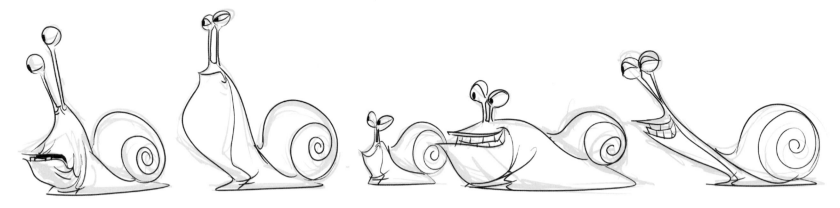

(above) Shannon Tindle, (below) Mike Hernandez

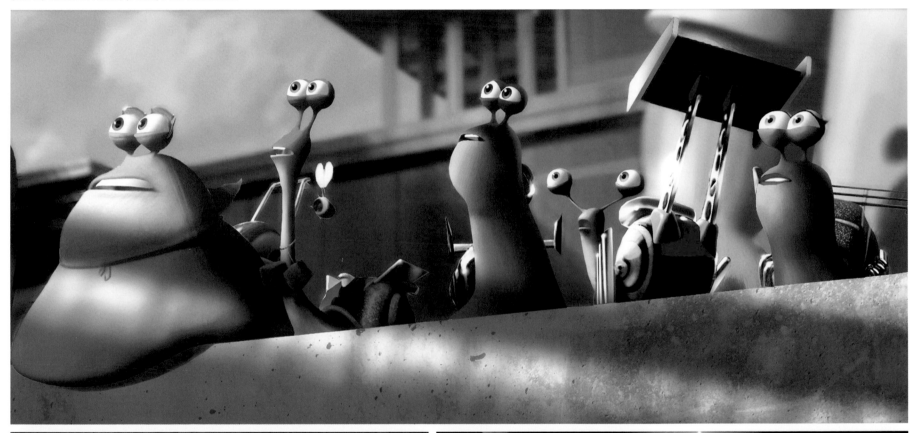

Ken Pak

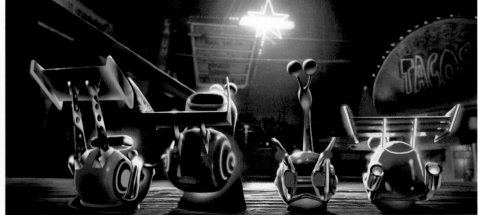

Mike Hernandez

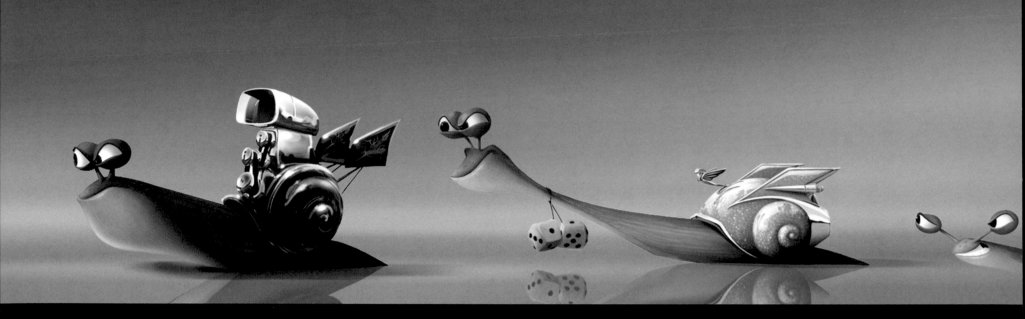

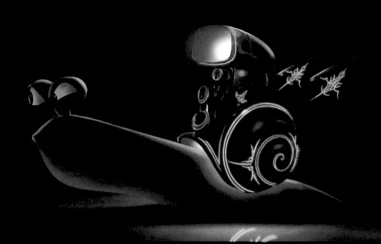

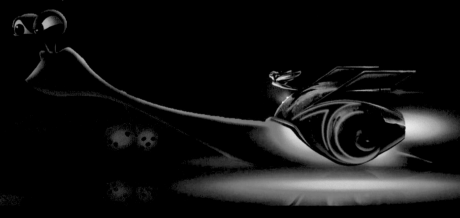

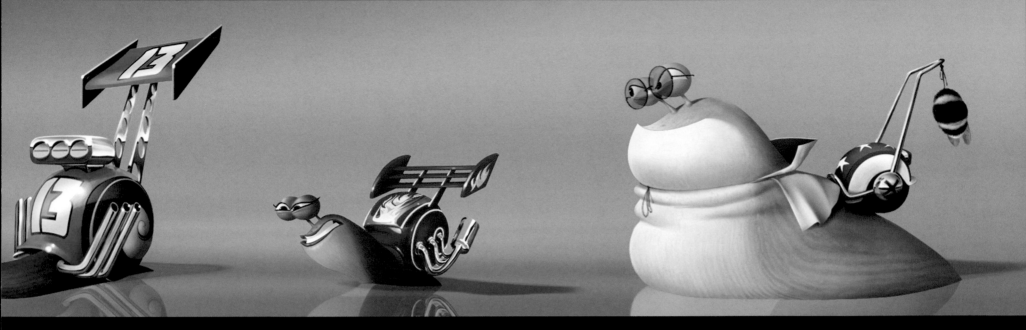

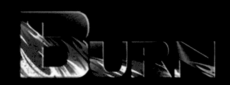

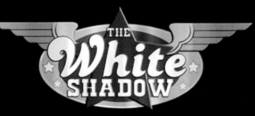

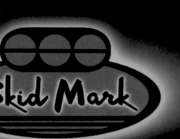

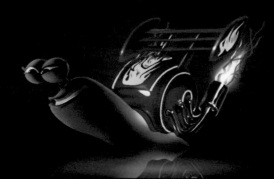

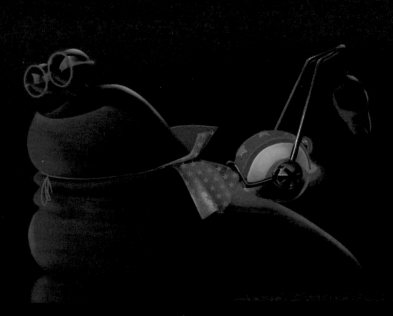

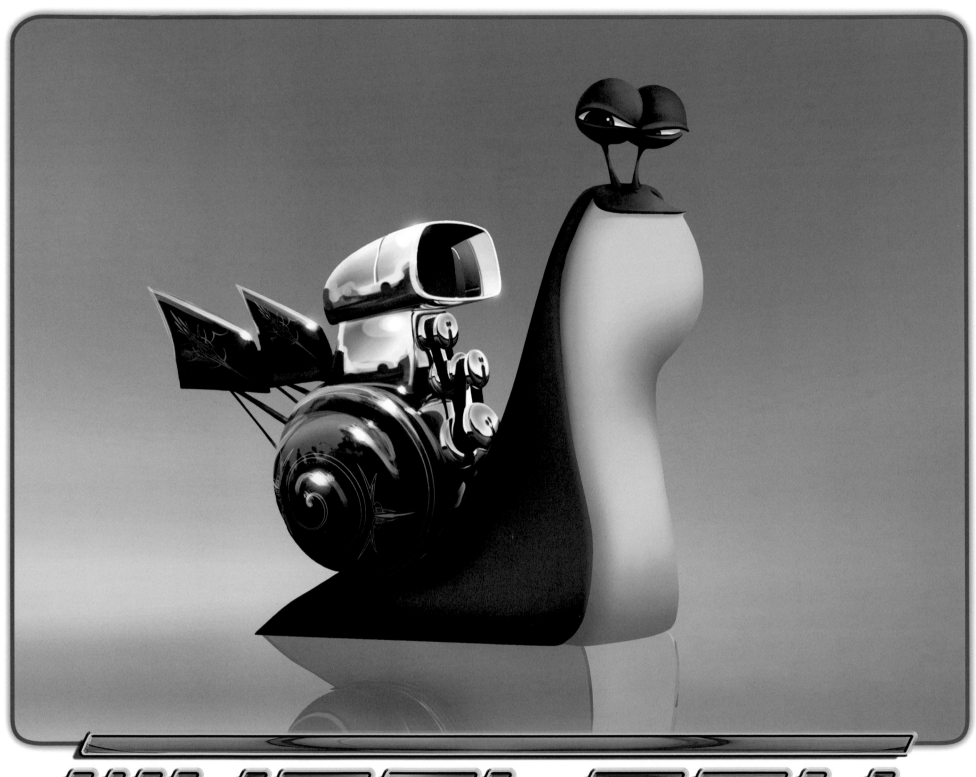

WHIPLASH

> *"The racing snails are a whole culture of snail who don't live by the code that the status quo is good enough and acceptable. Turbo thinks they're great."*
>
> **DAVID SOREN,** DIRECTOR

Ennio Torresan

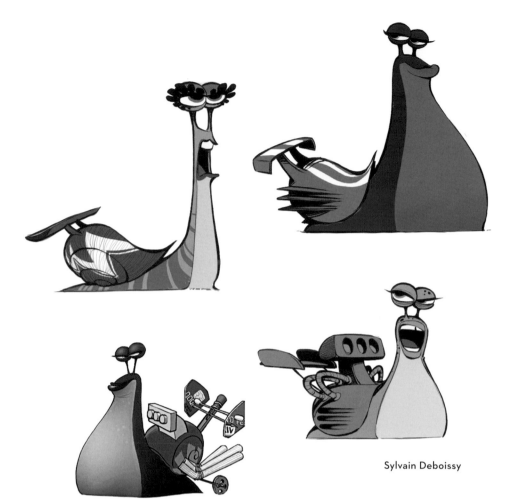

Sylvain Deboissy

WHIPLASH

THE RACING SNAILS COUNT Whiplash as their leader. A cool, tough character with a saturated purple hue who recognizes fresh talent when he sees it, Whiplash asks Turbo to join his crew after the display of blazing speed Turbo gives during the back-alley snail race. In fact, Whiplash, voiced by Samuel L. Jackson, is the very first snail to fully support Turbo.

"Whiplash needed to be the most aggressive and threatening, and then ultimately a kind of coach or cornerman," says director David Soren. "Sam brings that intimidating edge, but he also brings a lot of warmth and charm."

With each snail representing a different aspect of car-racing culture, it was decided Whiplash's tricked-out shell would reflect the kind of muscle car one might see in *The Fast and the Furious*. "There's something more masculine about the muscle car," says Soren. "It's classic. It says racing, it says speed, it says tough." His eyes, at times, tell a different story, however. "We've got certain rules that we set up for the appeal factor of these characters, but with Whiplash, whenever he gets stressed, his eyes go walleyed and roll out to the sides," says head of animation David Burgess. "It breaks our rules, but it's really funny in the moment."

(pages 58–59 and opposite) Sylvain Deboissy – design & Mike Hernandez – painting

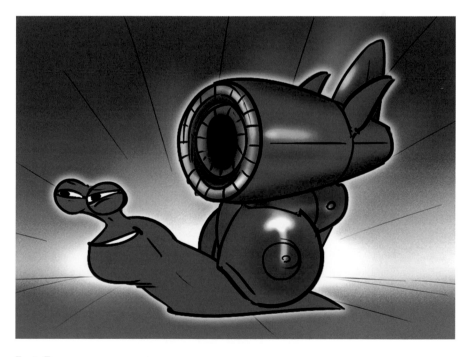

Ennio Torresan

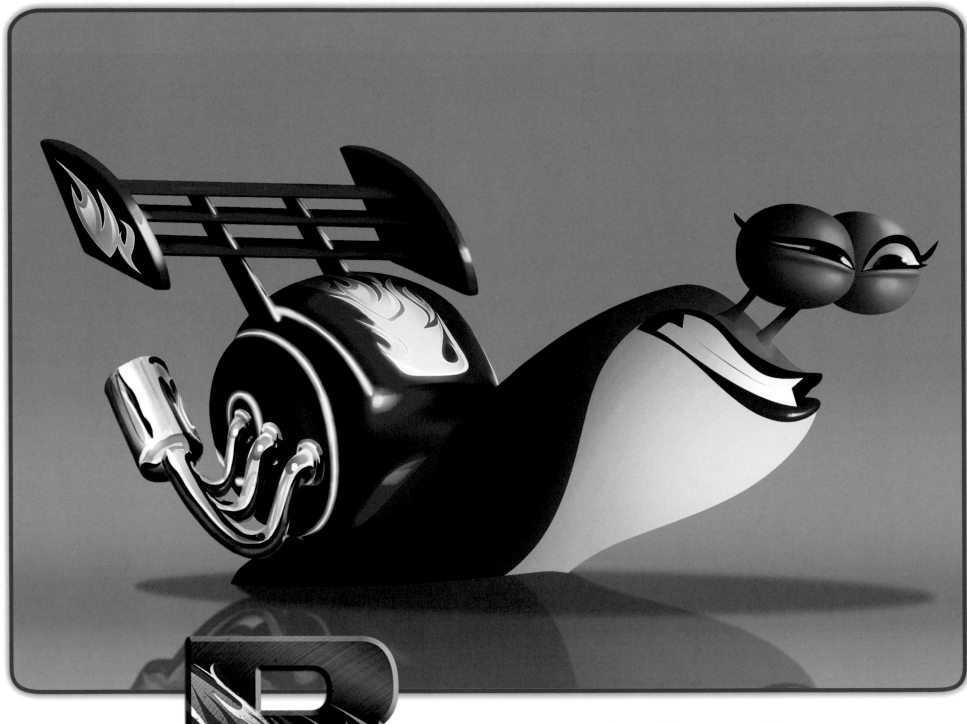

Burn

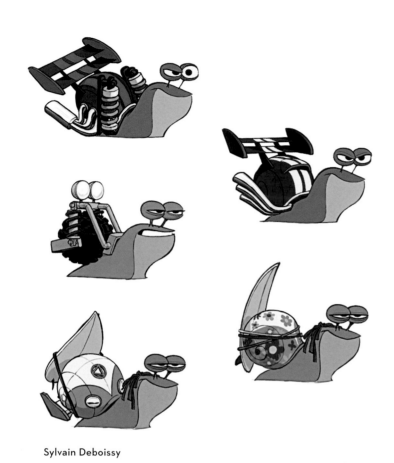

Sylvain Deboissy

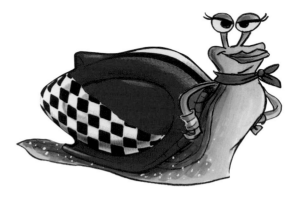

David Soren

BURN

COMPACT AND FEISTY, BURN is the only female member of the racing snails, with the fire-red tint and yellow-flames paint detail on her shell that can only indicate a classic street-racing hot rod. Her lids get a little extra upturned line to help signify her femininity, but the personality is a mixture of sweet and sassy. Though she flirts with Turbo before zeroing in on Chet as boyfriend material, you wouldn't call Burn a girly girl. "The challenge was to not make her different exclusively because of her sex," says Soren, who cast Maya Rudolph as the voice of Burn. "There had to be a personality there."

"I think when we were trying to figure out what made her unique, we started talking about Pinky Tuscadero from *Happy Days*," says Burgess. "The tough chick who's really nice. So she started to become a gum chewer, with a little bit of a street vibe. Sort of the 'Hey, howzitgoin?' type."

Ennio Torresan

Andy Schuhler

(opposite) Sylvain Deboissy – design & Mike Hernandez – painting

SKIDMARK

THE BLUE-AND-YELLOW RACING SNAIL with a shell that typifies a top-fuel dragster known as Skidmark. His name comes in for some expected teasing from his colleagues, who don't understand why he thinks it's cool. Not as fleshy as his buddies, Skidmark boasts a tiny head, a tiny mouth, and eyes at the end of really long stalks.

In the effort to differentiate the personalities of the racing snails from each other as much as possible, Skidmark—voiced by actor Ben Schwartz—was given an eager, fast-talking, almost puppy-dog-like enthusiasm, born out of a possibly self-conscious attitude surrounding his name. "He's supercaffeinated and really pumped up," says head of animation David Burgess.

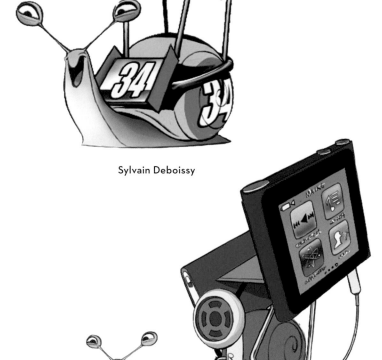

Sylvain Deboissy

Ennio Torresan

Shannon Tindle

Sylvain Deboissy

Ennio Torresan

Sylvain Deboissy

(opposite) Sylvain Deboissy – design & Mike Hernandez – painting

64

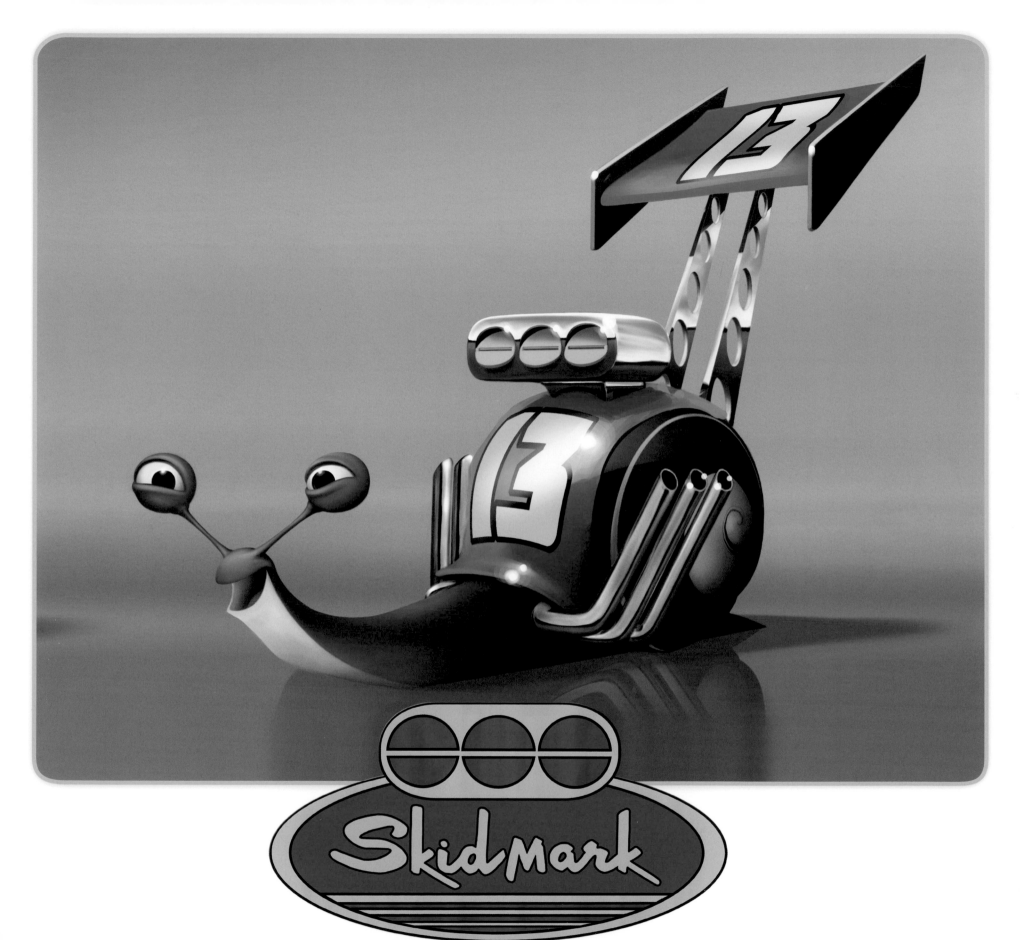

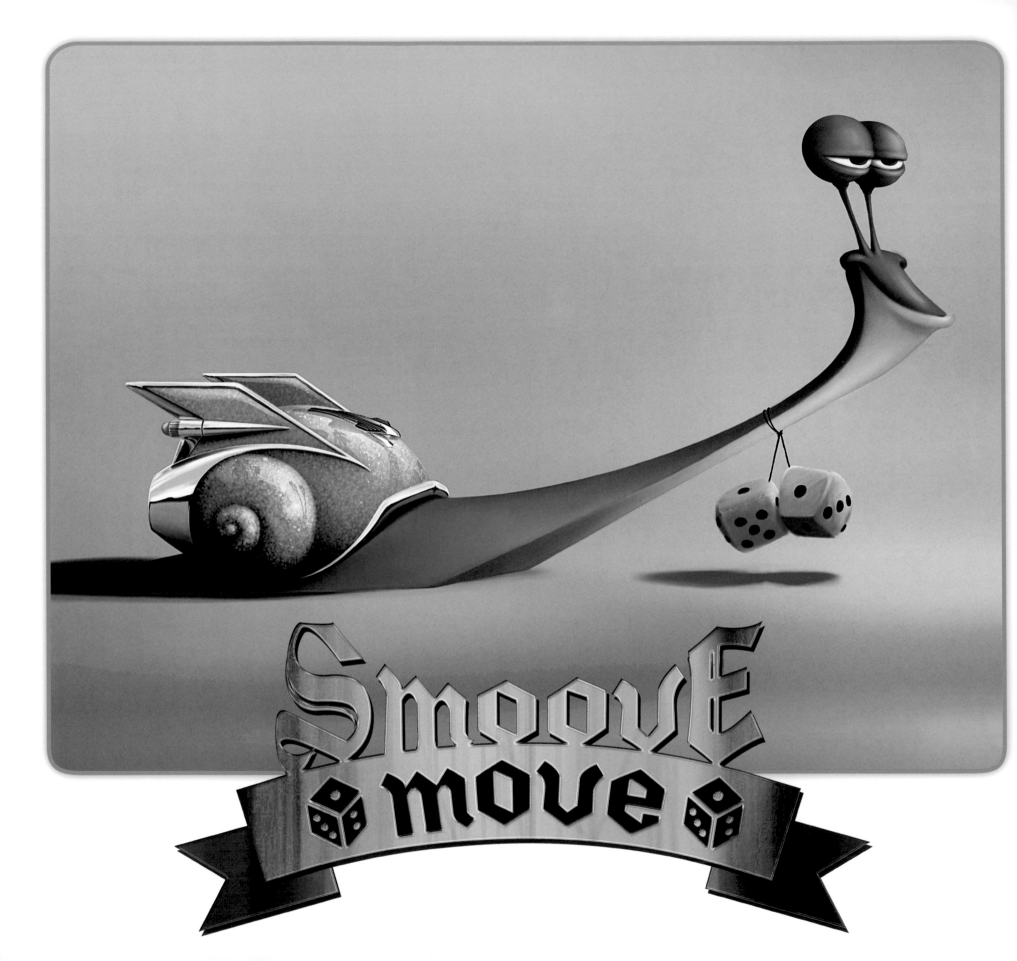

Marcos Mateu-Mestre

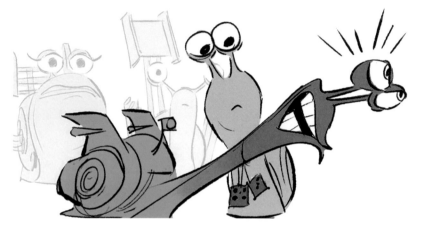

Andy Schuhler

Ennio Torresan

Sylvain Deboissy

SMOOVE MOVE

IF A SNAIL COULD ever be called lanky, Smoove Move—one of the earliest racing snails David Soren came up with—would be that mollusk. Graced with a long neck from which hangs pink dice, and a close-to-the-ground casing with a lush green glow, snaky, hip Smoove Move is the lowrider of racing snails. He's voiced by the inimitable Snoop Lion, formerly Snoop Dogg, and maybe now Snoop Snail?

"From the beginning we wanted a chilled-out character, a cruiser," explains character designer Shannon Tindle. "Think of older cars, fifties-style driving cars that just look laid-back."

The idea was a character who contrasts with the other, more hyper snails. "He's more Zen, since everybody else was pretty hotheaded and got wound up easily. We wanted a snail who was a little more smooth."

As Smoove Move himself says, "I'm movin' so fast the whole world's goin' in slow motion, baby."

(opposite) Sylvain Deboissy – design & Mike Hernandez – painting

Ennio Torresan

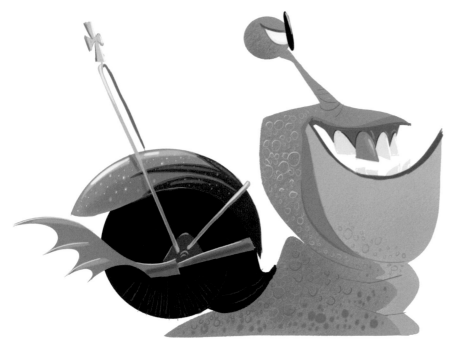

Shannon Tindle

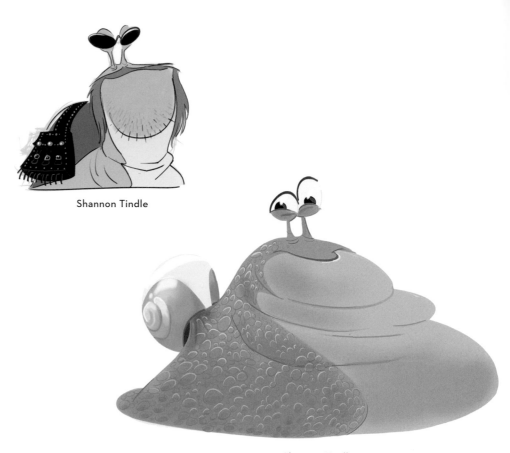

Shannon Tindle

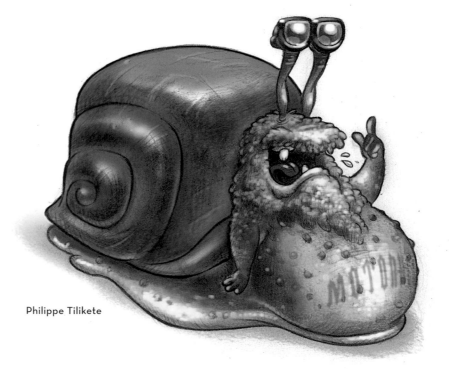

Shannon Tindle

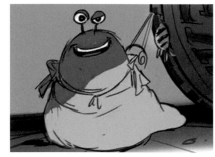

Andy Schuhler

Ennio Torresan

WHITE SHADOW

"Here one second, gone the next," says the chopper-influenced racing snail known as White Shadow, whose bulky, almost Jabba-the-Hutt-like frame doesn't fool Turbo into thinking he can move fast. Inspired by the open-road aesthetic of motorcycle riders and a stunt showmanship personality, White Shadow turned into a particularly fun character for the production team.

"He's very delusional, kind of crazy, and so big that we can get these huge mouth shapes on him," says head of animation David Burgess. "He thinks he can do all these cool stunts, when in fact he can do none of them."

"White Shadow is needlessly mysterious," says Soren. "I love the tiny shell on his back, and the cape. He's got a flair for the dramatic, which is not at all justified, but he carries himself like that anyway."

Philippe Tilikete

(opposite) Sylvain Deboissy – design & Mike Hernandez – painting

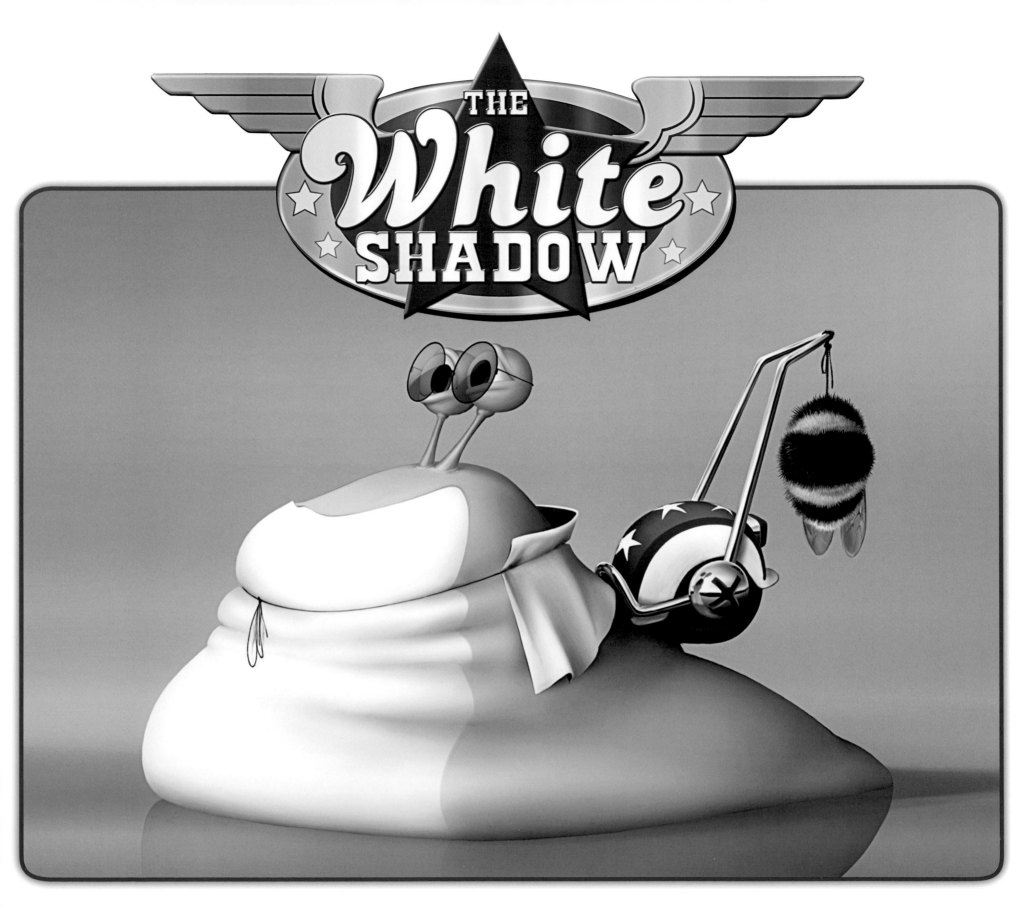

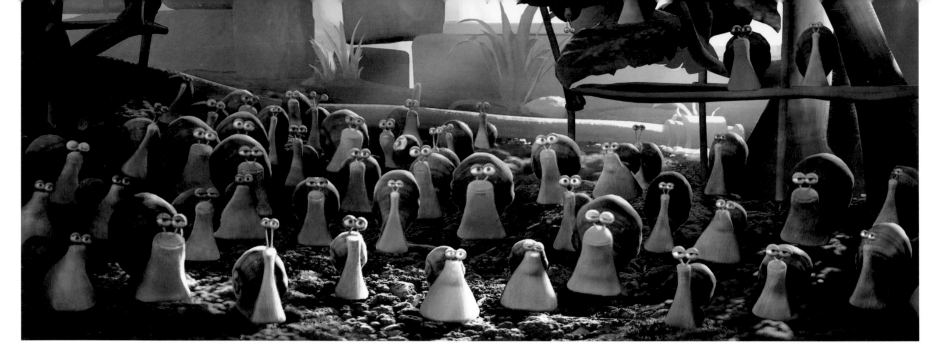

Mike Hernandez

OTHER SNAILS

IT'S A WIDE WORLD OF MOLLUSKS in *Turbo*, which led the artists down many different paths in creating the racing snails. Discarded ideas included a snail meant to evoke the off-road pizzazz of a dune buggy and one intended to reflect the hulking physicality of monster trucks. A potential female racing snail was called Dynamite, a smart-alecky type who might have been the gang's muscle car representative.

As for the snails who populate the tomato plant, variety was the name of the game: tall and skinny, short and fat, the giant-shelled alongside those more modestly adorned. Their colors stayed closer to natural-world hues, so that the more explosive colors of the racing snails really popped. "There's one break-out generic character, and that's the foreman," says art director Richard Daskas. "He's green, with a dark green mustache, but it's really a moss-tache, almost like a fungus has grown on his lip. Everyone stares at it. It's really funny. Plus, he has a mushroom growing out of his shell. He's one of my favorites."

(above and below) Sylvain Deboissy

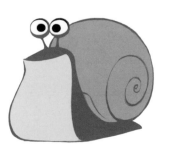
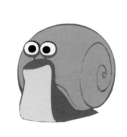
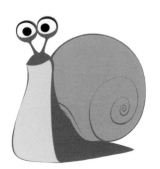
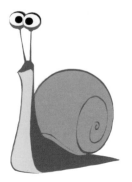

70

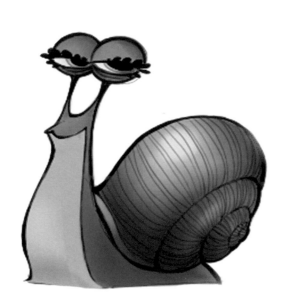

Sylvain Deboissy

Nassos Vakalis

Sylvain Deboissy

Shannon Tindle

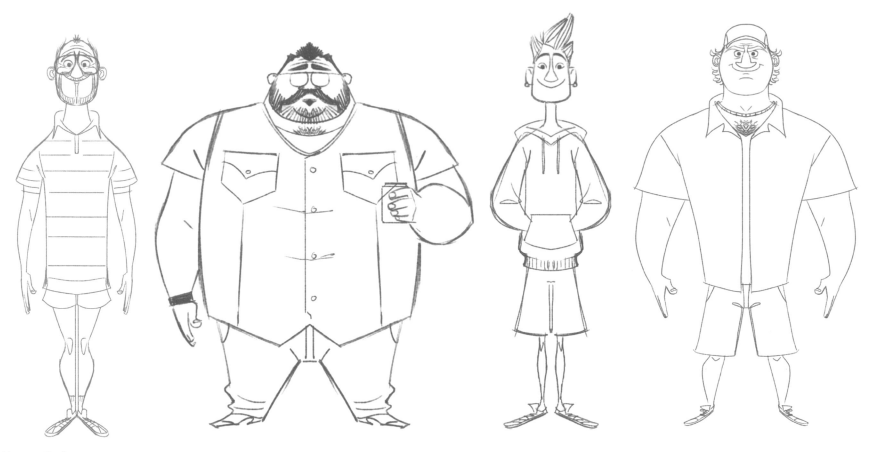

Shannon Tindle

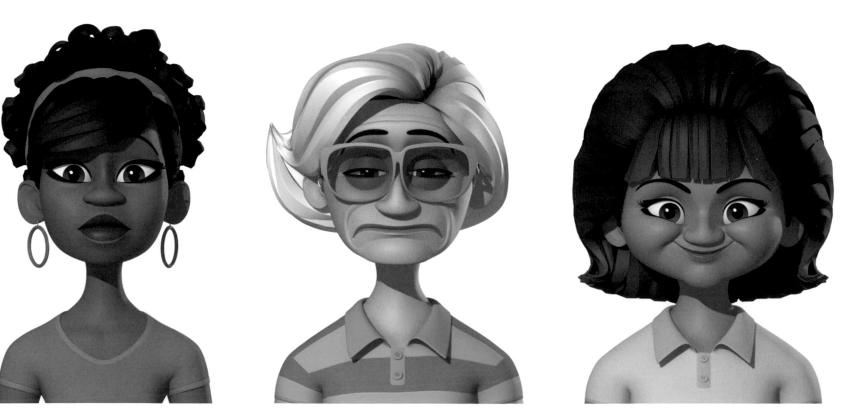

Shannon Tindle – design & Michel Guillemain – model

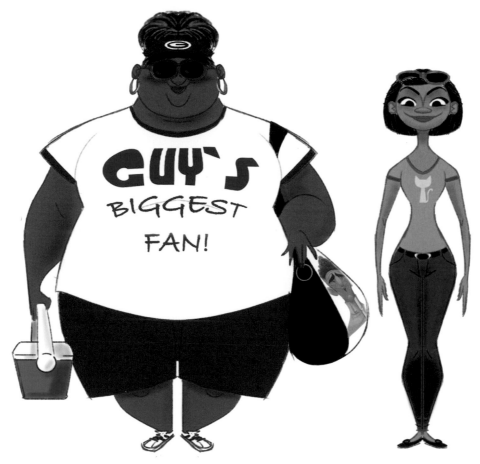

Shannon Tindle

HUMAN CHARACTERS

Filling out the rest of *Turbo* are a variety of characters who help establish the movie's real-world universe: a trike-riding boy whose excursions trigger the snails' "tuck and roll" safety mechanism; an Indy 500 bigwig pressured into allowing Turbo to race and his snail-loving grandson; a dude with a phone camera (called, in the script, "Dude With a Phone Camera") whose recording of Turbo goes viral; and an assortment of strip mall consumers, drivers, racetrack denizens, race announcers, and Indy officials.

Characters with fleeting screen time may not warrant the attention the main characters do, but that doesn't mean they aren't given creative thought. "I never call them background characters," says designer Shannon Tindle. "They're secondary or tertiary, and I had a philosophy going in

for them, because I never like how similar a lot of the proportions look on these characters in other movies."

A system was developed in which Tindle designed three body types—average, thin, and heavy—and a series of swappable heads within which characteristics could be applied. "It's amazing what you can do with sunglasses, hats, and facial hair, and with women, just hair style and skin color," says Tindle. "We were actually allowed to spend a little more time on these character models than what you typically do, so there's a broad range of characters, which was the original intent anyway. A wide range of ethnicities and body types. It's representative of the country now, and especially LA."

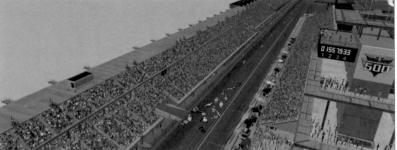

CROWDS

The job of creating an Indy 500 race for *Turbo* gave the crowds department an enormous challenge: one-third of the film that includes around 600,000 spectators. Before *Turbo*, the 2010 DreamWorks film *Megamind* had the greatest number of crowd characters, at around 70,000, which gives an indication of the task at hand.

A saving grace was that the Indy 500 crowd isn't doing a specific action, like the wave, or fleeing from a scene. They're in one spot, and for one reason: to see the race. But at the same time, anywhere a camera could be pointed during the race—whether on the track or during a pit stop—might reveal another 5,000 people. Visual effects supervisor Sean Phillips says, "It's not like you can cheat it. We may try to strategically put in pieces of set dressing so we can eliminate a whole grandstand, but those shots and the number of elements they have are enormous."

Rather than slap a color on a crowd area, the filmmakers wanted as much you-are-there realism as possible—such as touches of shadow and occlusion—which for the lighting department was especially painstaking. Says head of crowds Brad Herman: "We had to refine methods traditionally used to render forests of trees into an art-directable crowd toolset that would give the director the flexibility and control for animation performance he required while allowing our lighting department the ability to render these complex scenes thirty times faster than previous films."

74

(top) Nick Levenduski & Tanner Owen, (opposite) Jeff Sullivan, Josh Richards & Eric Morse

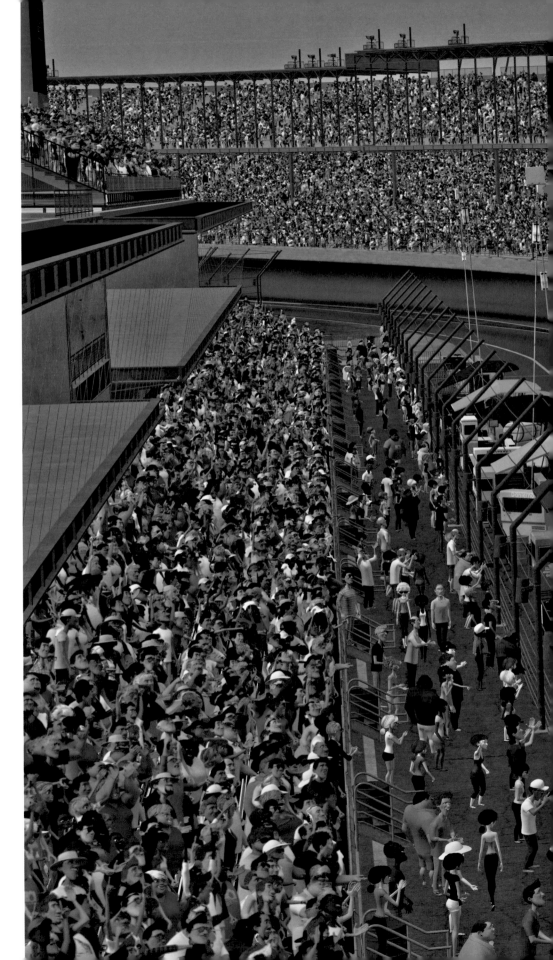

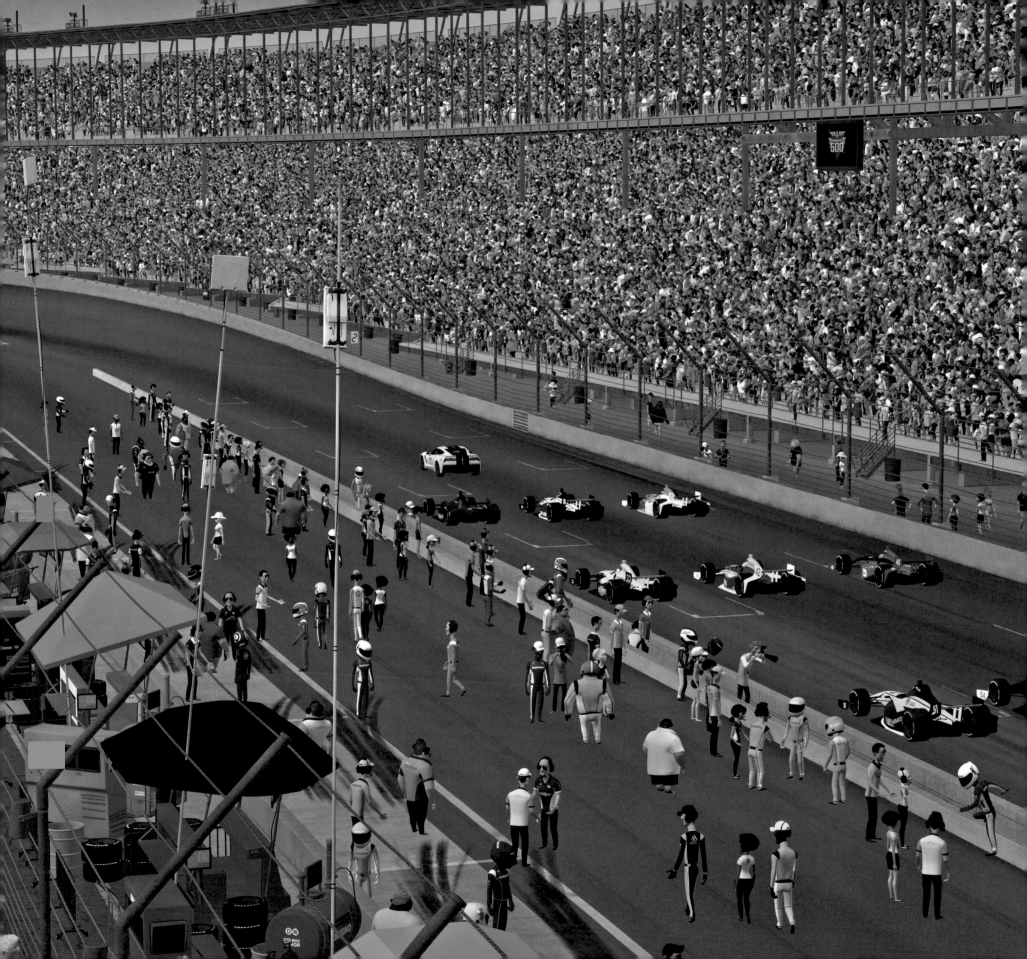

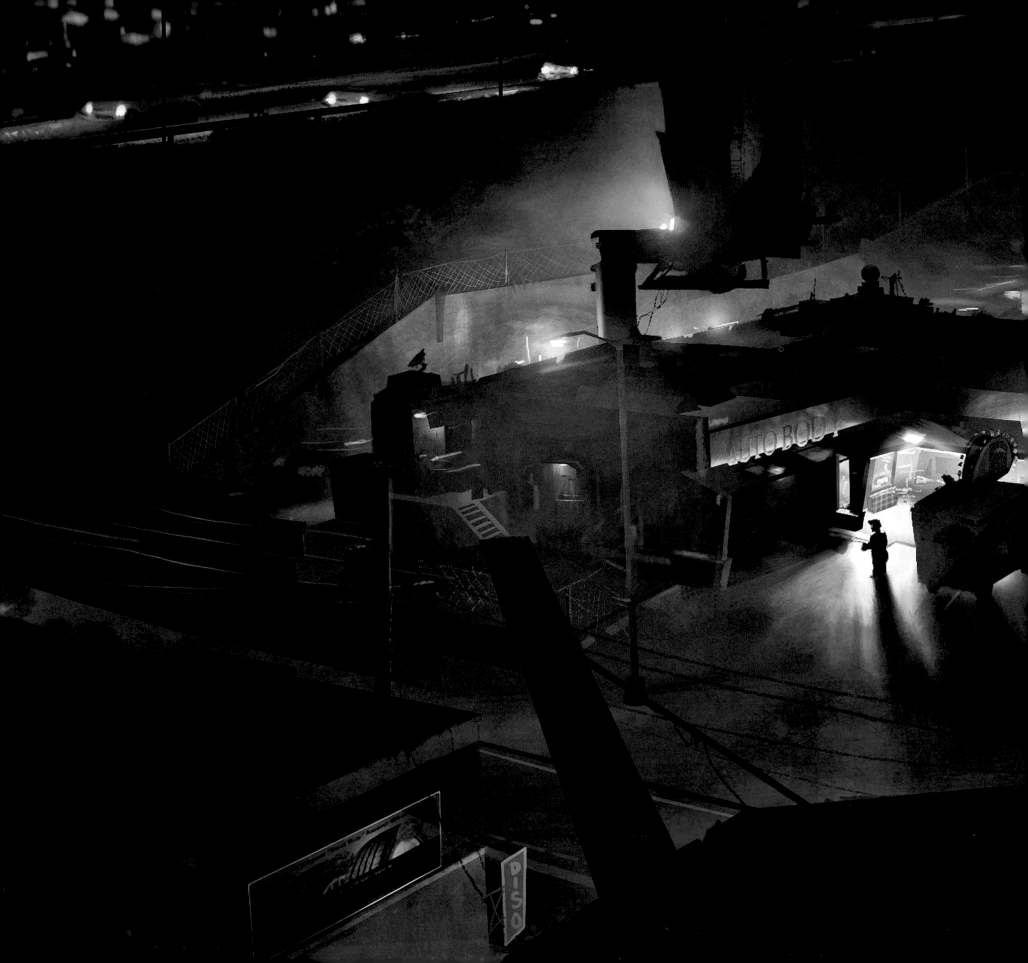

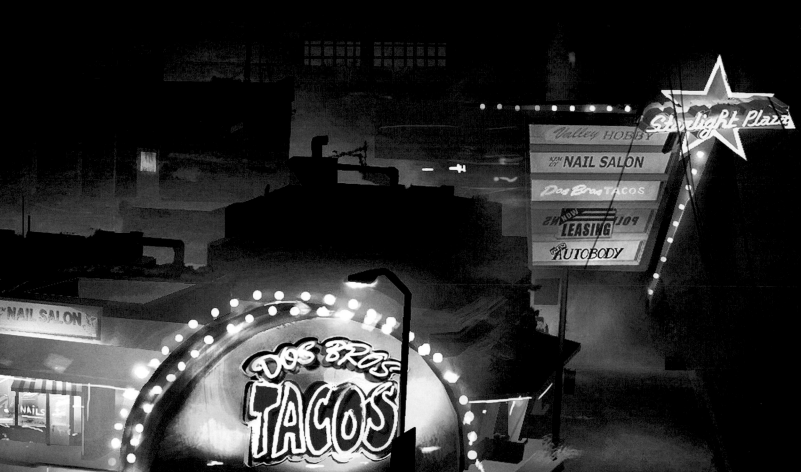
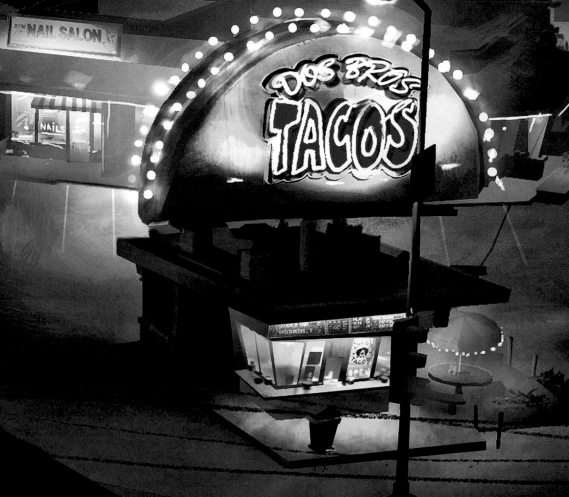

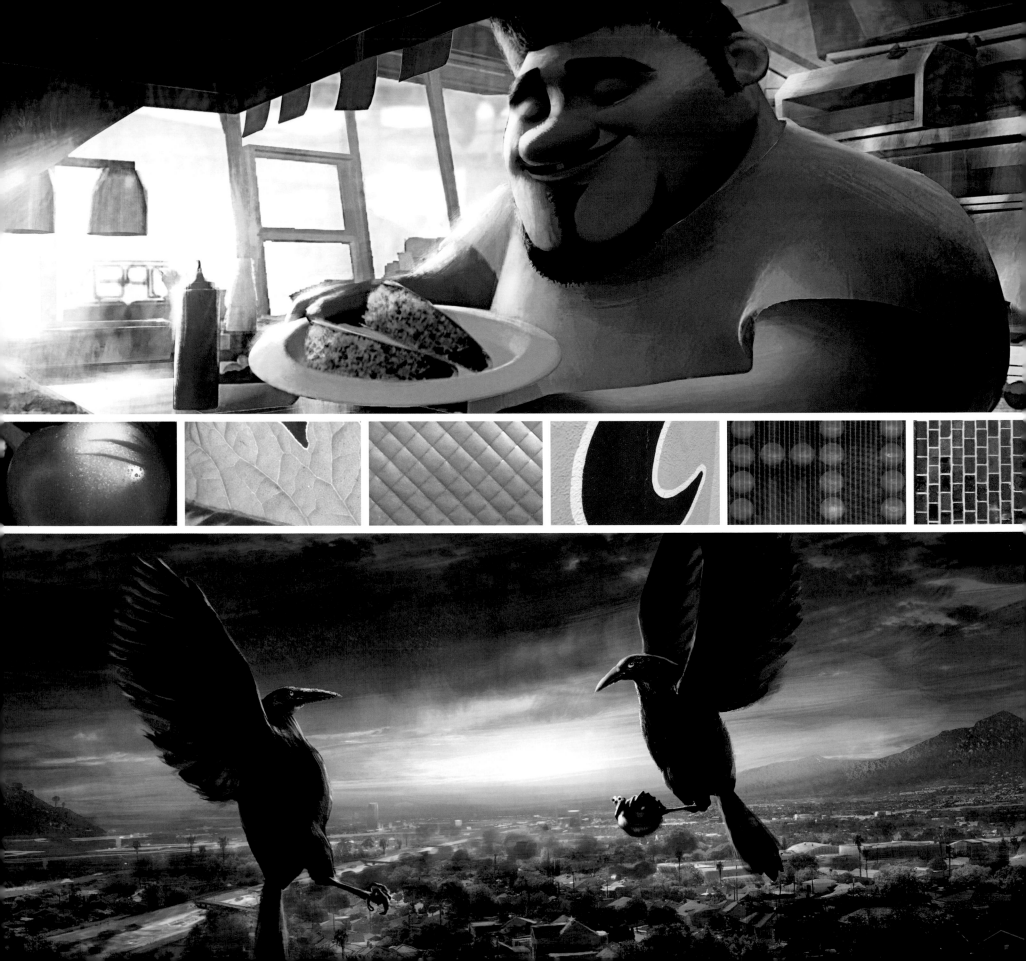

KEEPING IT REAL

Turbo's story is one of ever-expanding possibilities, as the closed nature of a snail's quotidian existence gives way to the open spaces of one special mollusk's dream made real. The succession of locations in the film needed to reflect that as well.

"I was constantly thinking about the sets in terms of the three acts," says production designer Michael Isaak. "Act one, Los Angeles, is a secluded neighborhood and streets. It's hard to see the horizon. Act two, the mini-mall, is a little more open, but it's still in this bit of a depression, and there are highways and buildings around. Then with act three at the Indianapolis Motor Speedway, you just blow the horizon out, and the skies are huge. The scale of each one of these places increases along with Turbo's journey."

Animation favors exaggeration in many aspects—from character design to colors to environment—but for the idea of a racing snail to gain traction emotionally, a viable reality had to be achieved for the world around Turbo. The street-lit spread of the Los Angeles skyline, the shadowy pools that populate sparsely lit garage interiors, and the textured sumptuousness of a world at snail level set the background for the story.

Initially, though, there was concern whether stylized characters could fit in with naturalistic backdrops. Early discussions about the realistic look for *Turbo* led the creators to consider smoky backgrounds, diffuse lighting, and expressive shadows. When this concept proved fruitful, the next step was getting reference points for the environmental verisimilitude Soren sought. Oftentimes that meant artists leaving behind the indoor comfort zone of internet research and venturing to real locations to experience firsthand what the places in *Turbo* would look like and feel like.

"This was a counterintuitive movie to design in many ways," says Isaak. "To say 'I'm going to get in my car and drive down the street and design stuff all around me' was a challenge. This stuff is the white noise on your commute to work. You don't think about it. But there are little clues everywhere that you can bring to the movie."

Lighting what's recognizable can be hard, says head of lighting Mark Fattibene. He adds, "Everybody knows what human skin, eyes, hair, and nails look like. They are complex shading and lighting models and therefore difficult to emulate. Luckily, David didn't want hyperreality in our human characters; he wanted stylization with an emphasis on character shape. However, he directed

(pages 76–77) Dominique R. Louis, (opposite, top) Mike Hernandez, (opposite, bottom) Mike Hernandez, (above) Marcos Mateu-Mestre

(top) Richard Daskas, (above) Dominique R. Louis

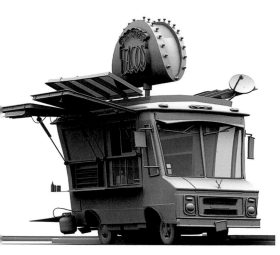

environments to feel authentic and gritty. Other simple surfaces—concrete, scratched glass, stainless steel—less complex but still require detail to make them feel 'real.' So when the audience sees the taco stand, we want them to think, 'I've totally been that taco stand. I've eaten there.'"

Finding gritty charm in the non-Hollywood Los Angeles of concrete, neon, diffuse sunlight, and dense urban centers was one goal for the *Turbo* team. Accurately re-creating the Indianapolis Motor Speedway, on the other hand, was about reconciling the factual reality of an iconic venue and the eye-catching demands of art. "We had to discover if we wanted to make it look real or not," says Isaak. "My brain instantly goes to 'how can we make this a fantasy place?' But the more we got into the process, the more we realized that in order to ground the story, to make Turbo's stakes more relatable, we had to embrace the authenticity of the place and the magnitude of this track."

The progression of the story also allowed Isaak to instill a shape language that moved from tottering and vertical to sleek and horizontal. "I wanted to know what it looked like to be safe and slow and trapped, and then free, exhilarated, and fast," says Isaak. "There's the top-heaviness of the taco truck, stuff stacked to the outside, and then the race car, which is sleek and low, with shiny surfaces. That for me was the expression of how to diagrammatically express these two very different worlds."

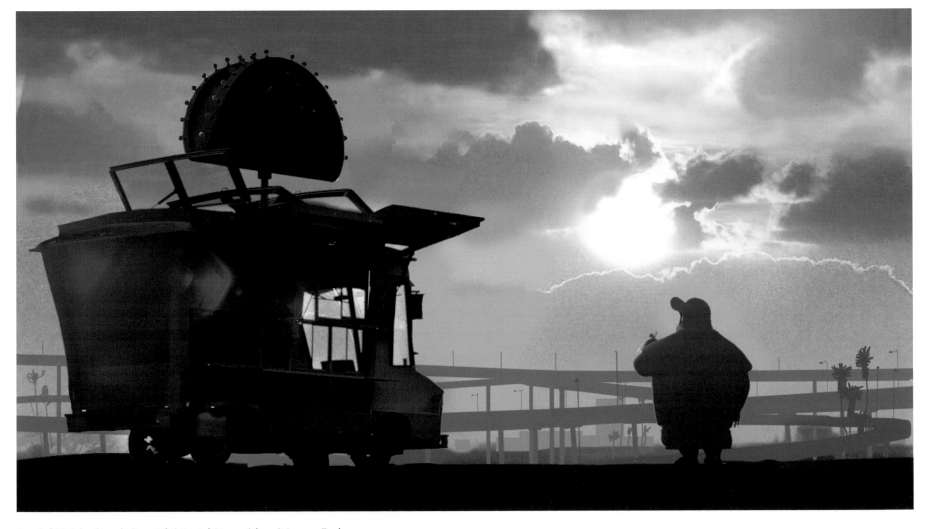

(top left) Michael Isaak, (top right) Daniel Simon, (above) Jeremy Engleman

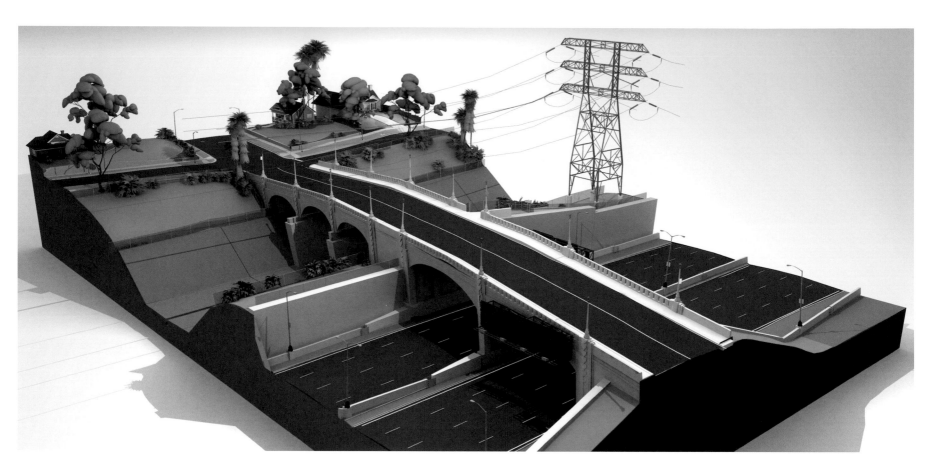

Michael Isaak

SAN FERNANDO VALLEY

Since director David Soren was inspired to create *Turbo* from the snail metropolis that was his verdant front yard, he had production designer Michael Isaak come to his San Fernando Valley neighborhood of rolling hills and ranch houses for a walking/talking/photographing tour that would help establish Turbo's environs. "I wanted it to be very specific to the Valley," says Soren, "and that style of house and garden."

Adds Isaak, "We were looking for places that had lots of planting, because we wanted to keep the sky out of Turbo's field of view for a while in the movie. We wanted to keep him covered and protected."

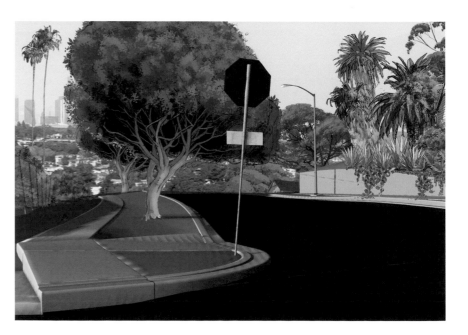

Mike Hernandez

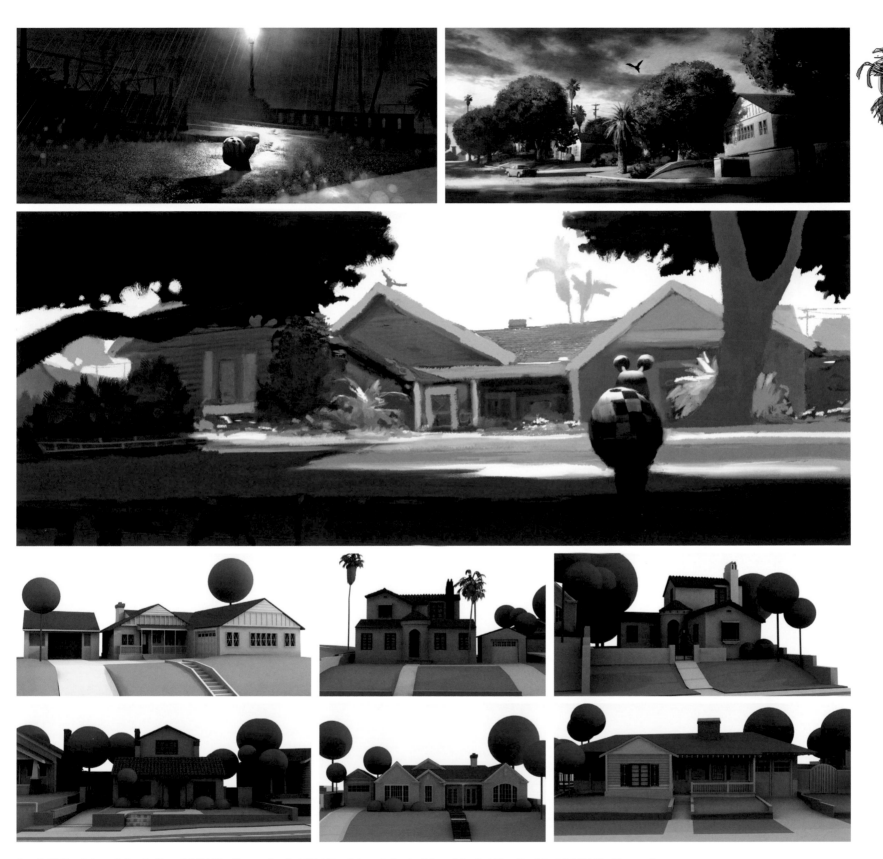

(top left) Dominique R. Louis, (top right) Mike Hernandez, (middle) Dominique R. Louis, (above) Rachel Tiep-Daniels, (right) Mike Hernandez

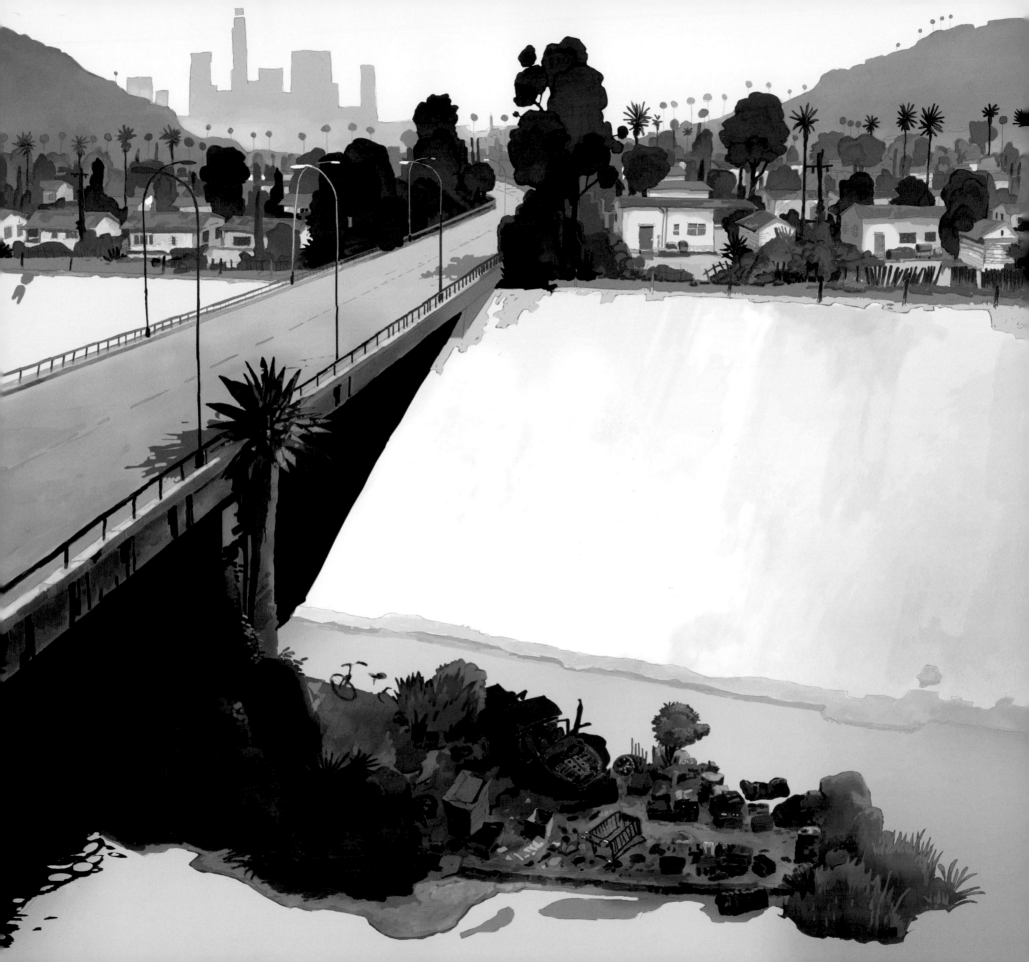

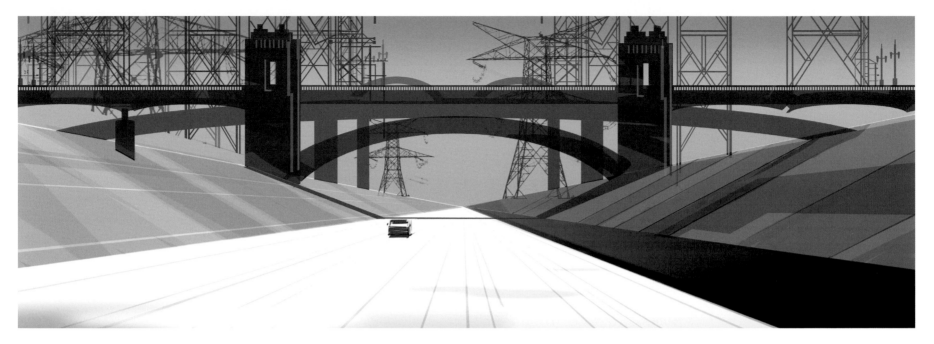

(opposite) Tang Heng, (above) Marcos Mateu-Mestre

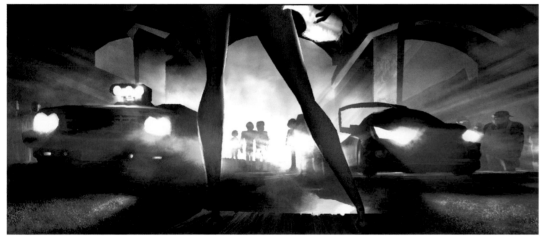

Dominique R. Louis

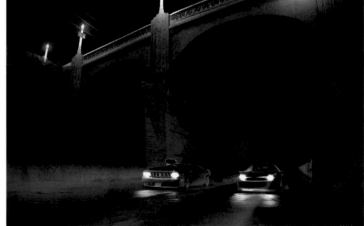

Jason Scheier

Dominique R. Louis

Danny Williams

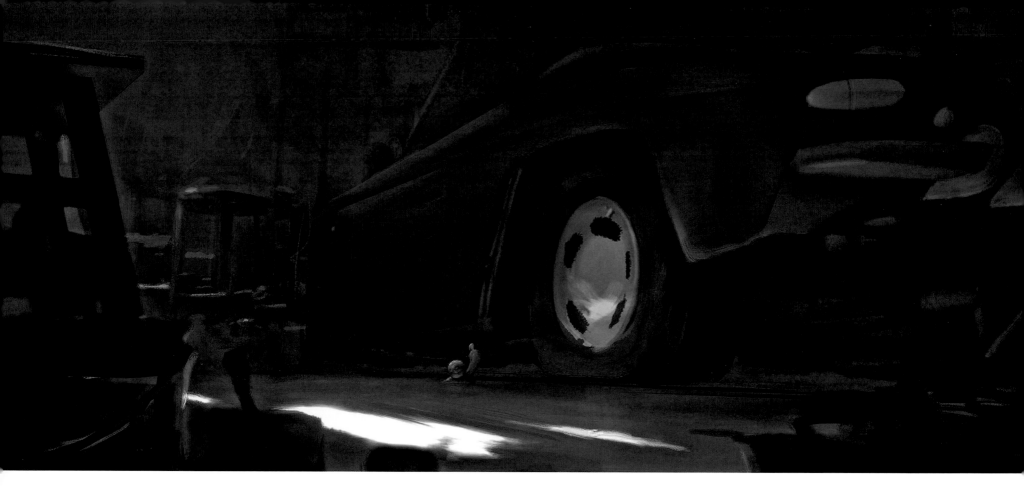

Dominique R. Louis

HOUSE GARAGE

THE GREEN, LEAFY ENCLAVE of the movie's first part would be a paradise for your average everyday snail. But Turbo's not your average everyday snail. Not interested in the natural world, he prefers to spend his time in the garage, a dark, cluttered space with a workbench that holds the one window to the world he cares about: a junky old television. That's where Turbo watches recordings of Indy 500 races featuring his hero, driver Guy Gagné.

"That's his escape mechanism," says Soren. "Going to that garage is his way of escaping the drudgery and dullness and slow-paced life he experiences at the tomato plant."

Though the garage is mostly shrouded in darkness, what's visible suggests a human resident who perhaps gave up on his own auto-racing dreams, says Isaak. We see tools, photos of cars, a newspaper clipping about a race won as a young man, a trophy that holds highlighters and pens now, and, of course, the racing videocassettes that Turbo watches, cosmically bonding in a way with the unseen owner. Says Isaak, "There's a car there, a cruiser he's been renovating, but it's a project fallen by the

wayside. I wanted to tap into some sort of sadness that could relate to what Turbo was going through, and at the same time give the place an auto-racing subtext."

Since Turbo can be seen slurping on Adrenalode—the energy drink Guy sponsors—a six-pack of it is visible, too, just so audiences don't get any distracting notions about snail resourcefulness. Says Isaak, "We don't want anyone to think Turbo went to the corner store. It's all stuff that's in his environment. Turbo's a really lucky guy, as it turns out. He happens to share a garage with the one kindred spirit he has in the world."

These early scenes also help give moviegoers a sense of the scale between Turbo and other objects—a videocassette, or a television, or the ruler Turbo uses to test his one-yard-dash time. It's a design principle Isaak always wanted production to keep in mind. Because these things loom large in a snail's world, stacked messily and dangerously, they must be approached with the same detailed artistic considerations—what Isaak calls "burning art calories"—that designers and artists would in rendering the film's more human-sized sets.

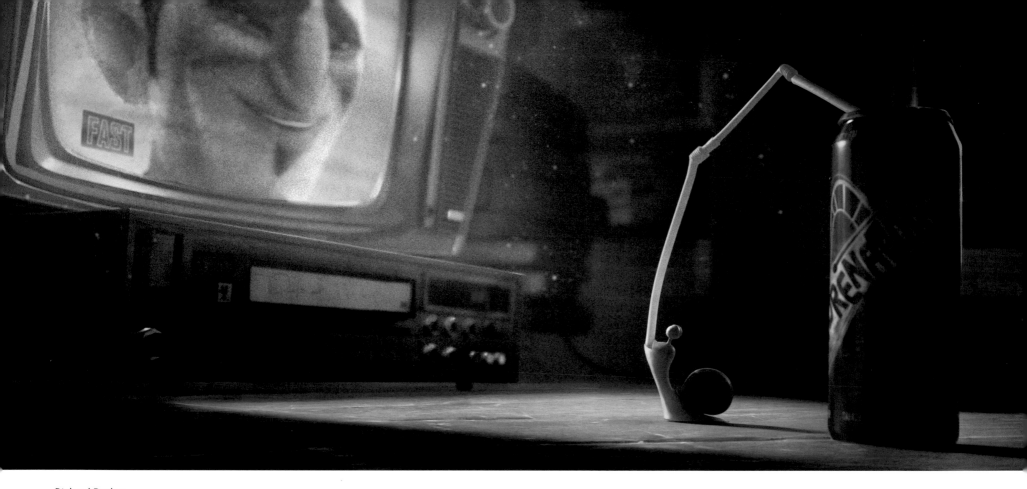

Richard Daskas

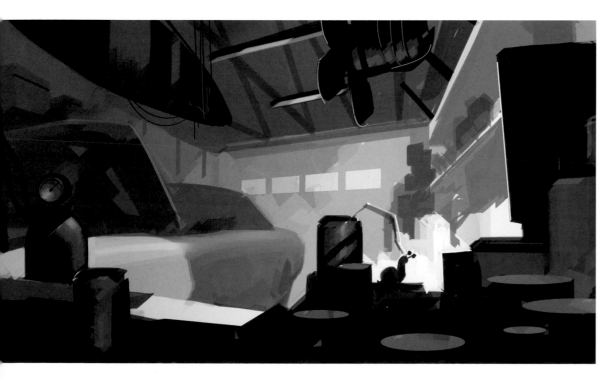

Marcos Mateu-Mestre

> "We worked really hard to get that lived-in vibe. We wanted the garage to feel like there was a backstory."
>
> **MICHAEL ISAAK,**
> PRODUCTION DESIGNER

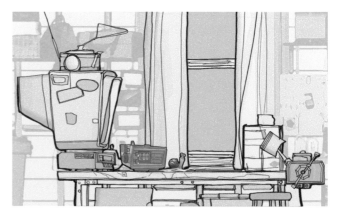

Jason Scheier & Brett Nystul

TOMATO PLANT

TURBO'S DAILY GRIND IS the tomato plant, a brick-enclosed section of the garden where snails file in like clock-punching factory workers to methodically harvest—and eventually consume—the vine-ripened goodies around them. It's a regimented existence, with Turbo as an unhappy cog, so it was essential to design an environment that suggested a routine for the snails. "It was challenging because it was supposed to be a boring world [from Turbo's point of view]," says head of story Ennio Torresan. "But it has to be entertaining and boring at the same time."

Rather than go the fantastical Rube Goldberg–inspired route of a deliberately cartoony industrial misery farm, it was decided to give the "plant" recognizable structure as a garden for humans but a factory in the minds of snails. No tiny snail cars or snail vending machines, either. This is the naturalistic world a snail would actually encounter.

"We added lots of man-made elements, for two reasons," says Isaak. "One, so that the chicken wire around the outside mimics the ideas of the walls of the factory, a fenced-in environment. And then secondly for scale, because we wanted to constantly remind the audience that these snails are very small and insignificant." To that end, many shots include a snail alongside a human object such as a glove, trowel, or watering can. Next to the plant entrance is the property's water meter, which, in the same frame as the snails', looms like a building. This way, the audience can quickly establish size ratios.

Also taken into account was moviegoers' familiarity with the macrophotography of nature films, where a creature as tiny as a snail is seen in sharp, life-size focus, while the background is

(top and right) Margaret Wuller, (below) Rachel Tiep-Daniels

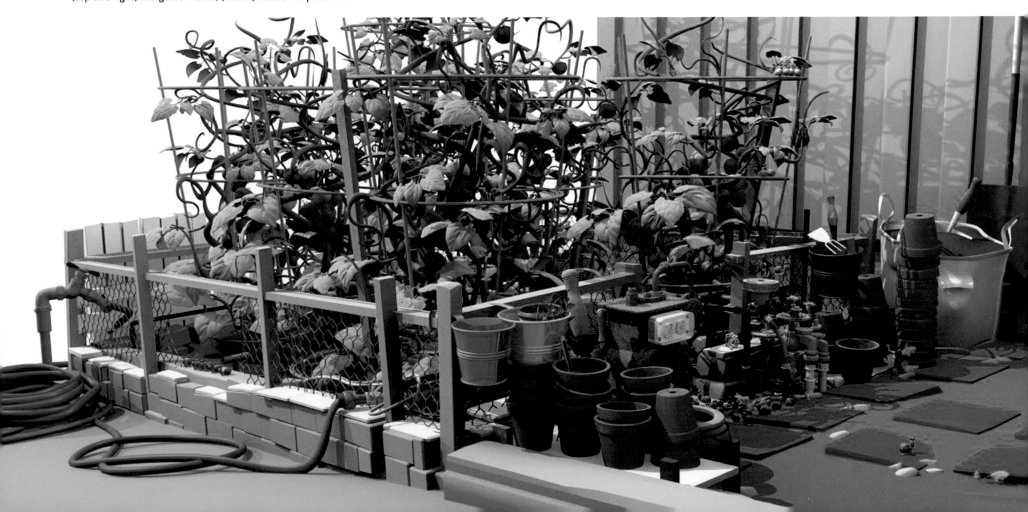

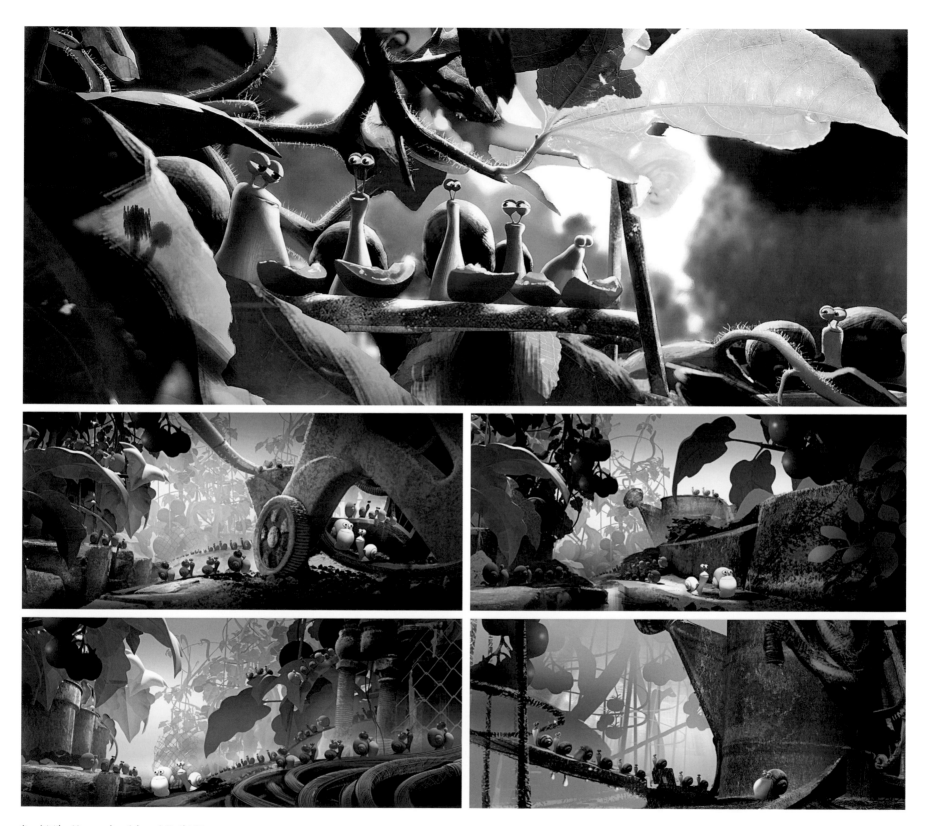

(top) Mike Hernandez, (above) Emil Mitev

Margaret Wuller

blurred. This played into the decision to keep the visual depth of field in the tomato plant sequence realistically tight. It also helped dramatize that Turbo is in a smothering, confined world. Though computer-generated imagery could have allowed the effects team to cheat background focus, says visual effects supervisor Sean Phillips, creatively it was important to keep a certain softness in the background. "People are so used to seeing that, we couldn't completely get rid of it and have you still feel like you're in this intimate little world," says Phillips.

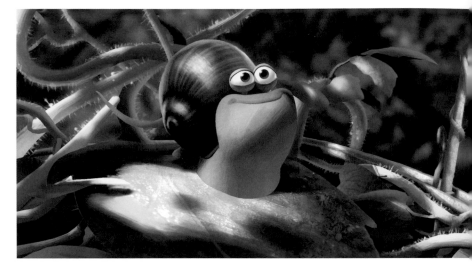

Mike Hernandez

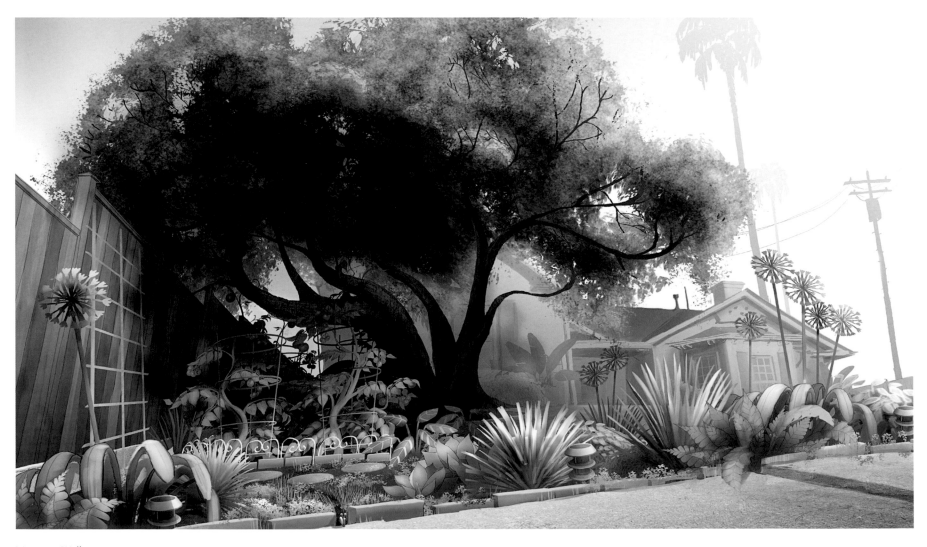

Margaret Wuller

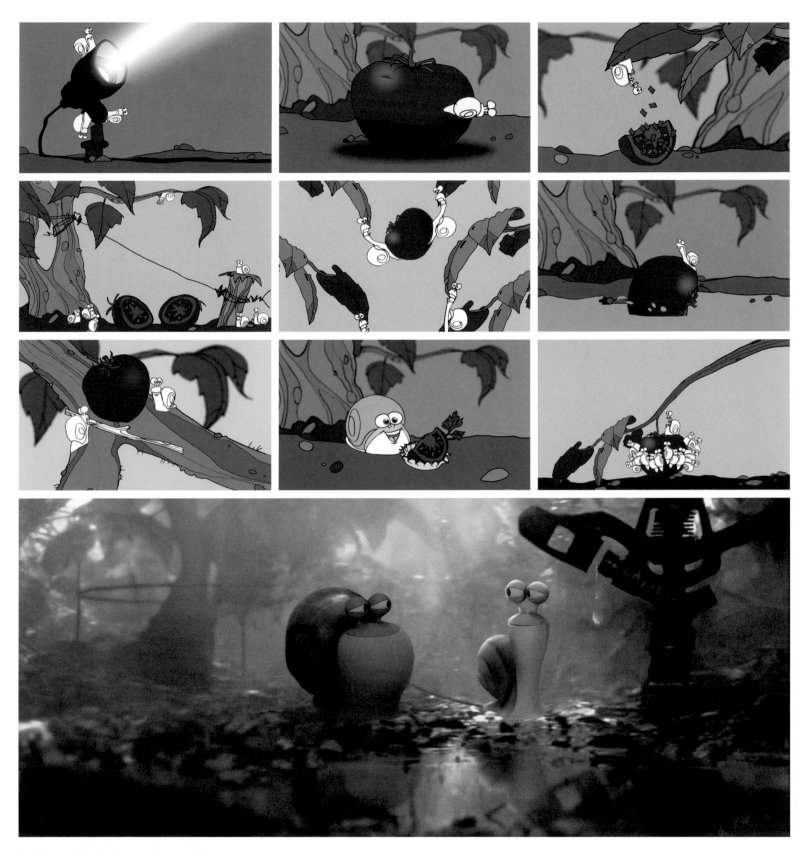

(top) Michael Isaak, (above) Richard Daskas

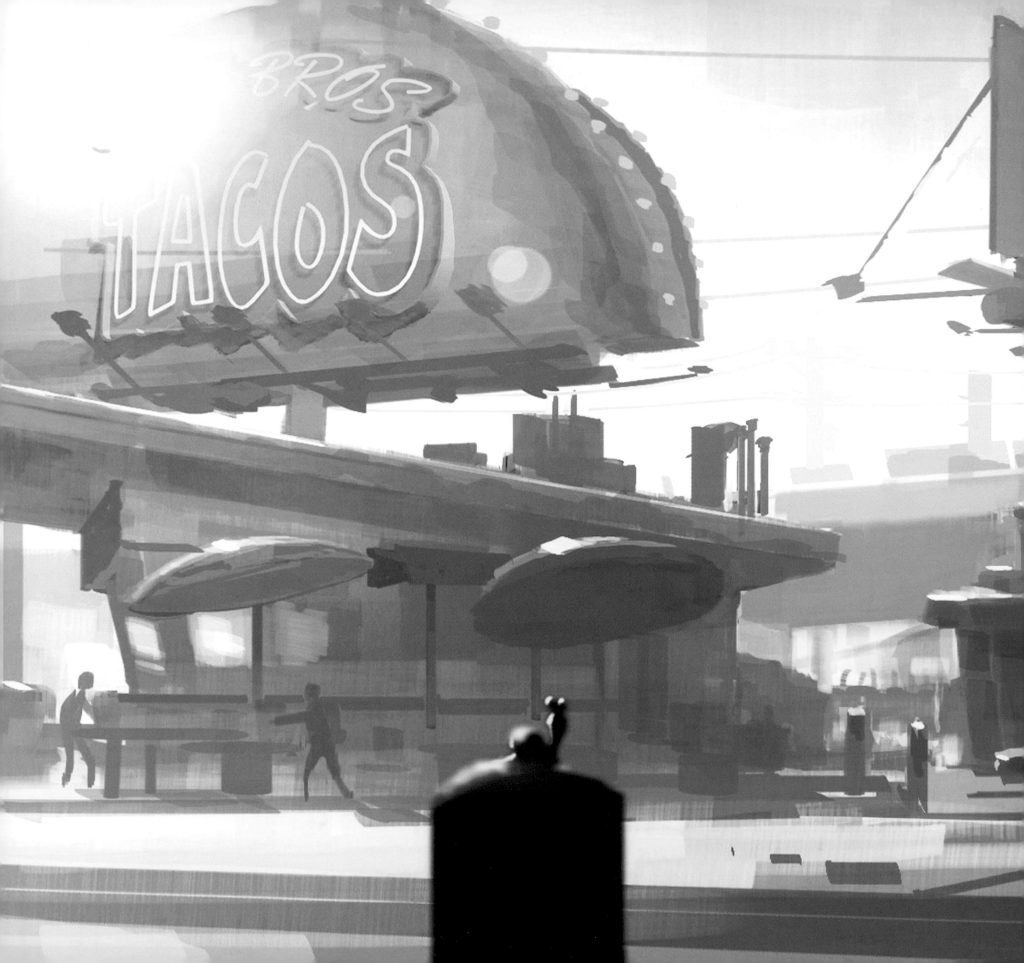

STRIP MALL

When you think of Los Angeles as represented in movies—animated or live action—it's usually one of three settings: sun-kissed Malibu beaches, star-wattage Hollywood, or wealth-emblazoned Beverly Hills. "Together, they're a very small part of the city," says director David Soren. "Nor are they the most interesting parts of the city, either."

The opportunity *Turbo* presented to re-create the types of buildings found in Los Angeles's San Fernando Valley—its concrete sprawl and clusters of multiethnic businesses housed in structures both nondescript and vibrantly creative—is what appealed to Soren. "The architecture of the Valley is unique, distinct, and something we wanted to try to capture in animation."

Though it wasn't anyone's job to reclaim the strip mall as an American institution, production designer Michael Isaak wanted to find the right LA-centric structural charm for the corner collection of small businesses—Kim Ly's nail salon, Paz's autobody shop, Bobby's hobby store, and Tito and Angelo's taco stand—where Turbo and Chet find themselves. "It came down to choosing the time period, and the ones we liked were from the forties and fifties," says Isaak, referring to the streamlined, more inviting design of the era. The mid-century-influenced sign announces you've arrived. We liked the idea of a shooting star, because it represented some of Turbo's aspirations."

Central to rendering the strip mall businesses was suggesting the down-and-out without necessarily making them look dilapidated. "They're down on their luck, but we didn't want it to be depressing," says art director Richard Daskas. "So if it seems like a bad neighborhood, at least they keep it clean. We wanted it to feel like there's pride of ownership there."

Hundreds of little touches were added to the strip mall businesses—a chair outside a front door, strung-up lights, awning colors, homemade signs, things patched up—that altogether had to spell timeworn but homey, without being obvious. "It's a weird game we play," says Isaak of his craft. "I didn't want any one thing to stand out. It's a vibe. So much design work is to get something to feel right but have you actually not notice it. If you're noticing the details, then you'd see the hand of the designer."

(opposite) Mike Hernandez

> *"We wanted to show the audience that the strip mall shopkeepers may not have a lot of means, but they have an insane amount of pride."*
>
> **MICHAEL ISAAK,**
> PRODUCTION DESIGNER

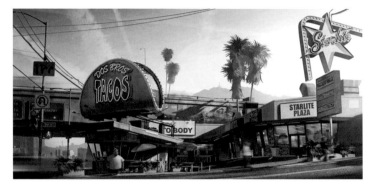

Mike Hernandez

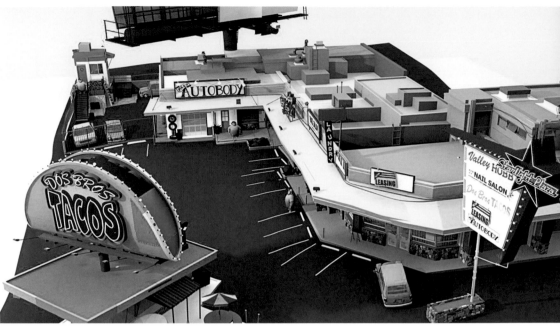

Rachel Tiep-Daniels

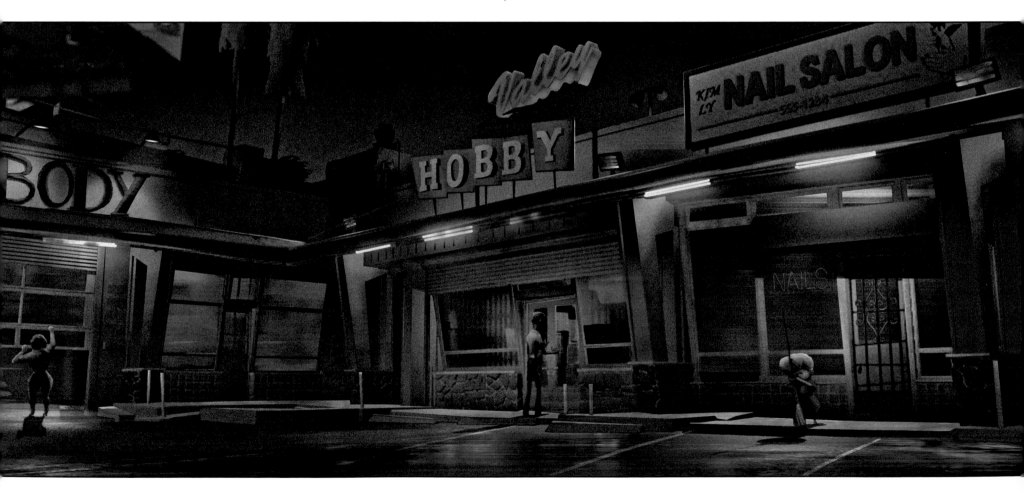

Mike Hernandez

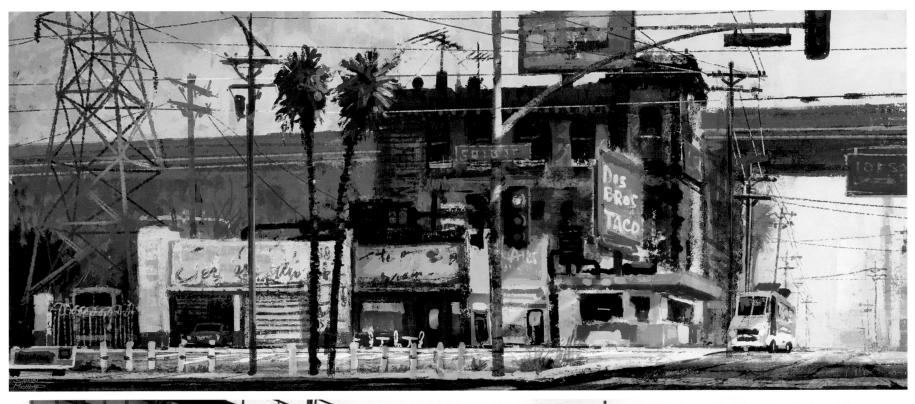

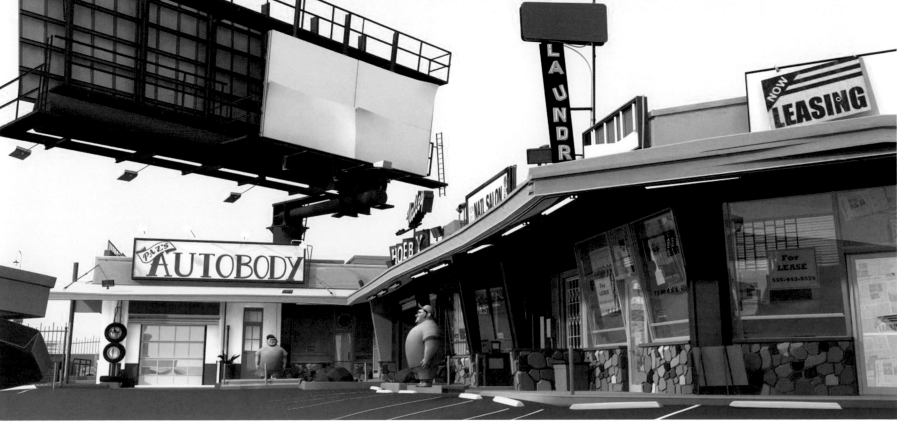

(top) Samuel Michlap, (above) Rachel Tiep-Daniels

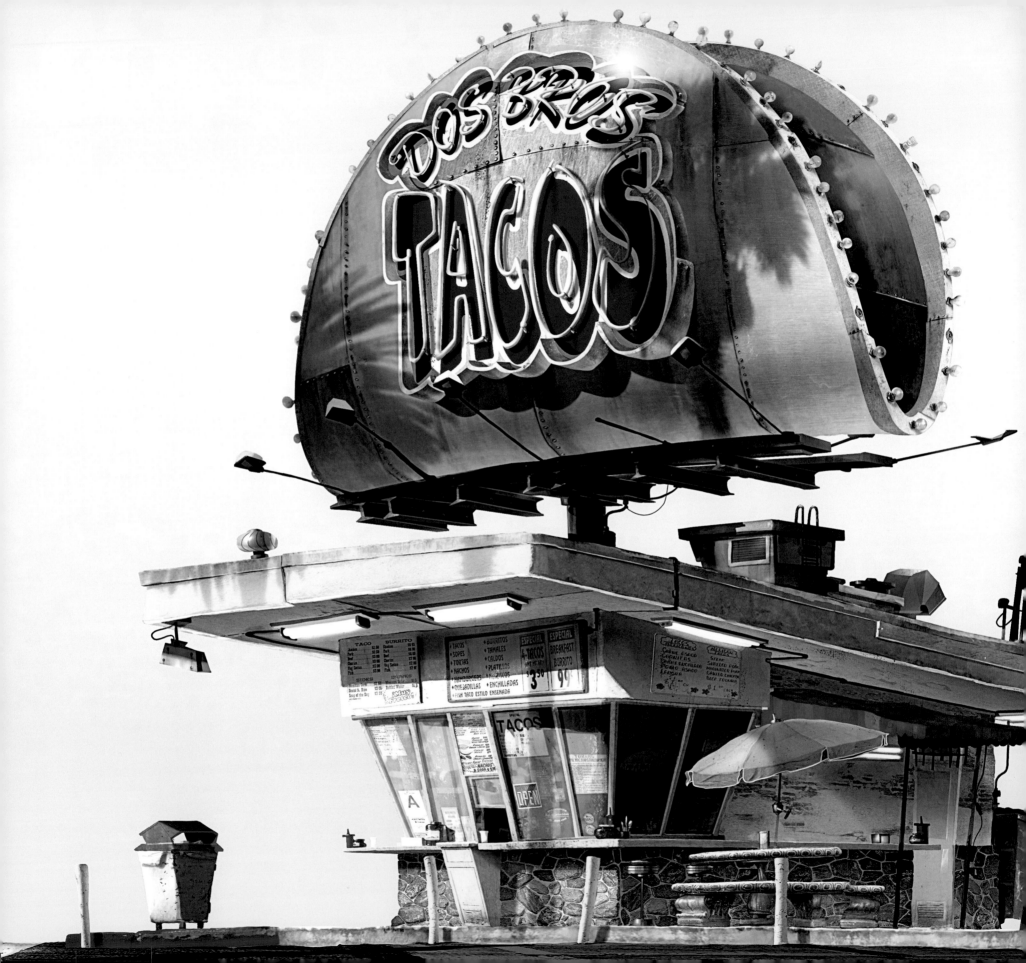

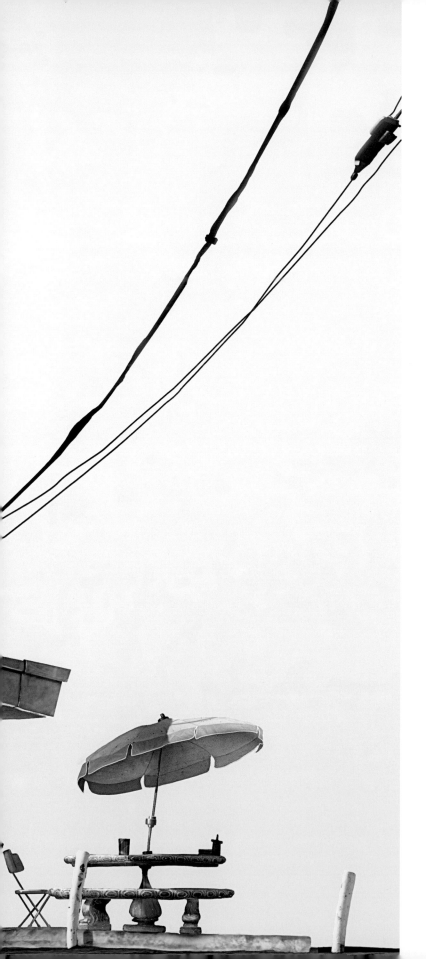

Sylvain Deboissy & Vy Trinh

DOS BROS TACOS

WITH THE CONCEPT OF top-heaviness in mind, it's hard to get more precarious-looking than a massive taco hovering above your business. Reminiscent of the iconic torus that sits atop Randy's Donuts in Los Angeles, the crispy-corn-shell-shaped sign announcing Tito and Angelo's food stand was designed to communicate something attractive yet unsettled among these struggling shops at the Starlight Plaza. "I wanted their environment to look precarious," says Isaak, who at one point had considered adding a blank billboard hovering even higher above the Dos Bros Tacos stand. "That image was in my mind early on, something melancholy and lonely. And with the highway right next to it, with cars racing right next to Turbo, it's also taunting him a bit. He aspires to go fast, and yet he's trapped just underneath it in this mini-mall."

Inspiration for the look of Dos Bros Tacos—the upswept roof sheltering a small outdoor eating area—came from a smattering of Valley taco stands from the 1950s. Inside, Angelo's workspace isn't big. "I wanted the place to be so claustrophobic, because these places are tiny," says Isaak.

(opposite) Michael Isaak & Richard Daskas

Craig Church

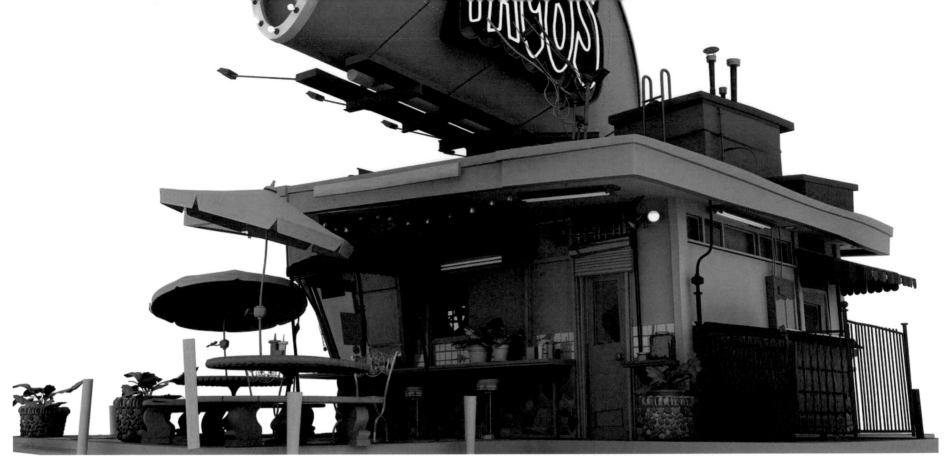

(above) Rachel Tiep-Daniels, (below) Mike Hernandez

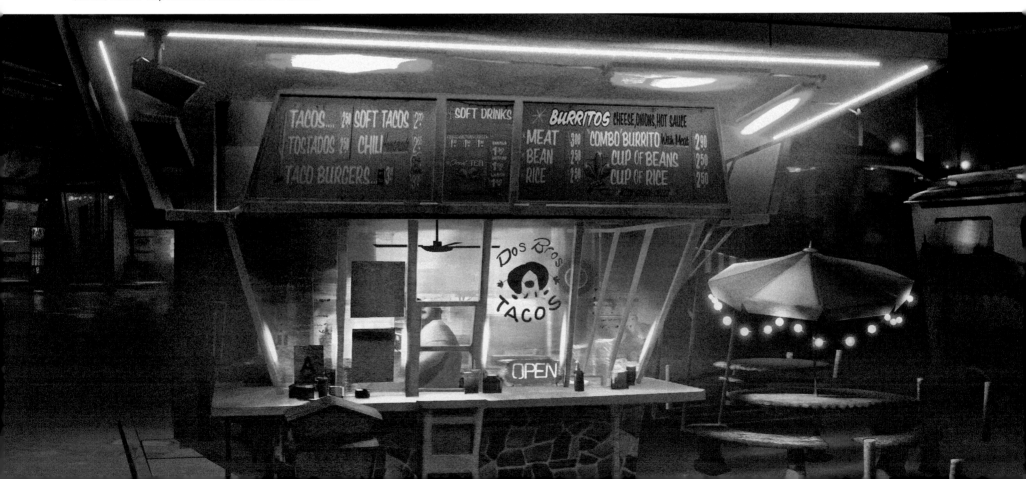

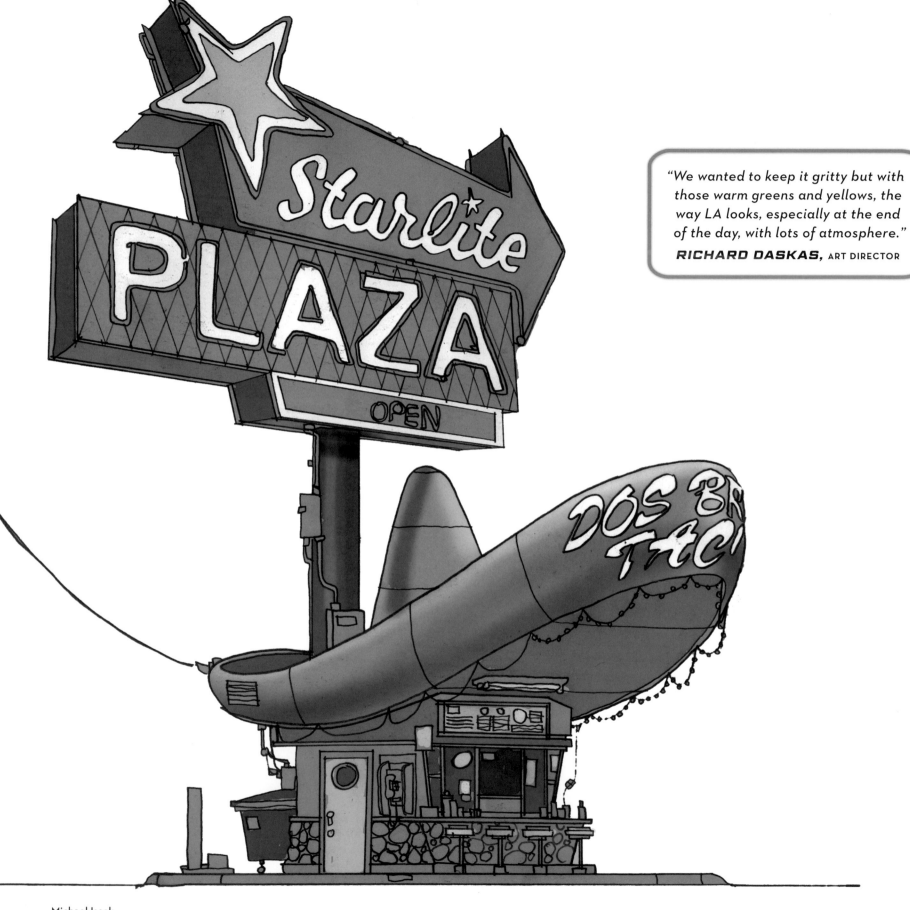

"We wanted to keep it gritty but with those warm greens and yellows, the way LA looks, especially at the end of the day, with lots of atmosphere."
RICHARD DASKAS, ART DIRECTOR

Michael Isaak

Peter Maynez

PAZ AUTOBODY

It's in the back of Paz's autobody shop where Turbo and Chet are introduced to the strip mall's secret snail-racing world. Initially it's a sinister place to our confused, out-of-their-element protagonists. But as it becomes apparent that Paz and her mini-mall colleagues mean no harm, we see this rockabilly gal's autobody shop for what it is: a charming independent business reflecting the owner's special taste.

Research trips to mechanics in the San Fernando Valley yielded plenty for Isaak and art director Richard Daskas to soak up. "I didn't want to go to a bix box store or a muffler shop," says Isaak. "I wanted to go to those kinds of garages that have been around for forty years, where stuff is stacked up, and spare parts are lying around."

The designers determined that Paz would be the kind of road enthusiast who'd have all the tools of her trade around, as well as all sorts of highway- and car-related objects she's collected over the years. "Stoplights, street signs, hubcaps, steering wheels from different cars she's worked on, fun details like that," says Isaak. "Even the word *A-U-T-O* in big red letters that we got from a garage we saw. We wanted it to be rich with detail and set dressing, with surfaces that look old and the kind of stuff you'd see at a swap meet."

Mike Hernandez

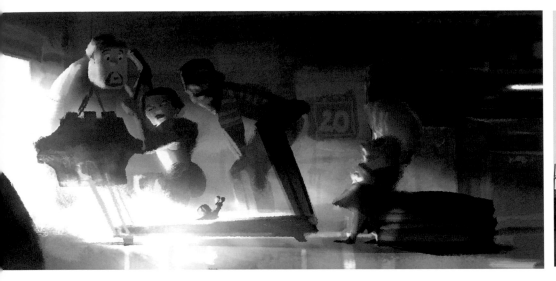

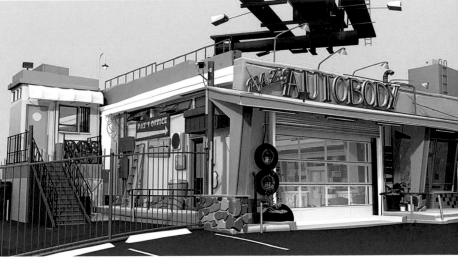

(above) Dominique R. Louis, (below) Jason Scheier

Rachel Tiep-Daniels

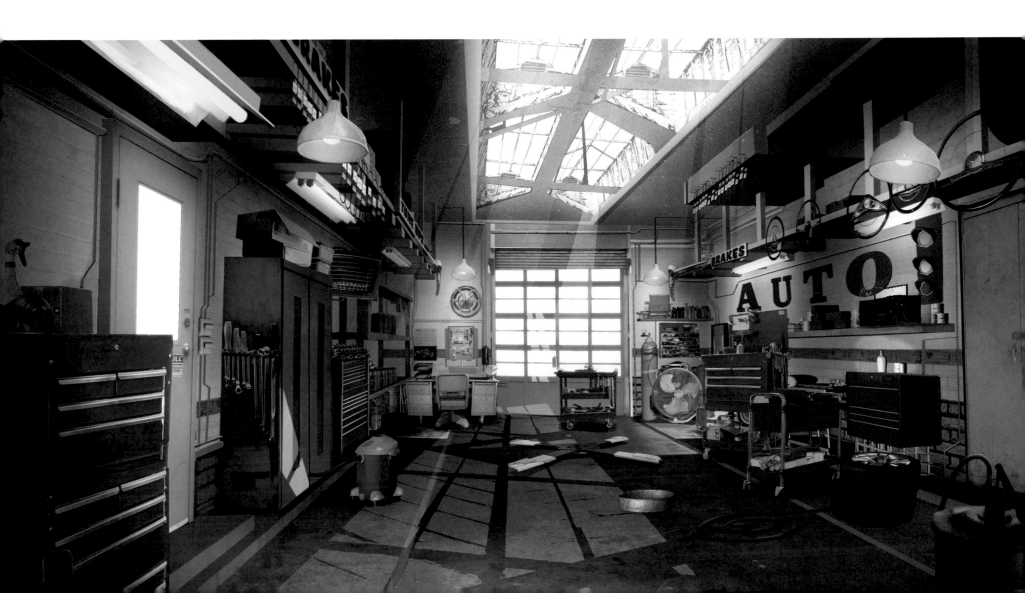

Jason Scheier

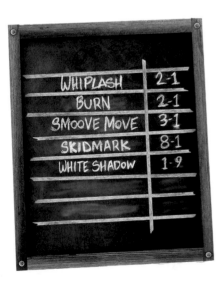

Craig Church

WHIPLASH	2-1
BURN	2-1
SMOOVE MOVE	3-1
SKIDMARK	8-1
WHITE SHADOW	1-9

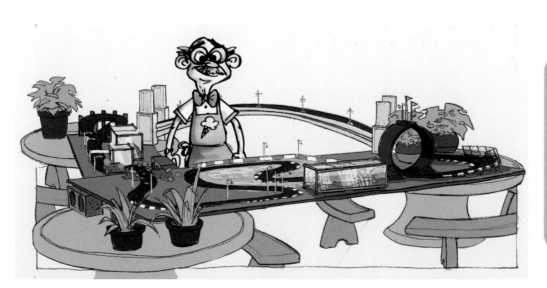

Peter Maynez & David Soren

"Tito's a bit of a showman, so he cuts this knife switch, and the hydraulic lift lowers down to reveal this racetrack. It's very dramatic, in line with Tito's personality."

MICHAEL ISAAK,
PRODUCTION DESIGNER

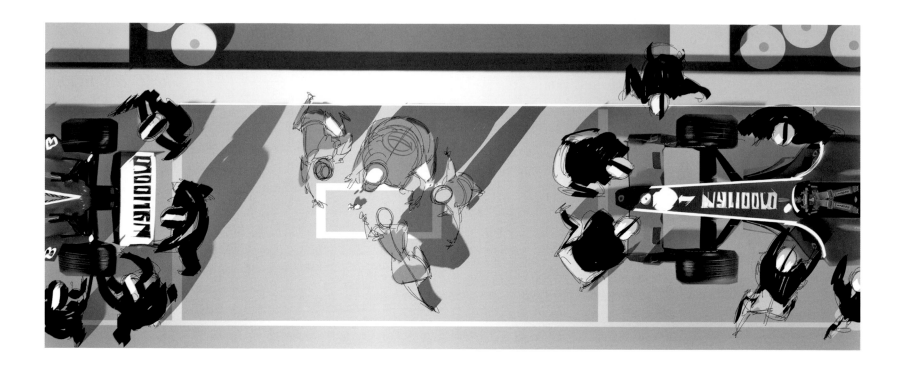

INDIANAPOLIS MOTOR SPEEDWAY

When Turbo, Tito, and the gang reach the century-old Indianapolis Motor Speedway to enter Turbo into the prestigious Indy 500 competition, it's as if the grandness of our hero's dreams have now been matched by the physicality of racing's premiere venue. "It's hugely emotional for him to see it in the flesh for the first time," says director David Soren.

Early discussions about whether the climactic race should be fictional ultimately led Soren to believe that if the movie was going to have a realistic edge, re-creating the Indy 500 was the way to go. "The obstacles seemed greater, the stakes seemed higher, and it just seemed more specific," says Soren.

Several key production members traveled to Indianapolis to see the Speedway, absorb its scale and breadth, study its makeup, and take in a race. Getting to stand on the 2½-mile track—a rectanglish oval that could house Vatican City, Wimbledon, the Kentucky Derby, Yankee Stadium, and the Rose Bowl, with acres to spare—was a daunting privilege for the *Turbo* team. "When you look out, you can't see beyond the track," says Soren. "The horizon is the track. You feel like you're on another planet."

It's also an advertising-free zone that, when empty, can feel like "an abandoned fairground," says visual effects supervisor Sean Phillips. "You realize that it's race teams that bring color and vibrancy to the place."

Production designer Michael Isaak realized early on that though essential physical elements about the Speedway couldn't change, some creative liberties could be taken. As the taco truck makes its first turn into the Speedway, for instance, and parks, those intimately familiar with the grounds may notice markers from entrances as much as half a mile away from each other. "I cherry-picked different elements I liked in order to get the most bold and dramatic entrances they could possibly have, which didn't exist in any one entrance," says Isaak. "It's sort of like the best of Indy entrances."

Also, the actual grandstands are raked in such a way that audiences can see the drivers, but drivers looking up from the track can't get a full view of the crowd. That inspired Isaak to scale everything in the Y axis up by 20 percent so that track-level shots looking upward, which would in reality show a flat plane of spectators, now revealed a stadium-tiered tower of crowds. "When Turbo is racing around the track, I wanted it to look like the Roman Coliseum, like there was a wall of people around him," says Isaak.

(above) Marcos Mateu-Mestre, (opposite, top and bottom) Dominique R. Louis

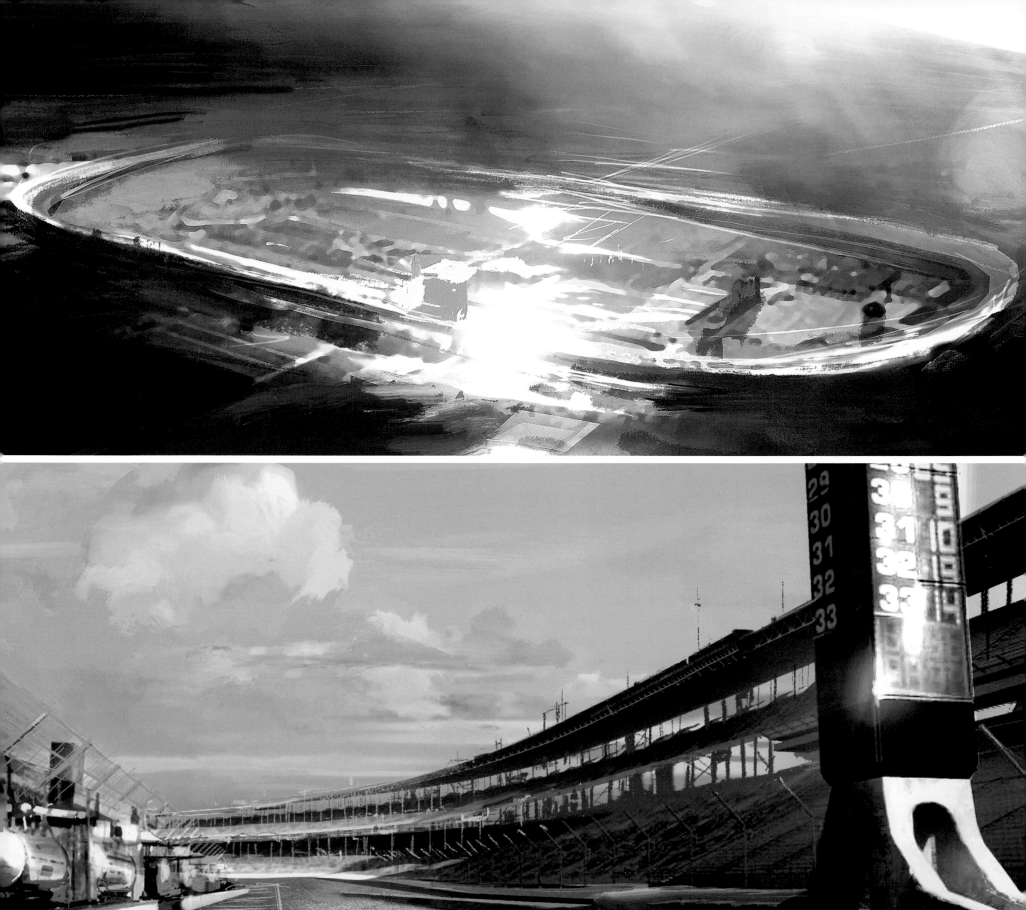

GAGNÉ'S GARAGE

ALONE ONE NIGHT IN Gasoline Alley, Turbo happens upon the garage of his hero, Guy Gagné. It's another moment of triumph, getting to bask in the racer's trophies, Indy car, and overall Guy-ness.

Aware that this would be the third garage to be rendered, production designer Michael Isaak wanted this final carport to be as distinct from the house garage and autobody shop as possible. "This is the spit-and-polished garage, everything brand-new and right off the assembly line," says Isaak. "It's Guy's shrine to himself. It's black and red because those are the two colors of Adrenalode, the brand he's identified with, and silver, the color of the winning trophy."

This is also the scene where Turbo's hero falls in his eyes, as Guy does a 180 from being the friendly sportsman of earlier in the day to the patronizing, vaguely threatening egotist who unceremoniously flicks Turbo out of his space. "Originally we lit it so you could see everything . . . the trophies, the car. But then we found that when you want to make the audience feel like they're not supposed to be somewhere, you have to take away light and darken areas. So we lit it to be uninviting."

(left) Vy Trinh, (top) Marcos Mateu-Mestre

(middle) Mike Hernandez, (above) Marcos Mateu-Mestre

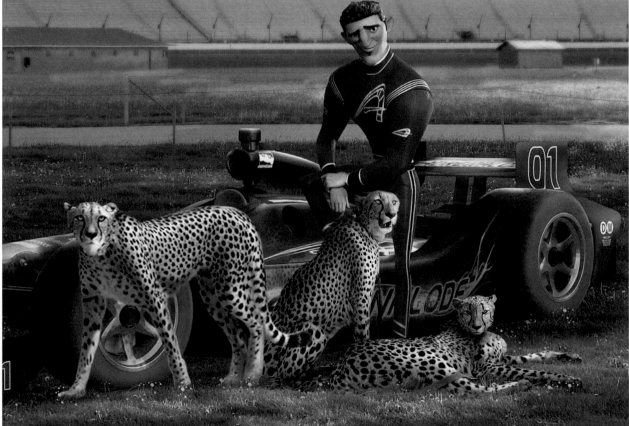

The Valley Review

SUNDAY, MAY 25, 2011 • THIS IS A NEWSPAPER • $1.50

GUY GAGNE WINS FIFTH INDIANAPOLIS 500

YES GUY CAN!

Guy Gagne celebrates his historic fifth Indianapolis 500 win after what many race fans are calling one of the most entertaining sports events ever.

NP

BY TAKAO NOGUCHI

INDIANAPOLIS - Lorem ipsum dolor sit amet, consectetuer Nam liber tempor cum soluta nobis eleifend option congue nihil im-

Ut wisi enim ad minim veniam, quis nostrud exerci tation ullamcorper suscipit lobortis nisl ut aliquip ex ea commodo consequat. Duis autem vel eum iriure dolor in hendrerit in vulputate velit esse

CONTINUED ON **PAGE 2**

(top) Mike Hernandez, (above) Richard Daskas Craig Church

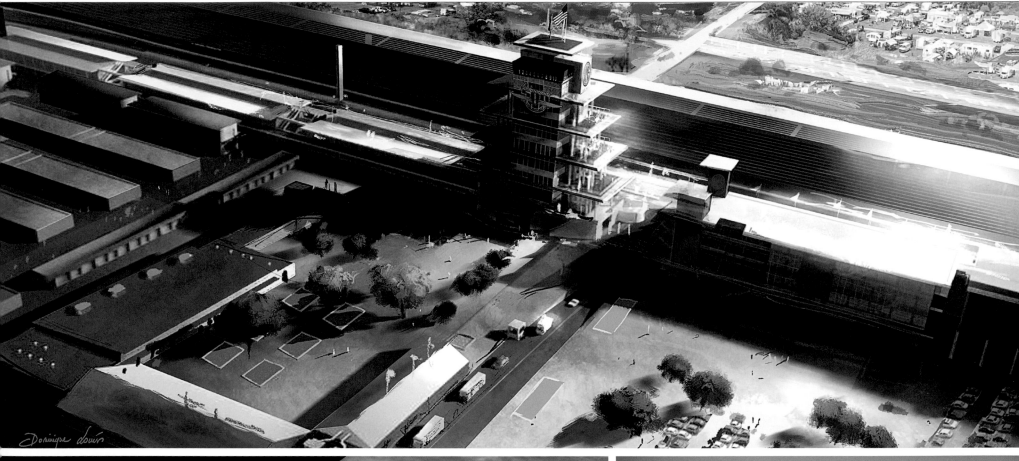

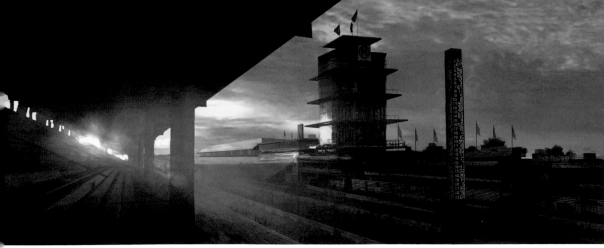

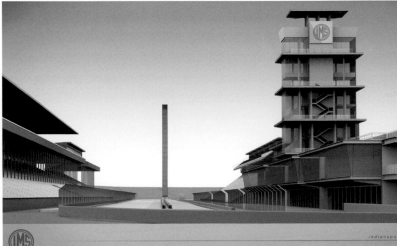

(top and above) Dominique R. Louis

Michael Isaak

PAGODA

ONE OF THE SPEEDWAY'S most recognizable buildings is the Pagoda, named for its resemblance to the stacked structures visible throughout Asia. As an icon of the Indy establishment, it proved helpful as a marker for audiences to orient themselves as the movie cuts from the race to the announcer's booth, the VIP seats, or the media center. The unifying visual element was the Pagoda's distinctive green glass.

"What we did was have that green glass on at least one side of every single one of those Indy-specific environments," says Isaak. "The light pouring through that green glass will be a cue to the audience that they're inside the Indy establishment."

Head of layout Chris Stover points out that camera movements inside the Pagoda harken back to the gentler, steadier way the tomato plant was filmed. "You're in the safest part of the track," says Stover. "So it calls back the more controlled camera work we'd done in the first act, bringing those things forward into the third act."

Michael Isaak

Brett Nystul

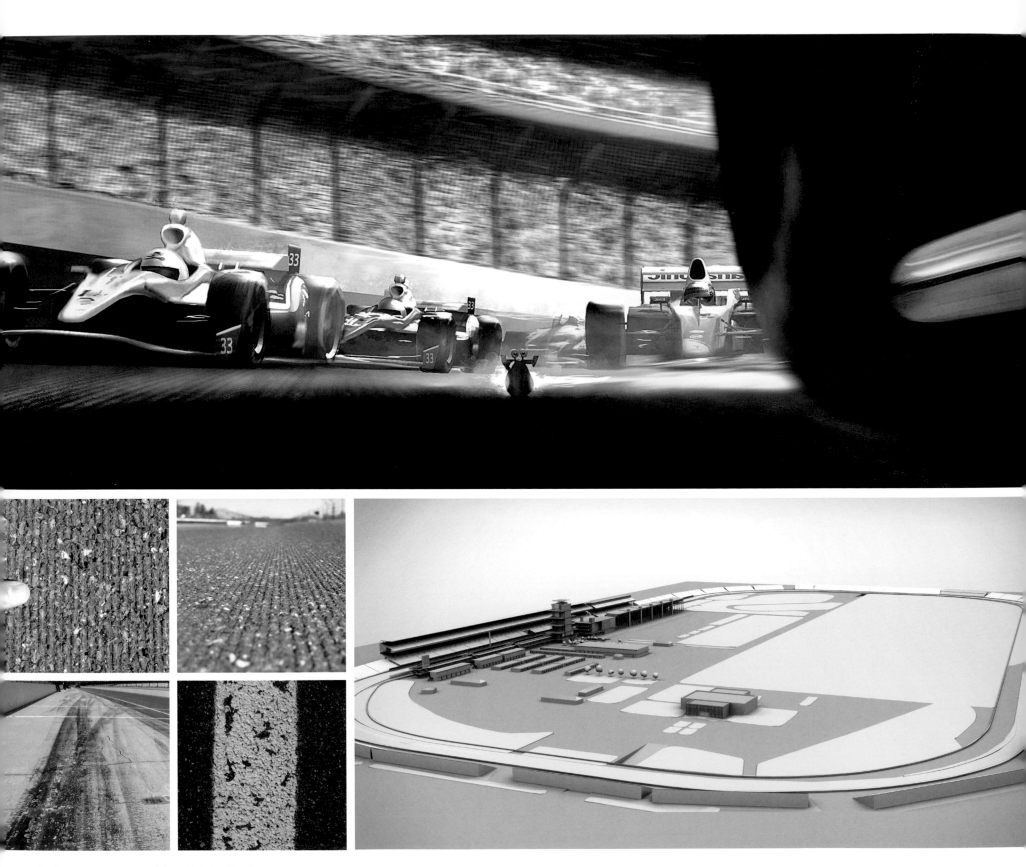

(top) Dominique R. Louis, (above) Michael Isaak

RACETRACK

With **"Start your engines!"** Turbo begins the greatest, scariest, most thrilling moment of his life: racing in the Indy 500. The production team felt the same way, in a sense, in that re-creating this hallowed auto competition required extra reserves of skill, perseverance, and ingenuity.

When production designer Michael Isaak was inspecting the real Indy racetrack, the task at hand was apparent: view the 2½ miles of racing road as Turbo would. "All of the road surfaces Turbo experiences before then are ratty and patchy, but this is immaculate," says Isaak. "Turbo gets to go fast in the first act, but it's always sort of bumpy. But this surface is like ice."

The race itself had to be approached as its own narrative within the movie. "It's almost like a second movie inside the movie," says head of story Ennio Torresan. "As soon as that green flag drops, it's another story. We bring all the stuff that happened before to Turbo to this moment, and we're with him now."

David Soren describes a situation in which the tables have turned on Turbo's and Chet's relationship, when Turbo—originally the outcast—is the one in his element, while Chet wonders if his nightmare of worrying for his brother's safety will ever end. "There's incredible tension starting to build between the two brothers as we wonder, 'How far is Turbo really going to be able to take this?'"

Creating a race from scratch wasn't easy and required lots of story-boarding and reboarding to get the right amount of suspense and drama for what is essentially a journey in circles. One atmospheric alteration to the reality of the Indy 500 race was suggested by cinematographic consultant Wally Pfister. "The race is at twelve o'clock, so it's flat light and not interesting," says art director Richard Daskas. "Wally says he never shoots at a time like that, so he suggested we keep the sun really low in the sky so you get long shadows. We then have clouds roll in and out, so big shadows go across the track."

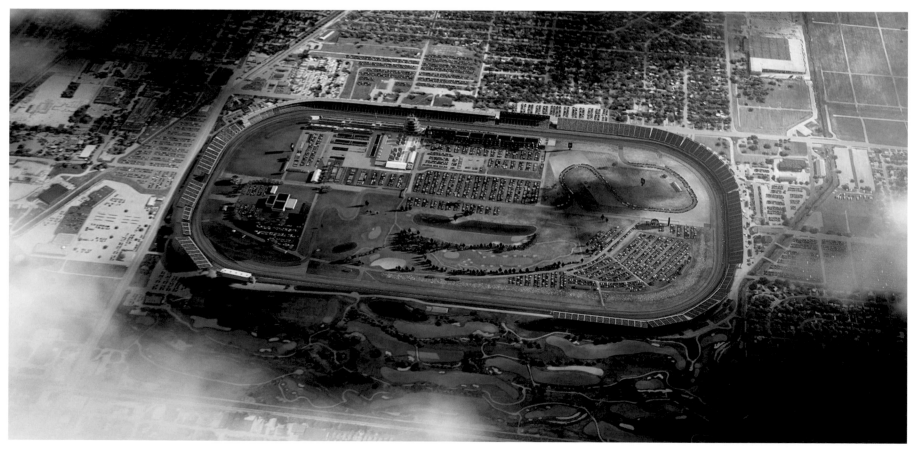

Production Still

Dominique R. Louis

What proved particularly invaluable was bringing in three-time Indy 500 winner Dario Franchitti as a consultant. He spent hours with the rough layout/previz and animation teams, clueing them in to when drivers pull back, when they pull forward, who has the white line, what causes a car to go into a wall, and myriad other racing situations. That way, if the time of the race was going to change, at least what the drivers on the ground go through—save the experiences of one souped-up snail—matched acknowledged reality. "He helped make all the racing authentic," says Soren.

One such detail proved especially beneficial in crafting a race with a 2-inch-high competitor. Marbles are small, rounded bits of rubber debris that fly off tires during a race and accumulate on the side of the track, forming a natural hazard. Cars that go "into the marbles" can lose their traction, fishtail, and spin out. "You can barely see the marbles when you're at one of these races, unless you're up close," says Soren. "But Turbo is up close. He's in that stuff, so it seemed like a great obstacle to use in the race."

Turbo's vantage point in general proved to be a superior opportunity for rendering a race like no other. "In animation, getting a camera 2 inches off the ground is possible, whereas with live action it'd be very difficult," says head of layout Chris Stover. "Even then, it was still difficult, because of motion blur when cars are going at over 200 miles per hour. To make the marbles readable, for instance, we'd need to slow stuff down. But when you're down that low, you get a perspective most people don't get to see: what it's like to be between two tires. It feels like ten-story buildings on either side of you. And these drivers get as close as they can without rubbing. So the danger level for Turbo is high."

Software was created, as well, to help facilitate the racetrack sequence. The DreamWorks research and development department partnered with Autodesk to build a system that allowed Stover's team to lock down the cars and Turbo to the track, embankments and all—imagine a plane that could rotate around a central vertical line—and keep them easily controlled through animation and any revisions. Adds Stover, "If David wants something changed from turn four to turn one, you grab the master controller, move it all to turn one, and then if we need to make any adjustments, we can do that on a per-car basis. But the system kept all our cars stuck to the track, so we didn't have to worry about cars or Turbo interpenetrating the track. It was a piece of technology that allowed us to get this race made and be as revision-heavy as we've been. Without it, we'd have been beating our heads against the wall."

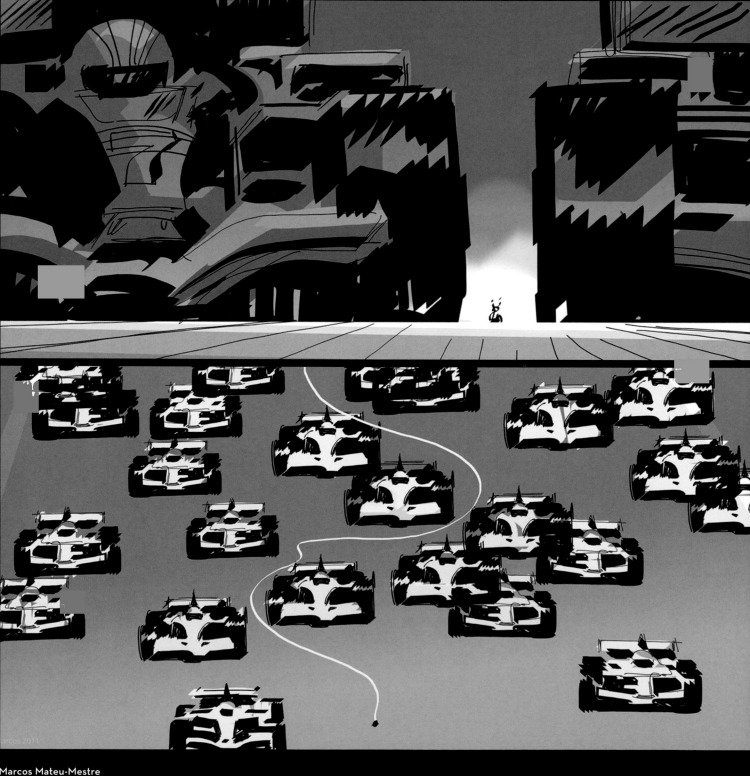

Marcos Mateu-Mestre

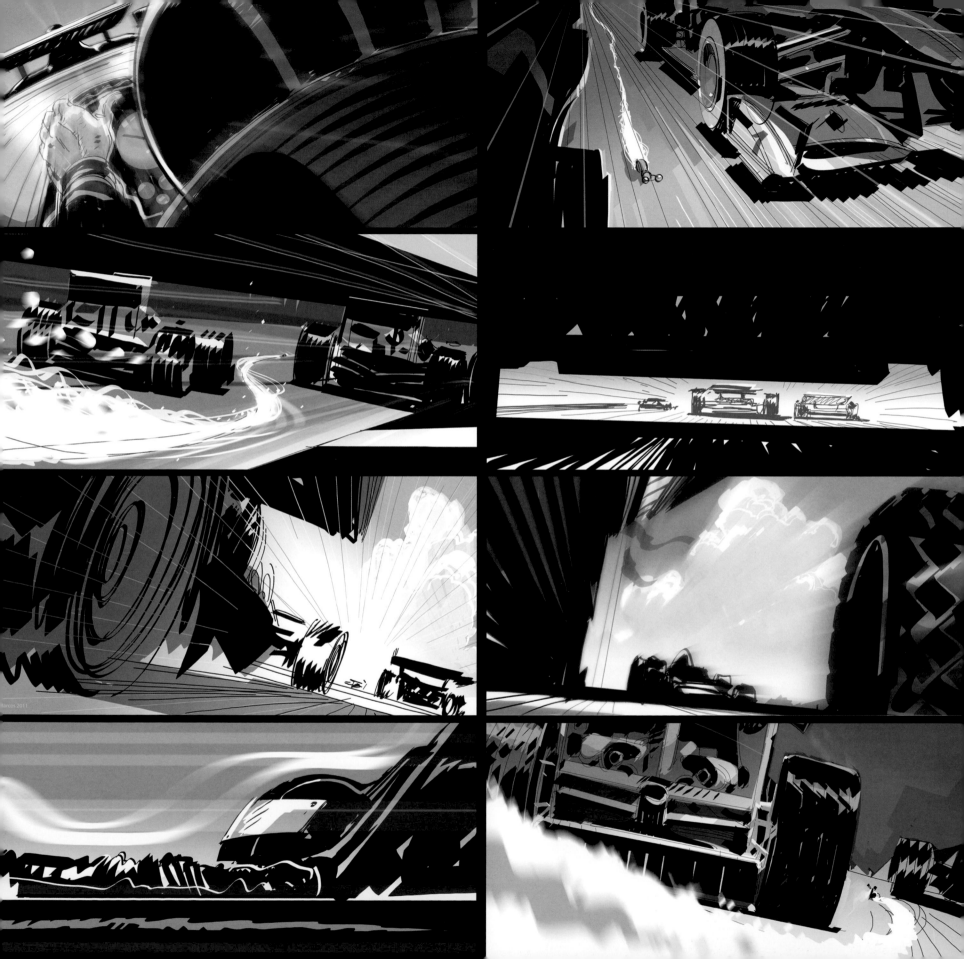

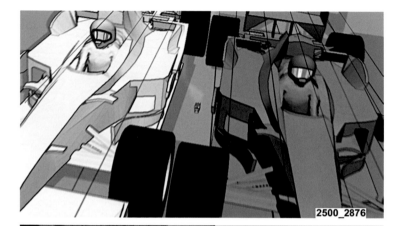

2500_2876

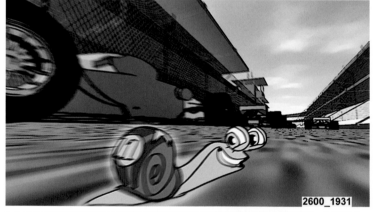

2600_1931

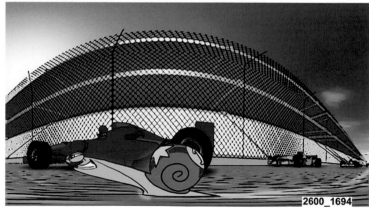

2600_1694

Nassos Vakalis

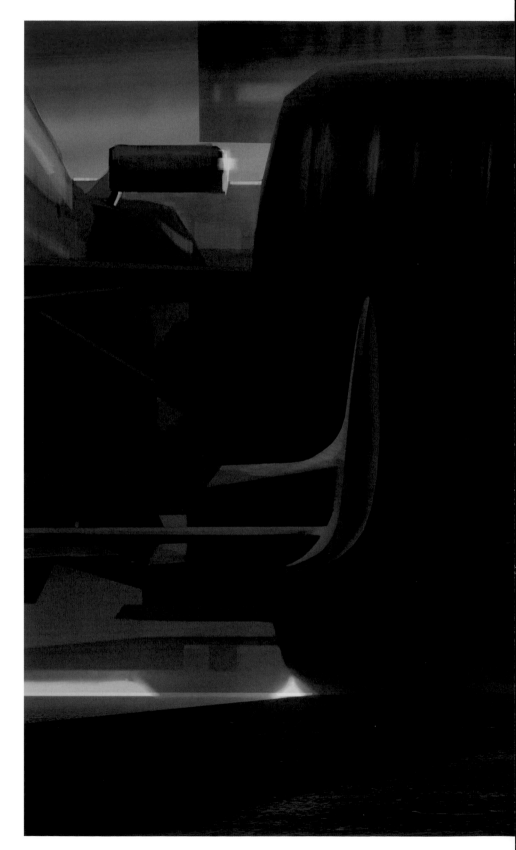

Marcos Mateu-Mestre – drawing & Mike Hernandez – painting

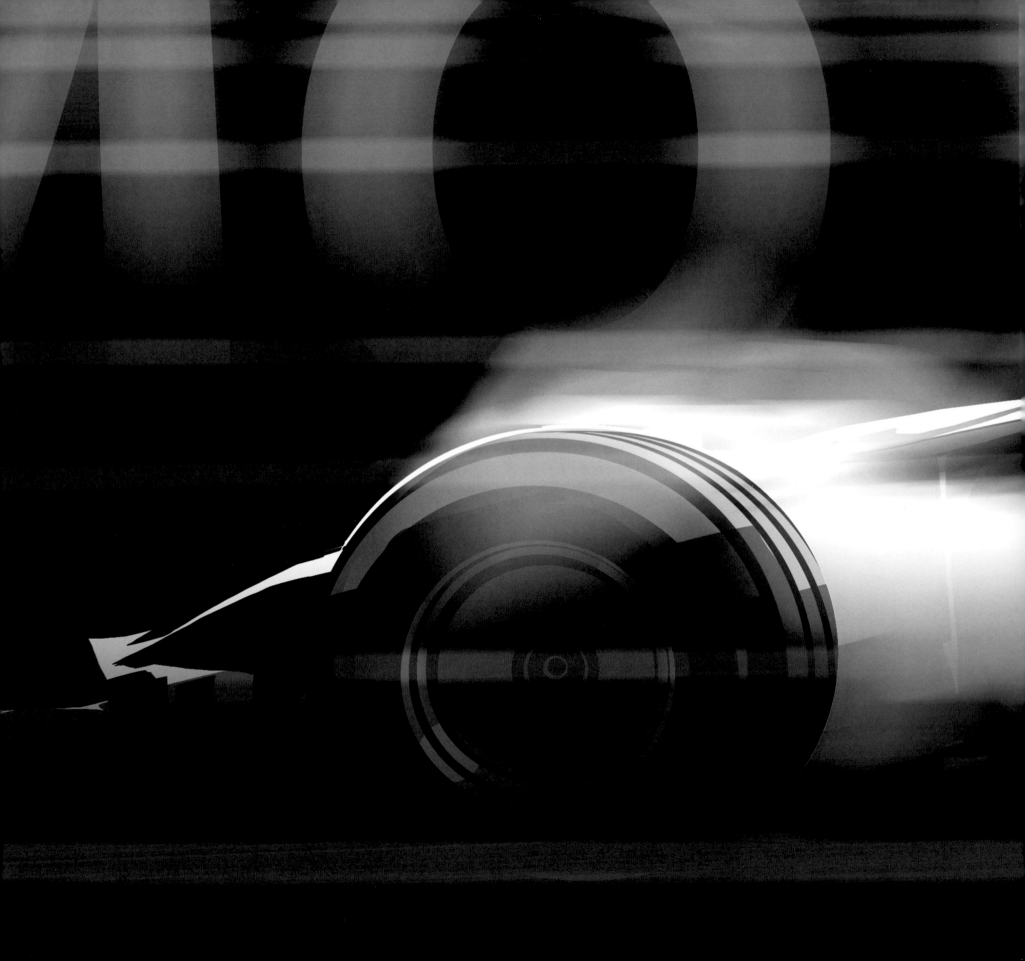

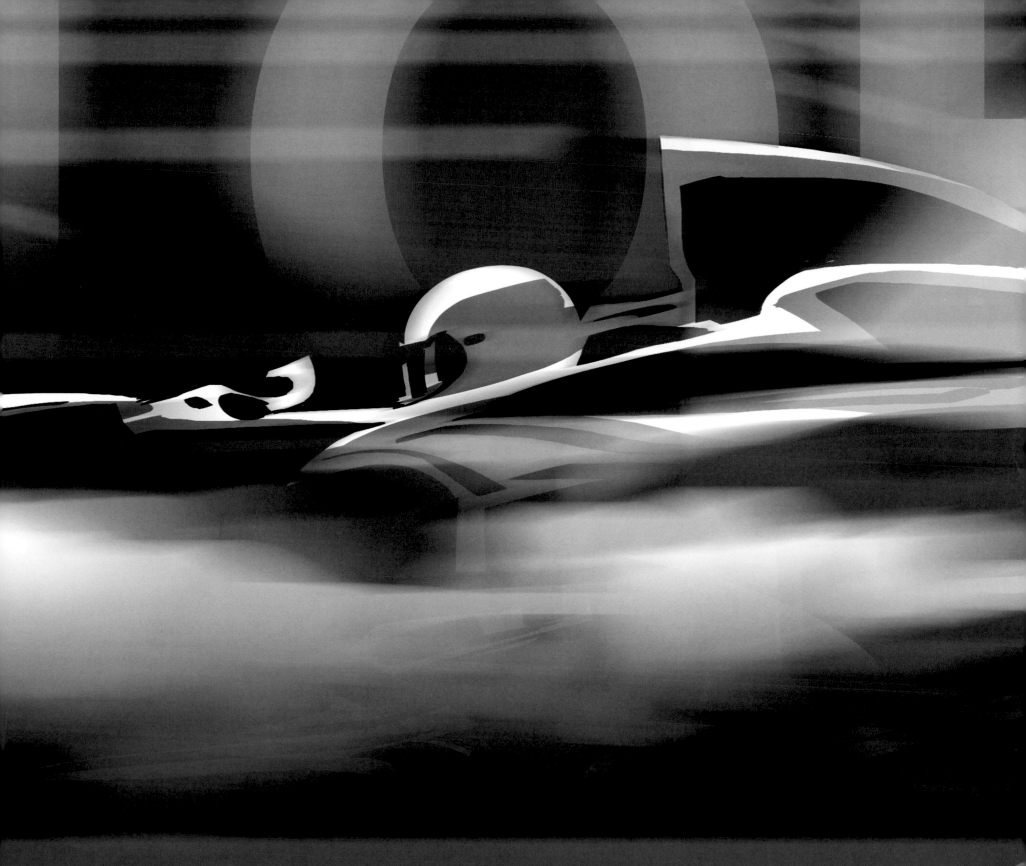

VEHICLES

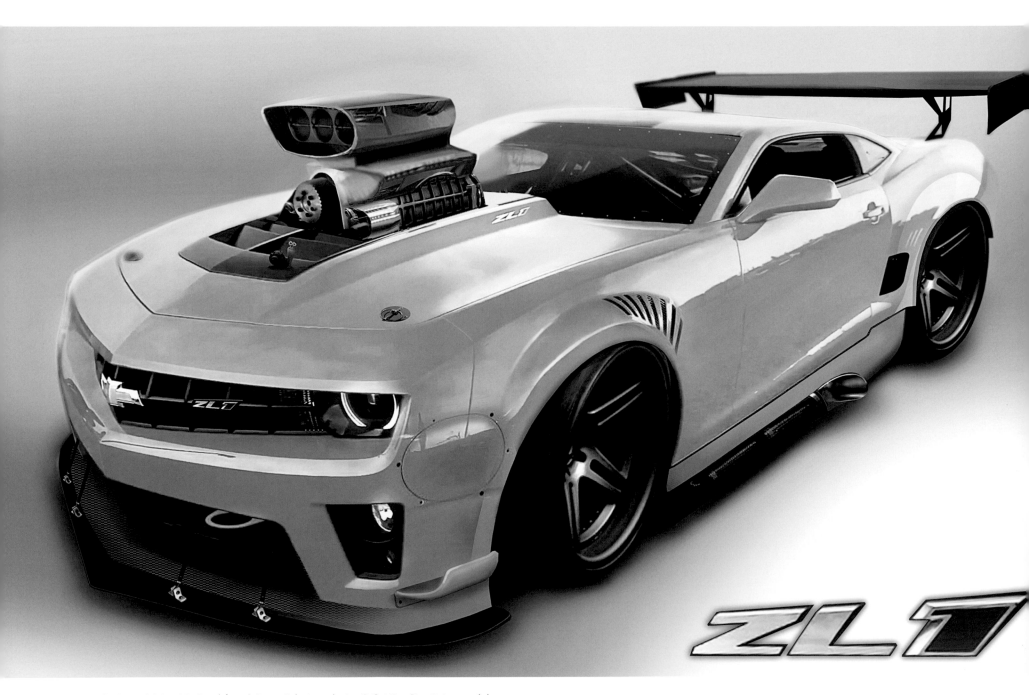

(pages 118–119) Marcos Mateu-Mestre, (above) Jason Scheier – design & Cristian Dumitriu – model

Jason Scheier

MUSCLE CARS

When the wind from a passing semi knocks a downhearted Turbo off an overpass and down into the Los Angeles River, he lands on the hood of a tricked-out, engine-on-the-outside Camaro on the cusp of peeling off in a drag race alongside a similarly souped-up import racer. When the flag drops, Turbo experiences what he's dreamed of his whole life: coursing, exhilarating speed.

For Turbo's maiden voyage at law-breaking velocity, artists and animators were initially inspired by the over-the-top thrill of the *Fast and the Furious* movies as a way to lock into Turbo's state of mind. Paying homage to Los Angeles street racers meant designing cars that captured the aftermarket bravado of this underground culture, where neither the people nor the surroundings are the focus, and the cars are the star. Artists Jason Shire, a racer himself, and Todd Gibbs threw themselves into the task.

"We didn't want it to look like a new-car commercial," says production designer Michael Isaak. "It had to look like people on the street bought a car on the lot, then personalized it, so you'll see specialty fins on the back, specialty steering wheels, all that stuff."

The final designed Camaro exists as a classic big American muscle car with an ominous hood scoop and forbidding air intake valve. The Japanese import that it races against is smaller, but boasts a heightened spoiler and aftermarket paint job with graphics, plus lights underneath.

Animation brought a touch of comedy to Turbo's hood ride by exaggeratedly rippling his flesh to show the effects of wind and speed, a bit that parodied a piece of footage from a television car show, in which the host's cheeks—as he traveled in an open-carriage sports car at top speed—contort to an almost cartoonish extent.

"We wanted to tap into that feeling that these vehicles are these street racers' lives, that they've personalized them, and it's where they get their thrills. Everything's dirty, rusty, and spray-painted, except for the cars, and it's exhilarating."

MICHAEL ISAAK,
PRODUCTION DESIGNER

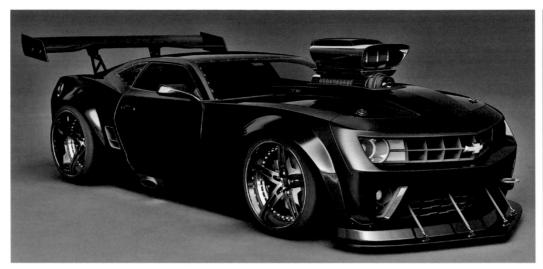

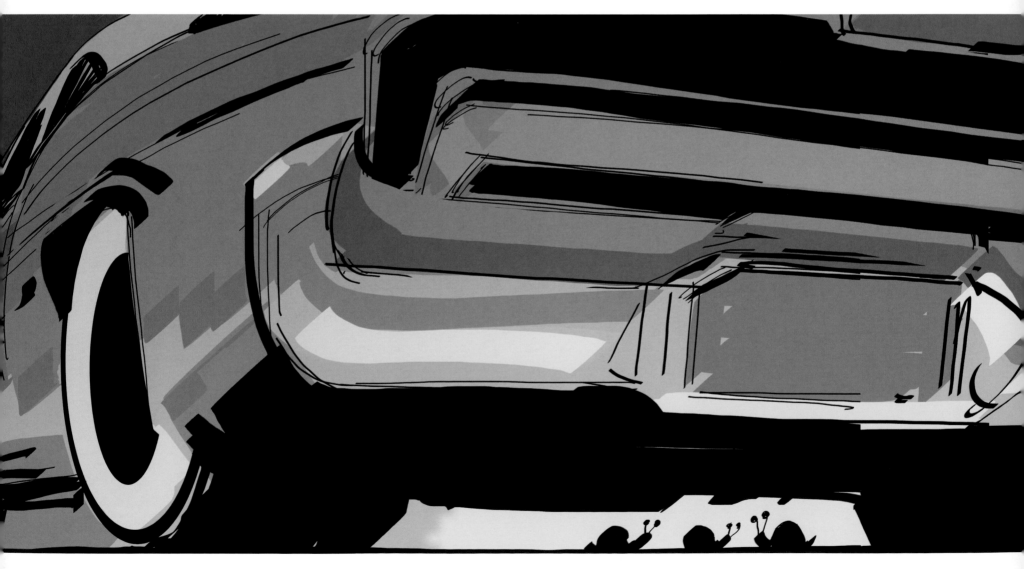

(top left) Jason Scheier and Cristian Dumitriu, (top right) Dominique R. Louis, (above) Marcos Mateu-Mestre

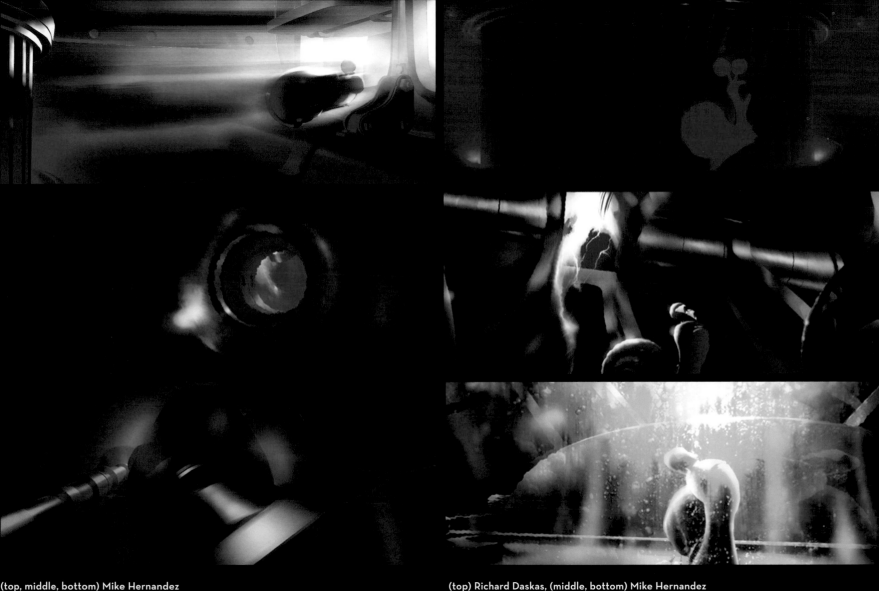

(top, middle, bottom) Mike Hernandez

(top) Richard Daskas, (middle, bottom) Mike Hernandez

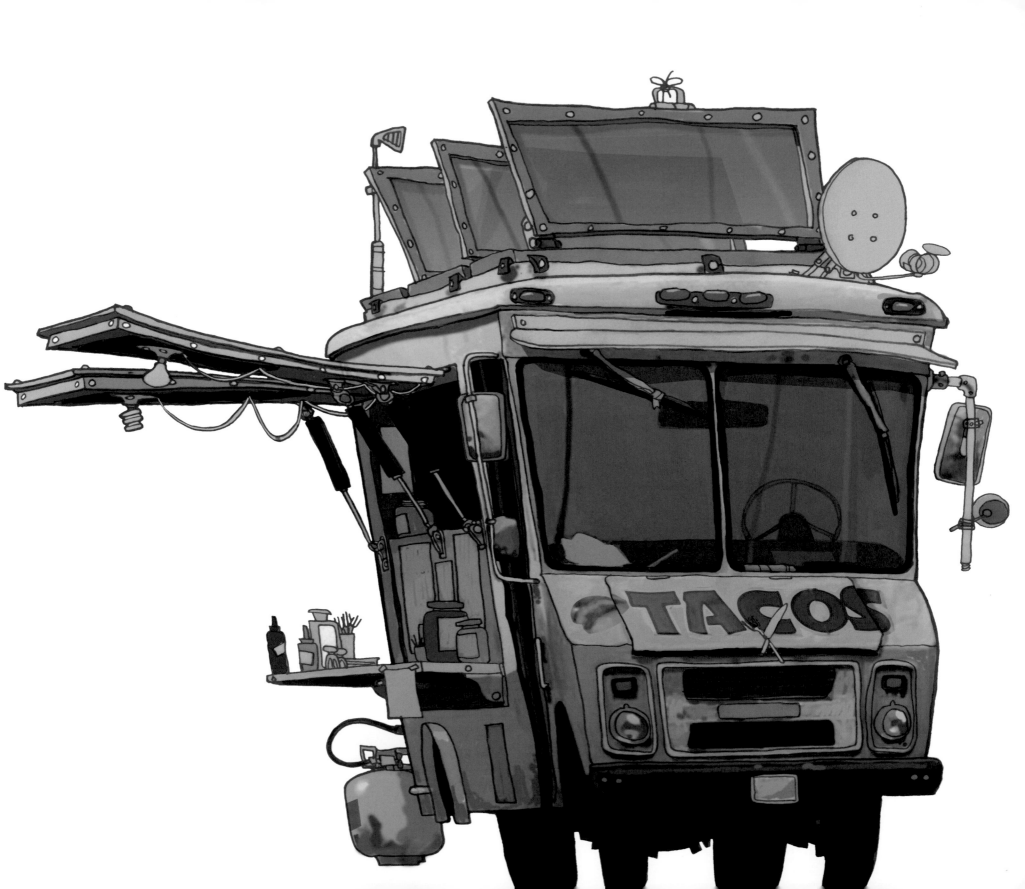

TACO TRUCK

Although food vans have become a hipster cuisine craze in Los Angeles, the taco truck Tito motors around in hails from an earlier time, when such vehicles symbolized cheap meals for laborers. Production designer Michael Isaak studied eighties-era models and talked to food truck manufacturers before coming up with his bucket-of-bolts version, and used an image of it next to a race car in an early pitch to director David Soren about his design aesthetic for *Turbo*.

When it came to the Dos Bros Tacos logo, Isaak also wanted his artists to keep in mind the pride of ownership of the struggling shopkeepers. He adds, "We didn't type something in a word processor and project it. We had our artists handwrite everything, then surfaced that onto the side of the truck. I wanted to see the brushstrokes, the craftsmanship."

Roy Santua

Vy Trinh

(opposite) Michael Isaak, (above) Michael Isaak

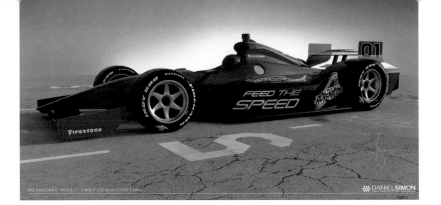

INDY CARS

Early designs for the open-wheel, single-seat Indy cars that would compete alongside Turbo in the climactic third act leaned in a more fantastical direction, but that didn't set well when juxtaposed with the already outlandish story of a snail who can go 200 miles per hour. "They were too spaceship-y," says production designer Michael Isaak. "It got away from embracing the authenticity. The more unrealistic we got, the less you could buy into the idea that a little snail is actually in this race." Besides, the movie's Indy car would essentially be one design resurfaced thirty-two different ways, so the core design was an integral element to the effectiveness of the race sequence.

When INDYCAR design went through some significant changes for 2012—including an even more aerodynamic look and a rear-wheel-hugging body—the opportunity arose to try again. Daniel Simon, who has designed vehicles for *Captain America* and *TRON: Legacy*, was asked to take a crack and came up with a sporty, masculine Indy model that, according to Soren, "even some of the people at INDYCAR were a little jealous of."

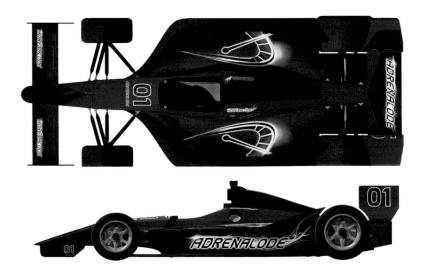

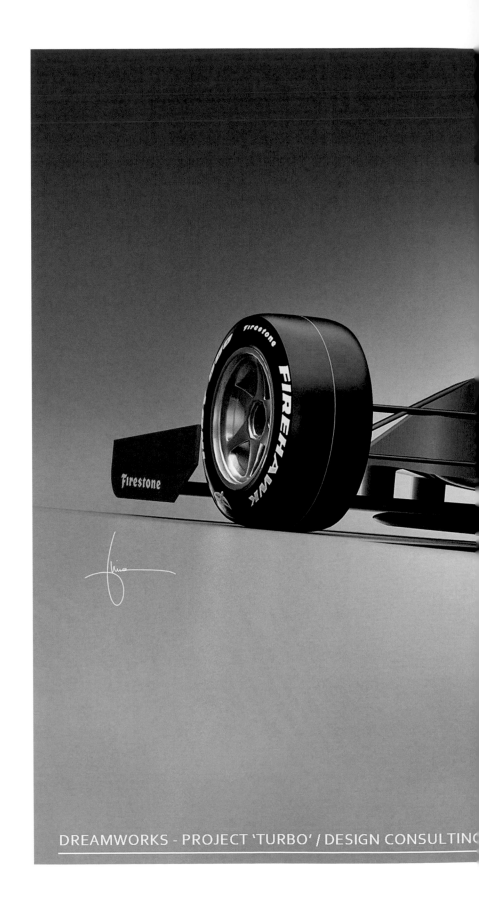

DREAMWORKS - PROJECT 'TURBO' / DESIGN CONSULTING

(opposite) Daniel Simon, (above) Daniel Simon – design & Vy Trinh – graphics

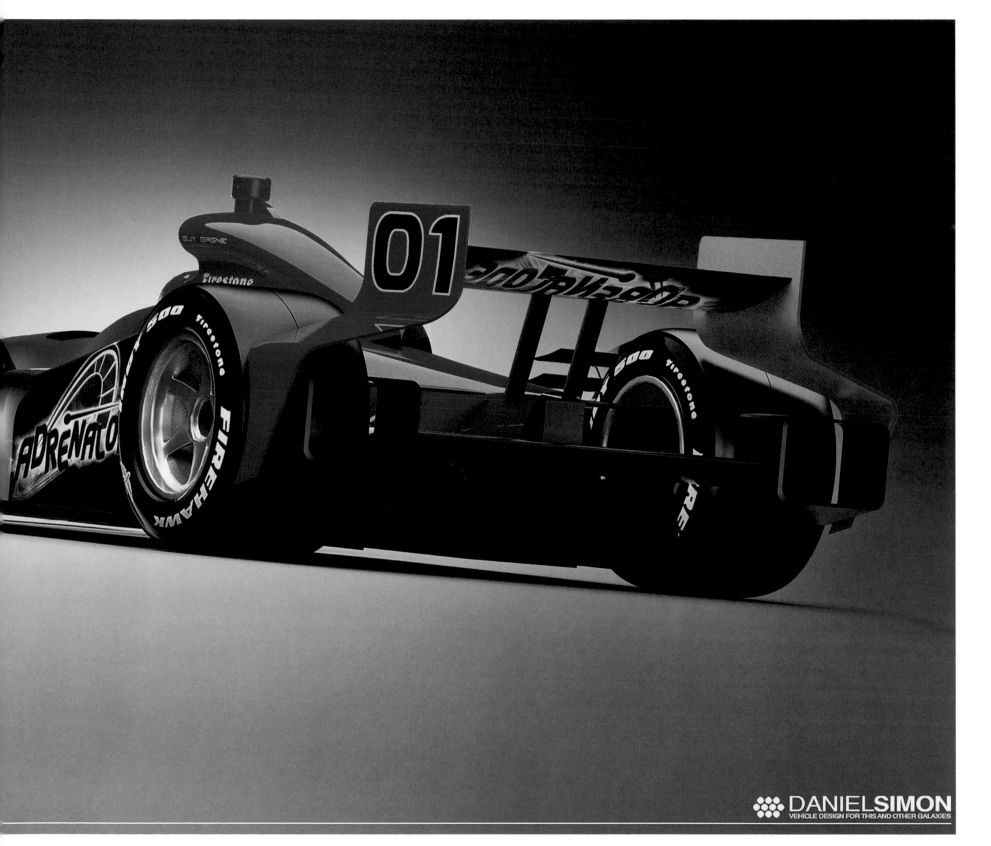

DANIELSIMON
VEHICLE DESIGN FOR THIS AND OTHER GALAXIES

Marcos Mateu-Mestre

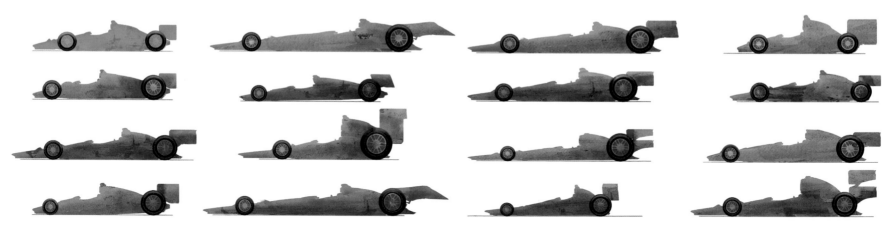

(above) Todd Gibbs, (below) Michael Isaak

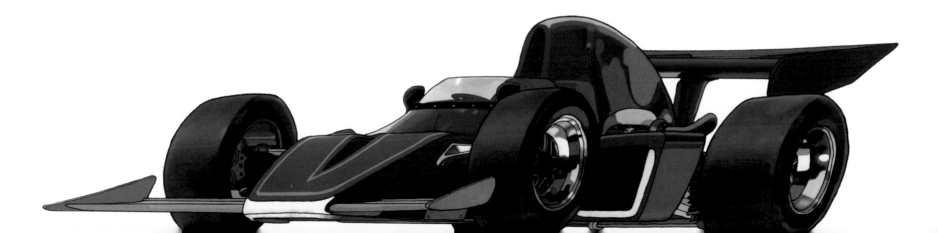

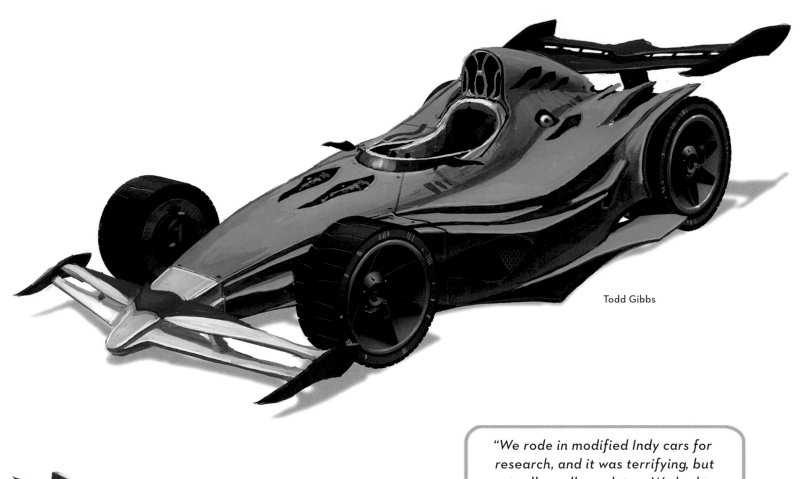

Todd Gibbs

Todd Gibbs

"We rode in modified Indy cars for research, and it was terrifying, but actually really cool, too. We had to convey that intensity."

LISA STEWART, PRODUCER

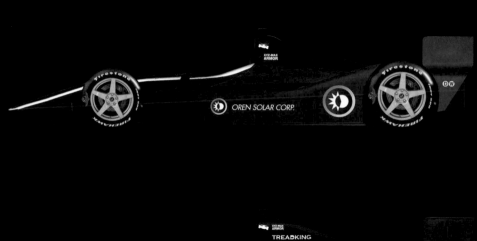
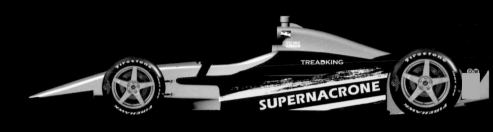
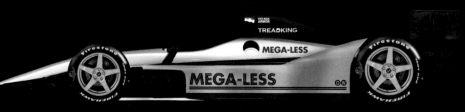
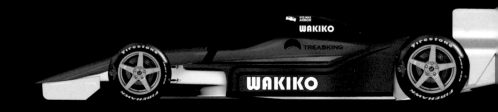
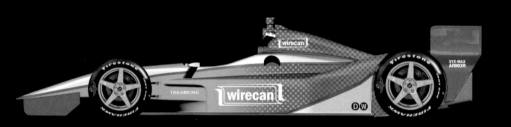
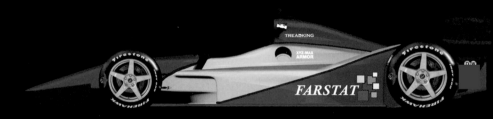
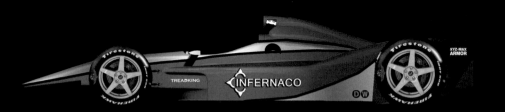
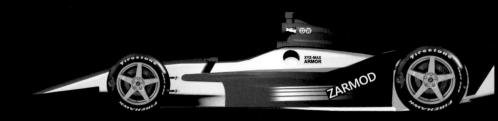
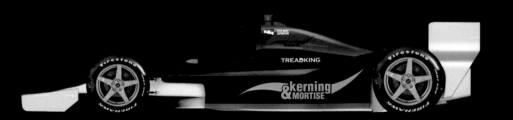
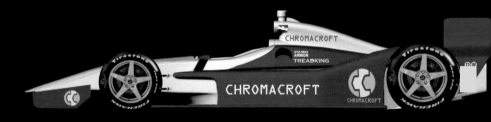

Daniel Simon - design & Vy Trinh - graphics

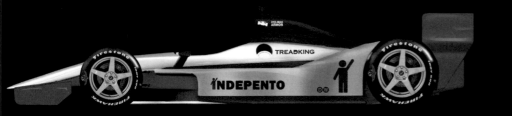

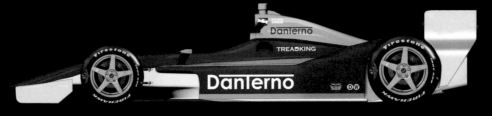

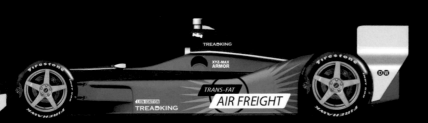

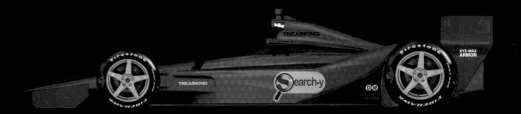

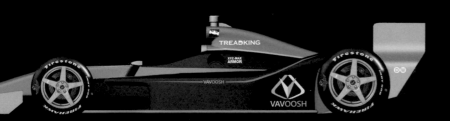

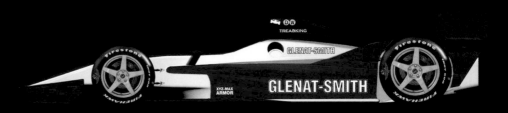

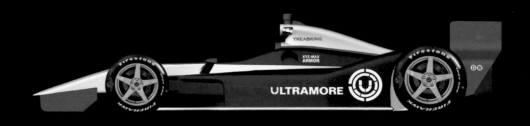

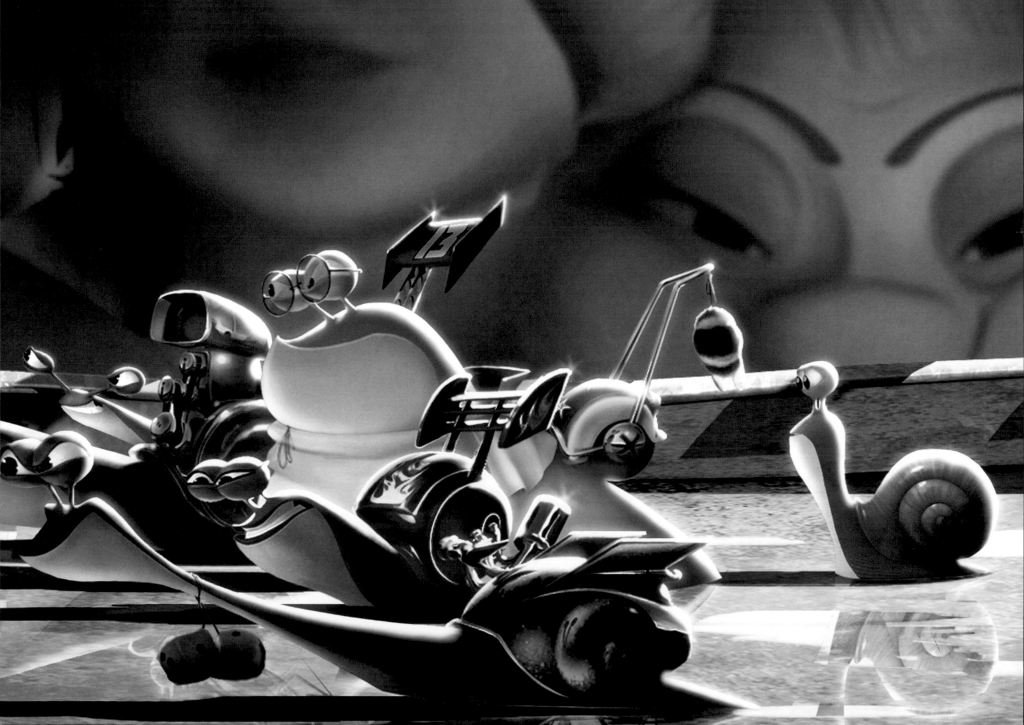

BUILDING A SEQUENCE

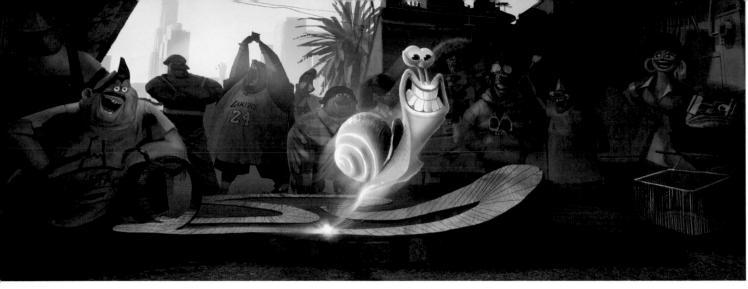

SEQUENCE 950: SNAIL RACE

In *Turbo*, sequence 950 represents a critical act shift. Plucked by Tito from the side of the road and transported by taco truck to the back of an autobody shop, the recently transformed Turbo and his worrywart brother, Chet, wonder what could possibly be in store for them.

"Our first exposure to this place is through their eyes," says director David Soren. "At first they think they're doomed to be eaten or worse. Then they realize they've entered into this snail-racing subculture and are surrounded by tricked-out snails who Turbo thinks are fast just like him. But that's not quite the situation."

To make sequence 950 come to life, the entire *Turbo* team of artists had to work together in an intricate pipeline from visual and story development through layout, animation, and lighting to make sure mood, storytelling twists, character moments, and humor fused into a memorable whole.

"David had something very specific in mind," says production designer Michael Isaak. "This sequence, after all, was where the seed of the idea for the entire movie came from, a gritty, secret racing world."

Turbo and Chet are introduced to a makeshift racetrack cobbled together from assorted bits and pieces, so designing said track was a critical component. "It had to feel strung together," says Soren. "A little bit crazy, and disturbing. The whole thing had to have this unsettling, almost gladiator quality, where they've suddenly been dropped into an arena, and who knows what's going to happen."

Although we haven't been formally introduced yet to the humans surrounding the racing snails, the makeshift track had to reflect the personality of Tito, who in Isaak's mind built it. "You see pans from the kitchen, nail polish bottles from Kim Ly's nail salon, flags that would have been put in drinks," says Isaak. "I wanted it to be a very intimidating location for Turbo and Chet, and also have the everyday craftsmanship of something handmade."

Parallel to the early visual development is storyboarding, which maps out the sequence as a series of roughly drawn pictures that lay out the narrative's key points, from the introduction of the humans and the oddness of the racing snails to Turbo's display of barely controlled speed that

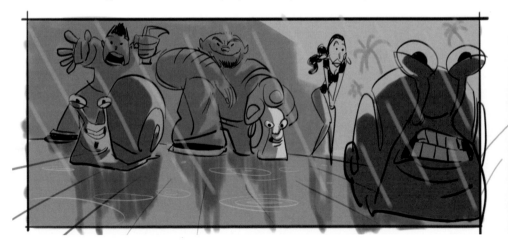

(pages 132–133) Mike Hernandez, (above) Shannon Tindle

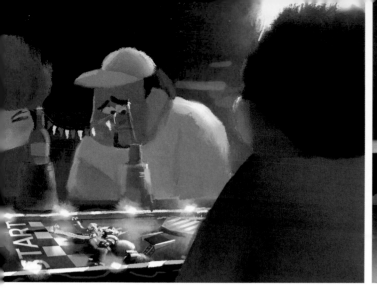

(opposite, left) Tang Heng, (middle and above) Dominique R. Louis

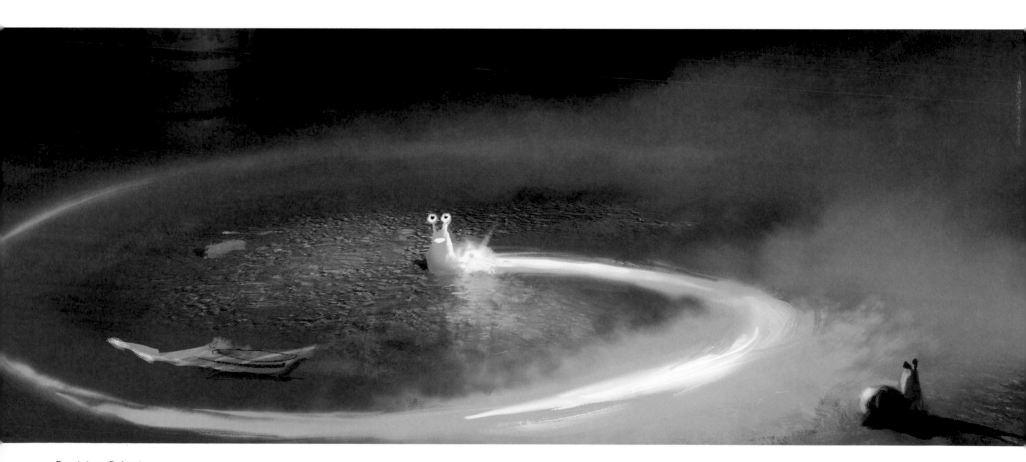

Dominique R. Louis

STORY PANELS

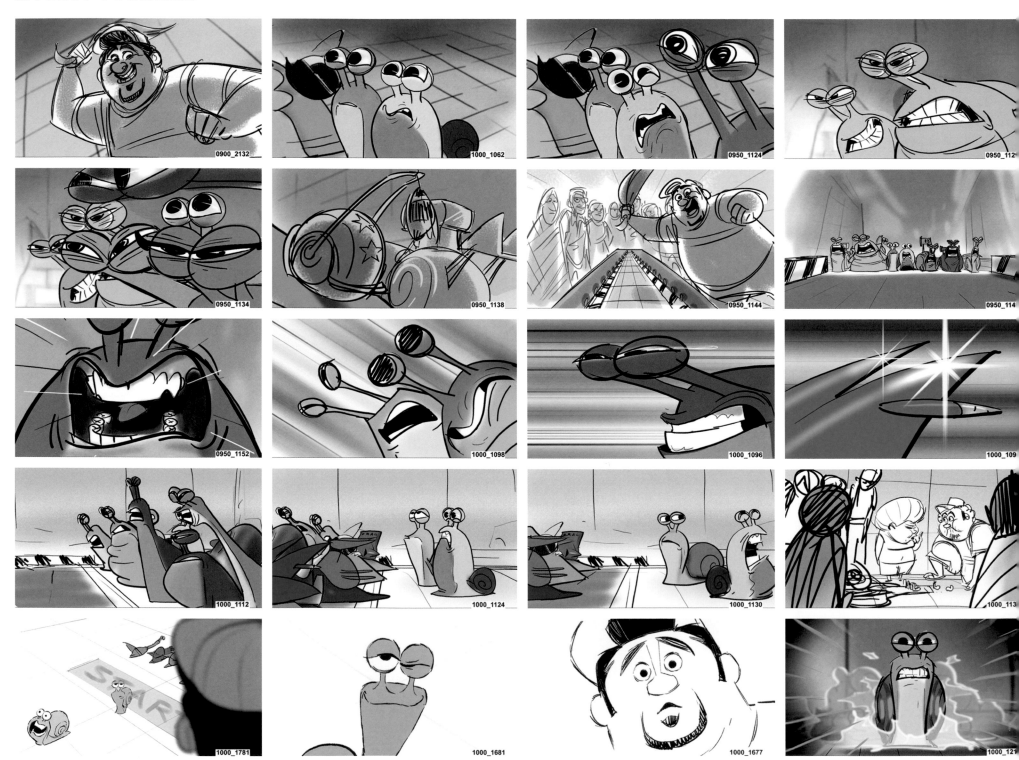

Ennio Torresan, Ken Morrissey & Andy Schuhler

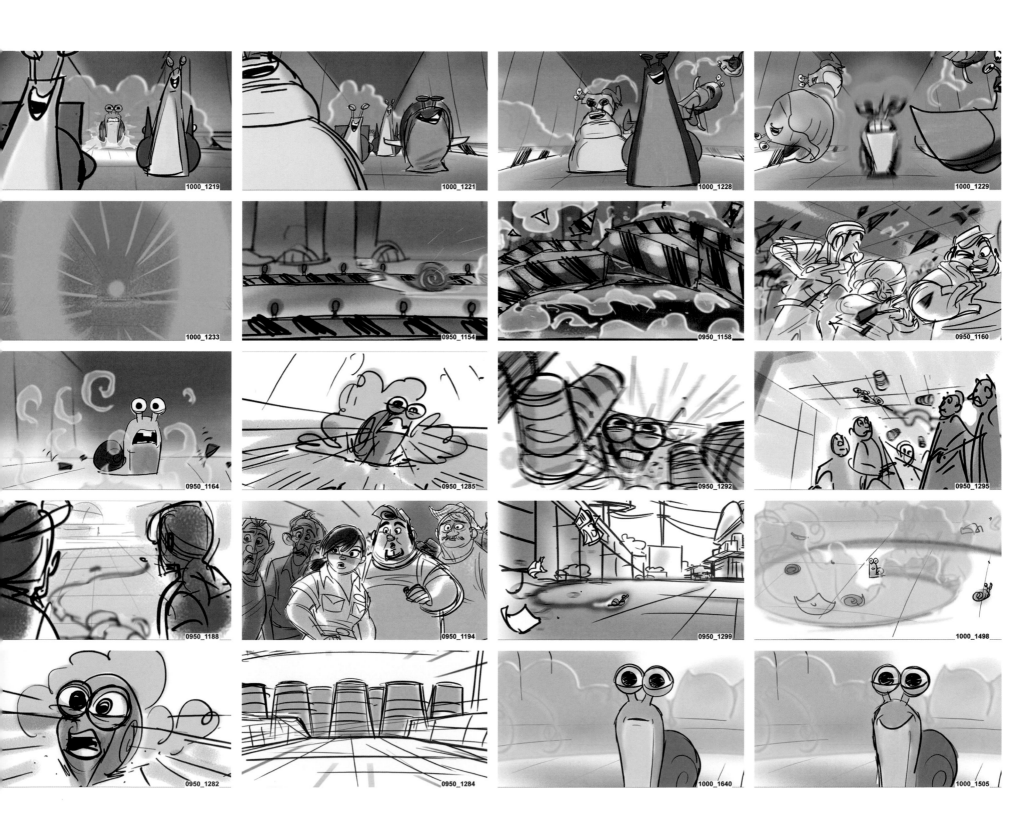

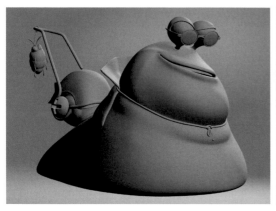
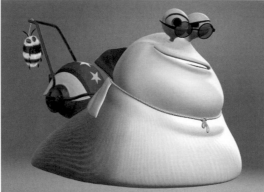
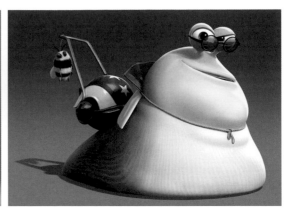

James Stapp & David Burgess | Deepa Agarwal | Lisa Tse

ends the sequence. Head of story Ennio Torresan says *Turbo* was a pretty quick storyboarding process, since Soren had worked so hard already to nail down the story before production got rolling. "He already had the story and structure in his head," says Torresan. "So we found the pieces, the acting, who these characters are. My primary job was to get our story team to find the right cinematography and the right acting, where before there were just ideas floating around."

Central to the sequence is a mislead, one that paints what we later realize is a friendly environment as initially mysterious and vaguely sinister. To that end, it was determined that the snail race should be run in the alley behind Paz's autobody shop. "We wanted to keep it hidden, as if they do this in their spare time in the back, not right in the middle of where she'd be working," says art director Richard Daskas. His department, the first in the pipeline for a movie like *Turbo*, creates the concept art, lighting design, character design, surfacing ideas, and modeling ideas. "The art department has to feed every other department, so we're on first," he says.

In order to give a realistic lighting atmosphere to 950, lighting designer Dominique Louis made dead-of-night field trips to seedy LA back alleys to photograph the orangey security lights behind many businesses. These were then used as reference for color keys that suggest the feeling for the sequence. "Each type of lightbulb has a different temperature," says Isaak, "and that temperature creates a slightly different color. So we balanced the ocher-y orange with a green light that we put against the wall. We went out of our way to replicate a vibe you would get in a place where you really weren't supposed to be."

Once modelers translated designs and drawings into 3D renderings that could be manipulated on a computer—characters, buildings, props, and the like—previz and layout got to work creating a cinematographic roadmap for a sequence. Where storyboarding is by necessity a succession of images, previz and layout bring movement to the process for the first time through camera work and editing. "We're kind of the point where all the art comes together," says head of layout Chris Stover. "We're responsible for shot design, staging, camera work, and we temp in lighting if lighting is part of the story process. We take care of final layout and stereo as well."

An important consideration for Stover's team was finding dynamic ways to introduce the humans and the racing snails. The camera is far

Koji Morihiro, Javier Solsona, Zsoka Barkacs & Ferris Webby

ROUGH LAYOUT

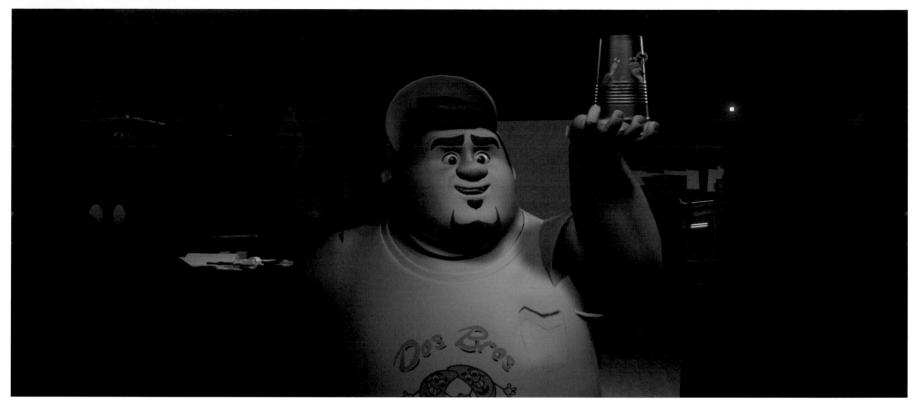

FINAL LAYOUT & ANIMATION

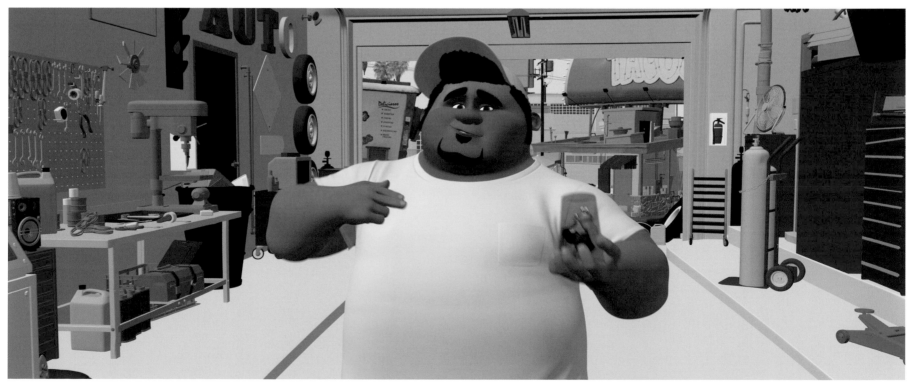

away for the moody silhouetted shot that is the humans' entrance, and when they move in to get a good look at Turbo and Chet trapped underneath their cup, wide lensing was used. Adds Stover, "The human faces are a little distorted, 'cause we're letting them get really close to the camera. It gives the audience a very uneasy feeling."

The racing snails, on the other hand, needed to pop as new characters, so one of the camera moves raked across the front of the lined-up snails as they revved themselves up for the start of the race. "We wanted to show that these characters are a bit eccentric, and they have their own personalities by the way their shells are designed," says Stover. It also helped set up a key punch line, first developed in the storyboards and fine-tuned in layout, that lays bare the reality of the race for these snails. "You're then able to have that shot where you back off everything, cut wide, and see that the snails are not really moving."

When camera choices were locked in, animation stepped up to bring movement, characterization, and individualism to the figures who populate the screen. First, rigs were developed that provided functionality to the animators—the ability to stretch and twist characters in myriad ways. Early on, head of animation David Burgess realized that the rigging developed for gelatinous alien B.O.B. in *Monsters vs Aliens* provided a nice template

for the snail rig requirements on *Turbo*. "In terms of the ability to scale and manipulate different parts of the body and not just translate and rotate, it was really unique," says Burgess. "We have shaper rings down the neck that we can twist to get that fleshy offset. There's a nice shot in 950 where you're pulling around and you see all five of the racing snails revving up, really pumping themselves up. There's so much fleshiness and looseness in that shot—I don't think we could have gotten it if we hadn't built in all these crazy, complicated secondary controls."

Careful consideration was also given to how Turbo shows off his actual speed at the end of the sequence. Says Burgess, "There's some nice suspense built up as he's waiting to show his stuff, but once he kicks into high gear, the track is so short that he completely shreds it. It flies into pieces and he's going too fast to stop. He ends up taking this joyride through the parking lot, and we really wanted to get that sense that he was out of control at the start. By the end of the sequence, he can handle his speed better. When he stops, he actually does it pretty gracefully."

Layout took a final camera pass once performances were locked in, so that the camera could approach what happens in a scene as capturing it, rather than leading the viewer to it. Adds Stover, "If I know a character's going to stand up in the middle of the shot, I want the camera to

react to that. We have a motion capture room where we have multiple camera rigs we can hook up and capture the camera in real time against the animation. Then we watch that through lighting as far as the depth of field and the way the camera feels. We want performances to feel organic, because that always gives you a more natural feel."

When visual effects got involved after animation as well, it was time to add those touches that augment the look, sensibility, and movement of the sequence. They run the gamut from making sure the dice hanging from Smoove Move's neck swing properly to adding a realistic rush of water when Paz douses the track before the snails race to the more fantastical, anime-style streaks of light winging past the racing snails that indicate their subjective view of how fast they think they're going. The newly transformed, 200-miles-per-hour Turbo and his demolishing of the makeshift racetrack also fell under the purview of effects.

Visual effects supervisor Sean Phillips describes the thinking behind what Turbo's super-ability should look like when he's getting ready to show the racing snails and humans what he can do. "We tried to tie into the idea of a dragster doing a burnout," says Phillips, who nixed red tones so it wouldn't look like Turbo was catching fire or morphing into a jet engine. "The spiral on his shell lights up blue to get him going, then smoke starts emanating from under his shell. As he starts to move, this blue light starts emanating out the back of him, and when he starts and stops,

he leaves a sort of blue tire tread for a short distance. As it cools off, it becomes a darker tire tread and evaporates away."

Phillips, an admitted car enthusiast who has worked in visual effects for live action and animation, says the *Turbo* job often felt like goofing off. "I was going through all these car videos for research that I would be enjoying in my free time anyway!"

The visual effects department works heavily with lighting, which is involved to some extent throughout the pipeline in a testing capacity. Final lighting ties everything together by providing the finishing illumination that nails down the mood, which in the case of sequence 950 meant breaking up the sequence into distinctive emotional notes: threatening for the silhouetted appearance of the strip mall owners, humor for the introduction of the racing snails, and finally a kind of star-making entrance when Turbo shows off his speed.

For the racing snails, lighting had to make a sharp turn from the gritty, hazy palette of Los Angeles and the sinister vibe behind the autobody shop. "These snails are purple, green, blue, red, and creamy white, popping bits of color into this otherwise cold environment," says head of lighting Mark Fattibene. "Much of our look comes from light bouncing from one surface onto another—the bright red of a snail's shell onto the gray track. Each bounce of light and spread of color adds to the visual complexity of the image while tying each element to those around it."

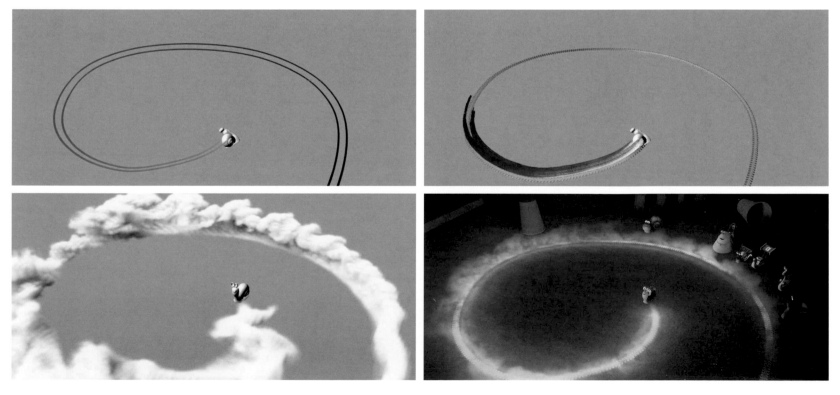

Matt Titus

STORYBOARDS

THE SEQUENCE IS MAPPED OUT WITH ROUGH SKETCHES THAT FORECAST ACTION AND CAMERA ANGLES

LAYOUT

ROUGH ANIMATION MODELS ARE PLACED IN A 3D, CG SPACE

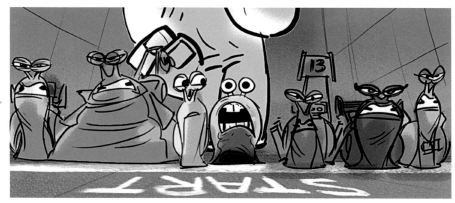

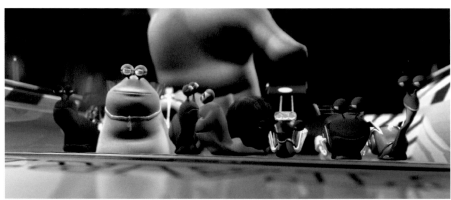

COLOR KEYS

COLOR TONES ARE ASSIGNED TO INFORM THE LIGHTING OF THE SHOT

FINAL FRAMES

SURFACES ARE TEXTURED, FX AND LIGHTING ARE INTEGRATED, AND A FINAL RENDER IS MADE

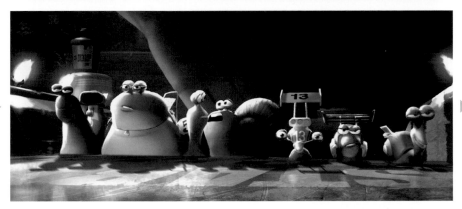
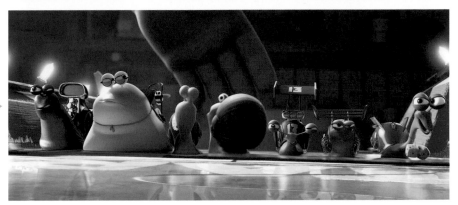

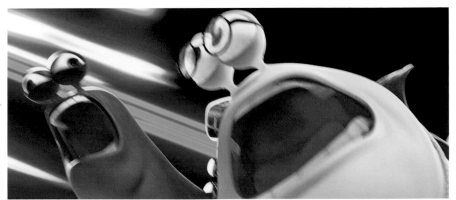
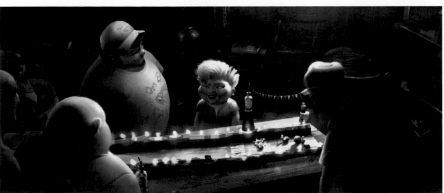
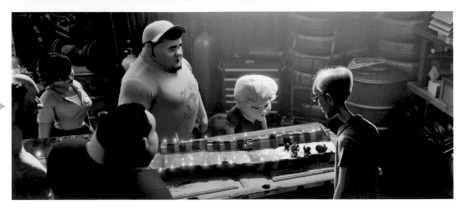

THE FINISH LINE

If a snail can race in the Indianapolis 500, what could you do that you never thought possible? That's what *Turbo* leaves us with, the feeling that if we can dream it, we can make it happen. It also just might help you realize who you really are inside, and what happens when you rev up and take off. It's been just that type of journey of discovery for the DreamWorks Animation crew, which tackled this unusual story and gave it the visionary scope and beating heart necessary to create an original animation adventure.

Turbo may be a dreamer and Chet a realist, but in an oddly enchanting way, this movie suggests that the push and pull of those opposites is what allows both to see their potential fulfilled. It's a dynamic expressed visually, too, with the stylized, graphic freedom of the character work and animation perfectly complementing the painstaking realism of the artists who created the live-action-influenced backdrops and production design. It makes *Turbo* a unique jolt forward in the development of CG animation.

These pages—and the dazzling, imaginative art they contain—give you a sense of that development, the artistic processes that fused together like a beautifully made engine into a work of entertainment that transports us all.

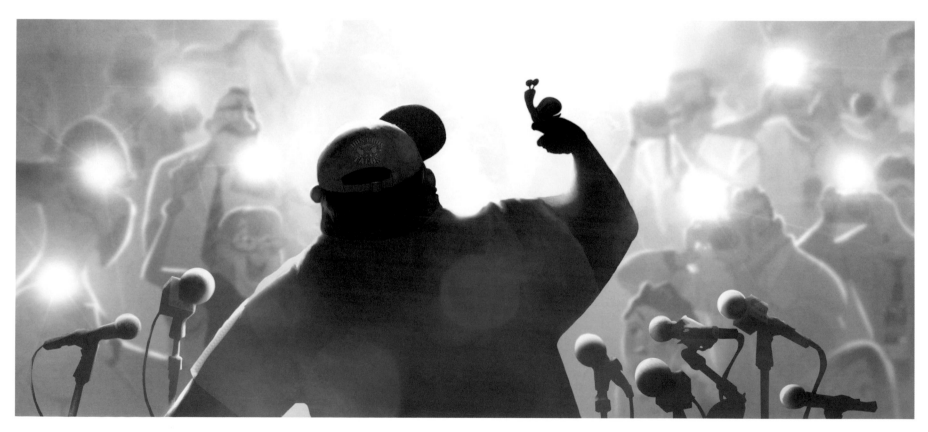

Marcos Mateu-Mestre – drawing & Dominique R. Louis – painting

ACKNOWLEDGMENTS

THE AUTHOR EXPRESSES HIS heartfelt gratitude to the creators and crew of *Turbo*, especially David Soren, Michael Isaak, and Richard Daskas. Everyone took time out of their fifth-gear schedules for the various illuminating and informative pit stops required to make this book happen. Their talent, hard work, and generosity are the engine of this project. Special thanks also to the mapping and navigating efforts of Kristy Cox, who with her fast-paced team at DreamWorks, including Karen Hoffman, facilitated a most helpful course to completion.

At Insight Editions, which put together a gleaming, beautiful showroom by which to celebrate artists and writers, big thanks go to publisher Raoul Goff, art director Chrissy Kwasnik, my wonderful editor Roxanna Aliaga, and her gifted colleagues Jenelle Wagner, Jane Chinn, Carolyn Miller, and Judith Dunham.

As always, the passenger for this ride was my lovely partner, wife Margy Rochlin, who makes every journey I take a trip worth remembering.

—ROBERT ABELE

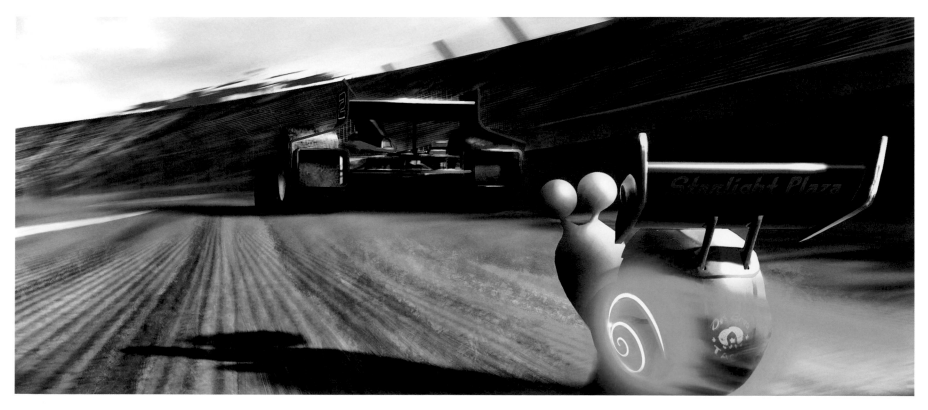

(pages 146–147) Dermot Power, (above) Dominique R. Louis

DREAMWORKS ANIMATION **would like
to thank** Kristy Cox, Karen Hoffman,
Michael Garcia, David Hail, Jeff Hare,
and Shelby Martin.

COLOPHON

INSIGHT EDITIONS

PUBLISHER Raoul Goff

ART DIRECTOR Chrissy Kwasnik

DESIGNER Jenelle Wagner

EDITOR Roxanna Aliaga

PRODUCTION MANAGER Jane Chinn

ASSOCIATE MANAGING EDITOR Jan Hughes

INSIGHT
EDITIONS
PO Box 3088
San Rafael, CA 94912
www.insighteditions.com

Find us on Facebook: www.facebook.com/InsightEditions
Follow us on Twitter: @insighteditions

Insight Editions, in association with Roots of Peace, will plant two trees
for each tree used in the manufacturing of this book. Roots of Peace is an
internationally renowned humanitarian organization dedicated to eradicating
land mines worldwide and converting war-torn lands into productive farms
and wildlife habitats. Roots of Peace will plant two million fruit and nut
trees in Afghanistan and provide farmers there with the skills and support
necessary for sustainable land use.

Manufactured in China by Insight Editions

10 9 8 7 6 5 4 3 2 1

(endpapers) Danny Williams

(page 1) Paul Lasaine

(pages 2-3) Mike Hernandez & Michael Isaak

(pages 4-5) Mike Hernandez

(this page) Marcos Mateu-Mestre - layout & Mike Hernandez - painting